WHO NEEDS
THE FED?

WHO NEEDS THE FED?

What Taylor Swift, Uber, and
Robots Tell Us About Money,
Credit, and Why We Should
Abolish America's Central Bank

JOHN TAMNY

ENCOUNTER BOOKS

New York London

First American edition published in 2016 by Encounter Books, an activity of Encounter for Culture and Education, Inc., a nonprofit, tax exempt corporation.
Encounter Books website address: www.encounterbooks.com

Manufactured in the United States and printed on acid-free paper. The paper used in this publication meets the minimum requirements of ANSI/NISO Z39.48—1992 (R 1997) (*Permanence of Paper*).

FIRST AMERICAN EDITION

LIBRARY OF CONGRESS CATALOGING-IN-PUBLICATION DATA
Names: Tamny, John, author.
Title: Who needs the Fed? : what Taylor Swift, Uber, and robots tell us about money, credit, and why we should abolish America's central bank / by John Tamny.
Description: New York : Encounter Books, 2016. | Includes bibliographical references and index.
Identifiers: LCCN 2015045934 (print) | LCCN 2016014394 (ebook) | ISBN 9781594038310 (hardback) | ISBN 9781594038327 (ebook) | ISBN 9781594038327 (Ebook)
Subjects: LCSH: Federal Reserve banks. | Banks and banking, Central—United States. | Credit. | BISAC: BUSINESS & ECONOMICS / Economics / Macroeconomics. | ART / Popular Culture. | LAW / Banking. | BUSINESS & ECONOMICS / Education.
Classification: LCC HG2563 .T36 2016 (print) | LCC HG2563 (ebook) | DDC 332.1/10973—dc 3
LC record available at http://lccn.loc.gov/2015045934

To my parents, Peter and Nancy, for always believing in me.

To my wife, Kendall, for constantly inspiring me.

To Hall McAdams, whose teachings made this book possible.

CONTENTS

FOREWORD

Rob Arnott

AS YOU READ this volume, prepare to be surprised. John Tamny makes many controversial and provocative claims that run contrary to the prevailing views of the academic economics community and of the policy elite. Indeed, many of his claims will provoke anger among the guardians of the status quo. Readers should consciously set aside their commitment to mainstream economic thinking and read the book with an open mind. You may not come away agreeing with everything Tamny says, but you will—most assuredly—leave aware of a very new perspective on some very old topics. Your gray matter will be stimulated!

The field of economics was originally called "political economy," because policy choices have a profound impact on macroeconomic growth. With this latest volume, Tamny encourages us to take a fresh look at money and credit. He writes, as always, with clarity and insight, and skewers conventional economic thinking with great gusto. In so doing, he shows us that economics is no arcane field best left to the experts. The most important aspects of "political economy" can be understood by anyone with a healthy dose of curiosity and common sense. In their clarity and depth of insight, Tamny's writings remind me of Jude Wanniski's *The Way the World Works*. This type of critical thinking forces us to reexamine the prevalent economic theory in both academia and politics.

This is no heavy-handed tome on the evils of central banks. There are no polemics here. Through a series of insightful—yet controversial—observations of the modern U.S. economy, Tamny leaves us with some

powerful and important observations about the workings of our modern
economy, particularly as they relate to credit. In this slender volume,
Tamny reexamines the role of today's Federal Reserve, the supposed
price setter of credit, in shepherding (or not) our country's economy. He
expertly challenges the notion that the Fed can and does stimulate the
economy, not with formulas and finance theory but with compelling logic.
He explores whether the Fed is truly necessary, as conventional wisdom
suggests it is. The reader is likewise challenged to view money and credit
from an entirely new perspective.

When we think about credit, it is natural to think first of our own
credit. When we want to buy a house or a car, or start a business, a lender
will want to see evidence that we have (a) the future resources to repay
the loan and (b) a history of repaying past credit on time. In *Who Needs
the Fed?*, Tamny points out that credit is not just dollars and cents; it is
access to real resources. This approach hearkens back to that of John Stu-
art Mill and the notion that money is a veil: It has no meaning except as
a means of exchanging goods and services, both across the economy and
across time. With money, I can exchange my investment research ideas
for groceries or for an auto mechanic's skill in fixing my car, *either now
or in the distant future*. Credit gives us access to goods and services today,
paid out of future income (in other words, paid from our own commit-
ment to deliver future goods and services to others).

Should the federal government have a role in setting the price of
credit? Investors and the business media all over the world parse every
tea leaf between the lines of Fed statements, looking for some hint about
future policy direction, usually as it relates to prospective "easing" or
"tightening" of credit in the marketplace. But in reality is credit being
eased or tightened by the Fed, or by the marketplace? More fundamen-
tally, *can* the federal government set the price of credit—defined broadly,
not just in the fed funds rate—*even if it wished to do so*? Put another way,
when we apply for a loan, are we basing our decision on the latest quarter-
point move in the fed funds rate? Is the bank or other lender basing their
rate on Fed policy? Tamny presents thought-provoking examples of credit
transactions, ranging from Hollywood to Silicon Valley, from hedge fund
managers to football coaches, that provide an iconoclastic perspective on
the Fed's effectiveness in doing that which it is purported, nearly unani-
mously, to do well: managing the cost of capital.

Taking it a step further, Tamny asserts that, contrary to modern economic theory (but in line with common sense), the Fed's actions potentially have the opposite of their intended effect. If the Fed is "easing" credit, it stands to reason that it is redirecting credit away from where the free market would have desired. If that is the case, then the attempted easing can lead to a suboptimal allocation of credit, which is to say, a suboptimal allocation of real resources. Is this strategy pro-growth? Hardly!

In the 1970s in the United States, with an electorate upset over the high price of gasoline, the government thought it sensible to give its citizenry a break by imposing wage and price controls. On the face of it, this seemed logical—paying less for gas would give drivers a break, spurring renewed economic growth with the money left in their pockets. However, price controls *always* have unintended consequences. In the 1970s that meant that in addition to the artificially low cost of filling your tank, you had to pay with your time, waiting in a daunting line of cars at the pump, hoping to get to the front of the line before the station was pumped dry. Worse still, once the gas station (whose revenues were artificially low as a result of being forced to sell its product below the market value) ran out of gas, they closed their doors to save on operating costs, thereby decreasing their employees' income and further inciting panic at the sight of the closed doors. The increased panic made lines even longer, further increasing the price of the gas, as measured in time spent waiting in your car. So, exactly as common sense would suggest, price controls delivered economic contraction, not growth.

Credit has its price, just like gasoline. Seeking to control this price with easy credit is a futile endeavor at best; at worst, it can be a growth-destroying, resource-misallocating, and credit-tightening experiment in unintended consequences.

Tamny defines credit as access to real resources. He succinctly points out that the federal government has *no* credit of its own; rather, the fed is empowered to redirect credit—that it extracted from the private economy, through its ability to tax its citizens—namely, *our* credit. When the Fed seeks to stimulate the economy, by way of monetary policy, it renders the cost of carrying a national debt artificially low. However, as the Federal Reserve attempts to keep U.S. borrowing costs (and resulting deficits) down, it becomes an enabler of bad behavior, tacitly encouraging overspending, which drains the private sector economy that stands

behind the nation's credit. Exchanging lasting economic growth for a short-term discount on interest payments is a losing deal.

On the campaign trail in 2012, President Obama famously quipped "You didn't build that" in reference to business owners who were helped along the way by government investment in infrastructure. His logic was that local, state, and federal governments educate the individuals who become the labor force, build the roads and bridges that our businesses rely on, keep us safe with military and police forces, and so forth. The irony is that the president had it backward. The government can't spend without taking resources from the private economy first. The government didn't build the roads; they were funded by taxes extracted from the private economy and built by private contractors (who fought through government agencies and a morass of red tape to do so) in locations that the free market deemed necessary. In addition, when these public works projects become a boondoggle, the amount of money spent on them by legislators tends only to go up.

Tamny correctly points out that money government wastes is *gone*; forget the notion of a Keynesian multiplier on wealth destruction. In the private sector, money and credit run from failure rather than being attracted to it. Real resources rarely lay idle. Left to their own devices, market forces would no doubt have built roads the way they have built cars, planes, shopping malls, and skyscrapers, but with less chance of building a bridge to nowhere. This point may seem tangential to the discussion of credit, but it is very relevant. Unless government is completely dysfunctional, its agencies don't fully control where and how that infrastructure is built; rather, they attempt to react to market demands.

In much the same way, the Fed doesn't fully control access to credit. Furthermore, just as state and federal legislators can misallocate resources and overinvest in marginal projects, dissipating national treasure, the Federal Reserve can distort credit markets by unintentionally misallocating the nation's resources (credit equals goods and services!) by setting an artificial price for one swath of the credit market. In so doing, the Fed steers resources away from wherever the market would otherwise have sent them. Do the Fed's monetary "price controls" successfully loosen our access to real resources? No. Do they create a drag on economic growth? Based on the somewhat startling observations in the following chapters, we can only conclude that price controls on credit cannot lead to economic prosperity.

Tamny's conclusions are controversial. He suggests that the Fed is unnecessary and has the potential to do far more harm than good. He suggests that the protracted "zero interest rate policy" cannot possibly have helped to fuel the second-largest equity bull market in history. He suggests that artificially controlling the government's cost of capital guarantees a misallocation of resources away from the private sector to the public sector, funding current public-sector spending at the expense of future growth. He also suggests (as does Milton Friedman) that deficits are irrelevant; what matters is the level of public-sector spending.

Readers may agree or disagree with each of Tamny's conclusions. If we approach this important and highly readable book with a spirit of curiosity and a willingness to reexamine our beliefs, then we are guaranteed an intellectually stimulating adventure. Be prepared to reconsider your core assumptions about the nature of money and of credit.

ACKNOWLEDGMENTS

A LENGTHY CHAPTER could be dedicated to thanking and acknowledging all the people who made *Who Needs the Fed?* possible. I'll do my best to keep it somewhat brief, and declare from the outset that any errors of the factual or theoretical variety are mine.

Up front, Hall McAdams rates very special thanks. I first visited with him in 2003, and since then he's become a very important—and patient—friend. An expert on banking and free market economics, Hall has been pushing my buttons about banking, credit, and the Fed for years. His skepticism about conventional thought on all three nourished my own thinking in a major way. Absent Hall there would be no book, simply because our regular communication opened my eyes to the ideas that led me to write it. Hall's wonderful wife, Letty, similarly deserves mention for encouraging the constant communication between Hall and me.

Hall's teachings piqued my interest in finance and ultimately led me to books on banking by Robert H. Smith. Ironically Smith lives on the same street as my parents. This requires mention mainly because name recognition led to conversations and e-mails with Smith that provided me with essential information and insights that, in turn, gave life to *Who Needs the Fed?* Absent Smith, what I presume to be good about this book would be substantially neutered.

Arguably the toughest part of writing any book is putting pen to paper for the initial chapters. In this regard, Jessica Disch requires significant mention for attending a Taylor Swift concert with my wife, Kendall, and

for documenting the "surge pricing" offered by Uber in the concert's aftermath. Jessica's happy experience provided real-world evidence that the Fed's frequent pursuit of "easy credit" is wholly backward.

Big thanks go to Ralph Benko for being such an interested reader in what most would agree is contrarian thinking about money and credit. Ralph's passion about changing the economic debate is a constant inspiration. I also thank my longtime H. C. Wainwright colleague David Ranson for initially explaining to me the flawed mysticism that defines the theorizing about so-called money supply. David reached these conclusions back in the 1970s with Marc Miles and Arthur Laffer. It's worth stressing that Laffer's insights about monetary policy have influenced me more than his certain genius in the area of taxation.

My good friends Chuck Smithers and Steve Shipman have for years informed and expanded my thinking on monetary policy, all the while applying the ideas of sound money to capital allocation. Nathan Lewis and Richard Salsman know monetary policy arguably better than anyone in the field today. Hopefully both will see their insights scattered throughout. The great historian Steven Hayward always rates mention in any book by me, mainly because most aspects of this book that presume to entertain draw on research he conducted.

Windsor Mann is easily one of my favorite commentators. His energetically funny columns on the wasteful folly that is government ably informed my attempts to reveal government as the credit destroyer that it is. Tim Reuter was an essential sounding board throughout and a great early editor of what became *Who Needs the Fed?* I can't wait to read the many books and columns that both Mann and Reuter have in their futures.

Rob Arnott didn't just write the foreword for *Who Needs the Fed?* He's also been a great friend for many years, always willing to take a meeting with me despite creating and running one of the most prominent money management firms in the world. He's taught me enormous amounts about economics and monetary policy since we first met back in 2005, but Rob doesn't just teach. He's an avid listener, and his interest in my ideas has long been a source of confidence.

And then there are the grand economic thinkers who long ago left us. Henry Hazlitt's *Economics in One Lesson* continues to influence my thinking and style in profound ways. So do the masterworks of John Stuart Mill and Adam Smith. The great Robert Bartley revived the truth that money is only good if it's a stable measure, and his *The Seven Fat Years*

rarely leaves my side. But the biggest influence on *Who Needs the Fed?* surprised me. Though I first read and enjoyed Ludwig von Mises's *The Theory of Money and Credit* years ago, it was re-reading it ahead of writing this book that truly opened my eyes to its unrelenting brilliance.

Reverential thanks go to the irreplaceable George Will. He could so easily be distant and unreachable to someone like me, but he's instead made himself available, encouraged me, and thankfully reminded me of what a privilege it is to write for the public. Will told me the latter during a particularly difficult time amid the writing of *Who Needs the Fed?*, and it was a major inspiration. That he's also gone out of his way to promote my thinking in columns cannot be minimized for its impact on my career. I'm forever grateful to this giant of opinion not only for liking my work but also for generously telling his readers about it.

That I have an audience in the first place is thanks to John McIntyre and Tom Bevan at *RealClearPolitics*. Their entrepreneurial nature made possible *RealClearMarkets*, which has since become a top locale for quality economic and market commentary. Lewis D'Vorkin at *Forbes* has loomed large here, too, for making Opinions a home for highly insightful economic commentary.

Kim Dennis of the Searle Foundation, always optimistic, has made possible the distribution of my books to a much wider audience. Whatever accomplishments I've enjoyed are in large part thanks to her.

Juleanna Glover has been an energetic supporter of my work, as well as an essential source of ideas that have expanded my writing horizons. Her encouragement has been a very important driver of my confidence.

David and Karen Parker went to great lengths distributing my first book, *Popular Economics*. Their willingness to alert major organizations, friends, and ideological opposites to my way of thinking has meant a great deal.

Ruth Westphal has been enormously energetic about spreading my articles and books to a rapidly expanding group of people. She has also helped me secure all manner of speeches through which to promote my work. I'm beyond grateful for all that she, an excellent entrepreneur herself, has done for me, along with the freedom movement itself.

Bob and Ruth Reingold continue to support me in amazing fashion. Bob saw years ago what I like to think he thought of as talent and has been unstinting in his support ever since. I'm so lucky to know them both, and to count them as great friends.

Many of the people mentioned here I know thanks to Ed Crane. Ed made libertarianism cool, and his thinking very much informs my own. Ed has been consistent in his contention that government spending itself is the true economic burden. *Who Needs the Fed?* works off of Ed's thinking, which reveals government spending as the wrongly ignored source of credit destruction.

Big thanks go to David Nott, president of Reason Foundation. I'm proud to call Reason home, and I'm there thanks to David's belief in me. Nick Gillespie, Julian Morris, and Melissa Mann have similarly been very welcoming to me, and I'm excited to accomplish great things with all of them.

Roger Kimball of Encounter Books requires prominent mention for his early excitement about *Who Needs the Fed?* It's been a thrill working with him, along with Katherine Wong and Sam Schneider. Their optimism has greatly enhanced mine.

As for the great Steve Forbes, a day doesn't go by in which I don't think about how much he's done for me both personally and professionally. I'll surely fail in trying to repay all of his kindness to my wife and me, not to mention what he's meant to me professionally. Steve has the ear of CEOs and world leaders, but he's always made time for me and has always encouraged me. No words can adequately describe all that he's done on my behalf and all that he's taught me. A greater, kinder person would be hard to find, or fathom.

And then there are the people to whom I dedicate this book, Peter and Nancy Tamny. I can't believe how lucky I am that they're my parents. Unrelenting in their belief in and support of me all of my years, they also passed on to me genetic skepticism about conventional thinking. I'm truly grateful that they've always been there for me, along with my sister, Kim. I don't deserve a sister like her. Her enthusiasm about all that I do means more to me than she knows.

Last, but certainly not least, there's my wonderful wife, Kendall. All the books (one can hope!) are certainly for her. Kendall's influence on me has been profound. Without her there are no books, and there's not much happiness either. I hit the jackpot in convincing her to marry me, and time spent with her is a constant reminder of just how lucky I am.

INTRODUCTION

*If we were to destroy every piece of paper currency in the
world, and every bank account entry, we would not have
destroyed one shred of real economic wealth.*
—Warren T. Brookes, *The Economy In Mind*, 81

On August 13, 2015, and in an op-ed for the *Wall Street Journal*, the
economist Alan Blinder posed the following question: "Will the Fed raise
interest rates?"[1] At first glance there is nothing abnormal about his query.
A Google search of "Fed" combined with "Interest Rates" leads to 45 mil-
lion results. Particularly within the economics profession, it's broadly
accepted that the Fed can—*and should*—actively seek to manipulate the
cost of credit.

But imagine if Blinder's opinion piece had asked a slightly different
question: "When will the Central U.S. Hamburger Authority raise the
price of Big Macs and Whoppers?" The *Journal's* editors would have been
inundated with letters from incredulous readers protesting Blinder's con-
ceit, let alone that of the federal government. The prices of hamburger
meat, buns, lettuce, tomatoes, and name offerings like the Big Mac and
Whopper are set in local, domestic, and international markets. Reason-
able readers would correctly point out that no central authority could
ever successfully plan the price of these most American of food items.

Worse, assuming a government decreed submarket price, it's fair to say
that the supply of Big Macs and Whoppers would quickly shrink on their
way to disappearance. Rare is the business that can remain in operation
if the prices it's allowed to charge are a lot or even a little below its costs.

To this unlikely scenario, some might reply that money is different,
particularly the U.S. dollar. Perhaps there's an argument for a central

authority like the Federal Reserve to set the price of access to dollars, which are issued as legal tender by the federal government. But there isn't.

It is often forgotten that when the Fed (or any central bank, for that matter) presumes to dictate interest rates, it's in no way controlling the cost of accessing dollars. If it were, which would presuppose that money were in fact wealth, plentiful credit would be as simple as printing money, and lots of it; the helicopter strategy of wealth creation would be a valid one. Yet we intuitively know that money doesn't just grow on trees, nor can it be dropped from the sky.

More realistically, when the Fed raises or lowers interest rates, it is attempting to manipulate the cost of *everything* produced in the actual economy. That it has tried to do this to varying degrees since its creation in 1913 is something that warrants more extensive discussion. It is, quite rightly, all of our concern.

Stated simply, credit is not money. If it were, the "easy credit" that many-who-should-know-better clamor for would once again be as simple as printing lots of money. In fact, credit is always and everywhere the actual resources—tractors, cars, computers, buildings, labor, and *individual credibility*—created in the real economy. We borrow "money," but we're really borrowing resources. Credit equals resource access. We correctly balk at the notion of a central authority trying to divine the proper price of a Big Mac or a Ferrari. Yet, somehow we've come to accept that the Fed should have a role in setting the cost of *access to everything* we produce in what is called "the economy."

All of this commentary about how central banks can and should tinker with interest rates is a scary assertion from the economics profession, which believes that the cost of accessing capitalist production should be planned by government. Indeed, an "interest rate" is a price like any other. The interest rate is what those who have access to the economy's resources charge others for the privilege. When people borrow, they're not borrowing dollars; they're borrowing the real economic resources that dollars can be exchanged for.

Just as Burger King painstakingly sets the price of a Whopper to maximize its restaurants' potential to lure in hungry buyers, so is the rate of interest a price meant to bring savers together with borrowers. If this rate is distorted by governmental decree, then the odds of exchange decrease. For credit to be "easy," the price of credit must reflect both the needs of

those who seek to access it and the needs of those who have it. Put more plainly, the price of credit should be set in free markets. Markets are information personified, and as such they are quite capable of setting the rate of interest that most meets the needs of borrowers and savers. Prices set in free markets maximize the potential for transactions, including those between savers and borrowers.

In my first book, *Popular Economics: What the Rolling Stones, Downton Abbey and LeBron James Can Teach You about Economics*, I argued that when it comes to booming economic growth and immense prosperity, the answers are easy. That argument remains true. Also true is that just as the economics profession presents a major barrier to economic growth, its mysticism renders credit less attainable, by virtue of the credentialed presuming to set prices and intervene in markets in ways that wouldn't take place if markets were free.

Achieving economic growth and prosperity is as simple as removing the four main governmental barriers to production: excessive taxes, burdensome regulations, tariffs that limit one's ability to trade freely, and money deprived of its sole purpose as a measure of value. Economists and politicians have too often forgotten this in modern times, much to our detriment.

An economy is just a collection of individuals. As individuals, we must supply a good or service first in order to fulfill our infinite wants. That being the case, prosperity is as easy as reducing—and in some instances abolishing—the four basic barriers governments erect that make it difficult for people to produce, or better yet, supply.

When we define "credit" as the real resources produced by the individuals who constitute the economy, we see that abundant credit, like economics and economic growth, is also a simple concept. The more politicians get out of the way, by shrinking the four barriers to production, the more production there will be; soaring credit on offer is the natural result.

This relationship also tells us that despite what passes for conventional wisdom, neither governments nor central banks can expand the amount of credit available in the economy. Credit is what individuals produce in the real economy when they get up each day and go to work. *We are credit*, so the singular path to making credit abundant is to free individuals to pursue what animates their individual talents. Easy credit is the clear result of personal and economic freedom.

To further understand why the Fed can't create credit, readers must consider government spending. Government can spend only what it extracts from the real economy first, and spending without market discipline, as a rule, shrinks the total amount of economic resources available. Readers should view credit in the same way. Since the Fed has no credit to offer other than what it extracts from the real economy first, it can only shrink it insofar as it exerts its power to increase access to it. For the Fed to "ease" credit, it must by definition reduce the amount of credit offered by market-disciplined actors in the economy.

This is why questions like the one Blinder posed, about whether the Fed will raise interest rates, are cause for worry, if not horror. Neither government nor the Fed can create credit or make it easy to attain. Rather, government and the Fed can only, by their very nature, respectively, redistribute ownership of the economy's resources and distort who will have access to those resources in the first place.

In short, governmental and central bank attempts to manipulate the cost of credit, or make it "easy," do nothing of the sort. Instead, they shrink the availability of credit in much the same way as government artificially lowering the price of apartments and cars would shrink the supply of both. So if we accept the undeniable truth that abundant credit is the certain result of a free economy, then the path to expanded access to the economy's resources is a simple one.

In *Popular Economics*, I laid out the ease of prosperity sans graphs, charts, and indecipherable equations. Economic growth is easy, as the book made plain, and can be readily explained through examples from the world of movies, sports, and famous businesses. For far too long, the economics profession has been on a mission to make what is cheerful quite dreary and opaque.

In *Who Needs the Fed?*, my goal once again is to simplify the narrative. There is nothing advanced about economics. Growth economics is all about reducing the barriers to production, so I can't stress enough that the often-incomprehensible notion of credit is equally simple. And it can be explained by the world around us.

Up front, I want to establish that this book is not about the mechanics of bonds, credit default swaps, and other forms of finance. Furthermore, it does not aim to explain the mechanics of banking and the Federal Reserve. There are countless detailed books on those subjects.

Instead, *Who Needs the Fed?* covers the all-important subject of credit, along with the role of banking and the Fed when it comes to *accessing it.* There's quite simply no economic activity without credit, but the meaning of credit has been perverted in modern times by a political and economic class that operates under the delusion that credit is "money" and can be decreed "easy." The latter is a dangerous falsehood that requires correction. Accessing credit, and I will repeat this idea throughout the book, amounts to accessing resources. Credit and resources are one and the same.

It is important to say up front that the discussion of credit, like that of economics, should in no way be difficult. If readers can comprehend what is before them through sports, entertainment, and famous businesses, they can easily understand credit, banking, and the Federal Reserve. They'll also ideally conclude that the Fed is not only superfluous on its best day, and largely irrelevant to the credit discussion on average days, but also very much a barrier to prosperity on its worst days.

PART ONE
CREDIT

The Rate Setters at the Fed Should Attend More Taylor Swift Concerts

The price is determined at that level at which two parties
counterbalance each other.
—Ludwig von Mises, *The Theory of Money and Credit*, 287

ON JULY 15, 2015, pop singer Taylor Swift performed for two straight nights at Nationals Park in Washington, D.C. Globally popular thanks to catchy songs that sometimes describe past romantic relationships with the famous, Swift is one of the most important acts in music.

To properly understand the power that Swift wields, it's useful first to travel back a little less than a month before her arrival in D.C. It was then that Apple, the creator of the iPod, iPhone, and iPad, and the most valuable company by market capitalization in the world, announced its new Apple Music streaming service.

Amid its rollout, and with the idea of luring customers away from popular competitors such as Pandora and Spotify, Apple offered a *free*, three-month trial. Enter Taylor Swift.

Understandably offended that Apple would presume to build a new business on the backs of the musicians who had created the music it was streaming, Swift struck back on Tumblr. "Apple Music will not be paying writers, producers, or artists for those three months," she wrote. "I find it to be shocking, disappointing, and completely unlike this historically progressive and generous company." She added: "We don't ask you for free iPhones. Please don't ask us to provide you with our music for no

compensation." Swift backed up her words with a threat to withhold streaming rights to 1989, her mega-selling album released ahead of her 2015 tour.

Ever fearful of the bad PR that would blemish their new business line, Apple caved. Within hours the technology giant announced a reversal of its initial offer of free music to its early adapters. Apple promised to pay the artists for music streamed during the trial period.

So newsworthy was Swift's response to the technology colossus that even the *Wall Street Journal*'s editorial page, the holy grail of public policy opinion, saw fit to comment with unrestrained awe. The page's editors marveled at how Swift taught them "a good lesson about intellectual property rights—and the danger of taking on a woman who knows what she's worth."[1]

Swift also provided the world with a great lesson about credit. Economists frequently act as though cheap credit can be decreed through an announcement from the Fed of a "low" interest rate. Swift's pointedly open letter to Apple was a reminder that when it comes to credit there's always and everywhere a buyer *and* a seller.

Apple learned in embarrassing fashion that which doesn't seem to concern central bankers, who are apparently less sensitive to ridicule. It's one thing to declare from the commanding heights of government the supply of a market good inexpensive, but it's the height of folly to assume that those in possession of that market good will give it to buyers for nothing. Going back to Swift's threat to withhold songs from 1989, eager buyers of Apple Music were going to experience 1989 "scarcity" absent Apple's reversal.

Importantly, the lessons Swift provided don't end there. Everything anyone could ever want to know about the economy and credit is there for the taking in the example she offered. Knowledge is a function simply of keenly observing the world around us.

As mentioned at this chapter's outset, Swift played two nights at Nationals Park. The cavernous stadium can hold more than forty thousand attendees, and Swift filled the stadium both nights. Among the attendees were my wife, Kendall, and some of her friends.

Reaching the baseball stadium proved easy, but upon the conclusion of Swift's concert, there was a mad rush to get back home. While the Metro in Washington, D.C., serves Nationals Park, the lines to get on a train after the music stopped were endless. Word was that while the

Metro would remain in service well past midnight, it would take several hours to transport Swift's many fans.

With the Metro an unrealistic option for concertgoers eager to get home before midnight, cabs came into play as the second option. Unfortunately, the District of Columbia Taxicab Commission regulates the fares that its cabdrivers can charge. While the Commission allows for slightly higher rates during periods of heavy demand, these fares weren't enough to lure drivers (aka sellers) into streets clogged with desperate buyers. The area around Nationals Park was a madhouse.

While this fare control clearly wasn't working after the Taylor Swift concert, it's long been the norm in Washington, D.C. Cabs are allowed to charge passengers extra during major snowstorms, but as anyone who has lived in the District knows, the paltry increase in rates regulated by the Commission rarely makes it worth drivers' time to be out on perilous roads. Once again, when passengers (buyers) are most in need of drivers (sellers), drivers are not available.

Setting prices at artificially low levels to please buyers ignores that every transaction has a seller, too. Indeed, setting artificially low prices also ignores the purpose of prices in the first place. In a free market, prices are regulation *par excellence.*

In a free market, prices reflect not only the desires of buyers and sellers but also the weather, the news, what's scheduled to happen next week, and so on. Prices frequently fluctuate in a free market as a way of taking into account the dynamic wants and needs of buyers and sellers. Prices in information-pregnant markets are necessary tools for bringing together buyers and sellers.

Government regulation of prices doesn't fail because people who toil in government are inherently bad. They fail because no bureaucrat, no matter how smart, can ever divine a price that will reflect a constantly changing marketplace. That's why government regulation of prices frequently leads to scarcity when supply is needed most. It's impossible for an individual or a collection of individuals to know even a fraction of the information that the market is constantly processing.

As if the proverbial cab-shortage fire on that steamy evening in July needed any more gasoline, it's against the law for cabdrivers not in possession of a Washington, D.C., cabdriver's "medallion" to pick up passengers there. This rule is meant to protect the market for D.C. drivers, who are already unable to charge what the market will bear. But for Taylor

Swift fans it meant that getting home from her concert could take potentially hours.

So, despite a great concert enjoyed by Swift's many fans, the evening had the potential to end badly, thanks to the fatal conceit of government officials that they can successfully plan prices. Was a good evening ruined? No.

This story has a happy ending thanks to the intense entrepreneurialism that continues to define the American economy despite the barriers placed in front of this country's dreamers. Specifically, the story ends well thanks to Uber. Founded in 2009 by Travis Kalanick, Uber's business model is rooted in the correct understanding of commerce, namely, that there are no buyers without sellers, and vice versa.

Kalanick devised an app that people around the world are adding to their smartphones in increasingly high numbers, as evidenced by a private valuation of the San Francisco company at more than $50 billion.[2] Whereas it used to be that only the superrich had the means to ring a bell and summon a driver, thanks to Kalanick's app anyone with a smartphone can tap the Uber button and have a driver arrive in minutes.

It is said that the best way to predict how the poor and middle class will live in the future is to observe how the rich live in the present. Uber attests to the veracity of that statement. Once, only the rich had "drivers" at their beck and call; now, we all do. So, while the story of Uber could be used on its own to explain all anyone would need to know about economics, for the purposes of this chapter Uber's genius will be used to explain credit.

When my wife and her friends realized that the lines for the Metro were too long, and cabs nonexistent, they tapped their Uber apps. They were soon relieved to find that Uber drivers were in the area and available *within minutes*. However, an Uber ride that night would cost its passengers *3.6 times* the rate the company normally charged. Did my wife and her friends turn off their phones in disgust and delete the app because Uber was charging them so much during a time of need? No. They rejoiced.

Despite Uber's implementation of "surge pricing," my wife and her friends eagerly tapped on SET PICKUP LOCATION. A driver was there within minutes to take them home. They happily paid $34.03 for transportation that on a normal night would have cost $9.45.

Uber's surge pricing is a worthy metaphor for interest rates. Uber "gouged" my wife and her girlfriends that night, but they were only too

happy to be gouged. The other option was to wait potentially hours to get home. They valued their time and a good night's sleep far more than the $34.03 fare they ultimately paid to arrive home at a reasonable hour.

From simplicity genius often springs, and it certainly has with regard to Uber. While the Federal Reserve employs thousands of well-credentialed economists with doctorates from the best schools in order to divine the interest rate it naively presumes to set, Kalanick's app has ably revealed that the expensively dressed Fed truly has no clothes. It's no reach to say that the economists in the Fed's employ have IQs that render them among the smartest people in the world. Yet, even the brightest people with the best computers and models at their disposal are not smarter than the market itself. Neither one genius nor a collection of geniuses could ever properly process the infinite decisions occurring in the marketplace every millisecond.

Kalanick's intuitive understanding of this truth is the basis of Uber's immense global popularity. Fully aware of the tautology that there are only buyers as long as there are sellers, Uber ensures that its customers will be able to purchase transportation when they need it most by virtue of it placating the seller, too. Surge pricing is the company's way of luring drivers onto the road, and into the most nightmarish of conditions (rain, snow, after a Taylor Swift concert), so that it can serve its customers.

More to the point, Uber achieves an "easy" supply of drivers for its customers not by making their services cheap but by doing the exact opposite. Pricing is once again the free market's way of regulating the supply of the resources we deem credit. High prices—on New Year's Eve pricing from Uber has been known to "surge" to more than nine times its normal fare—are at times what ensure the existence of a market good that is in high demand.

Contrasting this with the Fed, economists with highly impressive resumes regularly commentate and opine on when the Fed will "hike" interest rates, and when the Fed will "ease." Fed officials lap up all the attention from the various forms of business media about what their next move will be.

Even more amusing, and disturbing at the same time, is that right when credit is needed most, when the economy is most imperiled, or when the nightmarish scrum equivalent of the aftermath of a Taylor Swift concert is upon us, the Fed's alleged wise minds almost reflexively "cut" interest rates. If Uber did as the Fed does vis-à-vis savers (for some-

one to borrow, someone else must first save), if it scoffed at the needs of its drivers during the periods of highest passenger demand, drivers would never be available when they were most needed for Uber's customers.

What all of this hand-wringing and speculation about price-fixing from the Fed should signal to readers is that intelligence and common sense aren't one and the same. Can these bright economists and Fed officials really be so dim? Can they honestly claim their meddling with the price of access to the economy's resources actually achieves something positive for the economy in terms of broadly available credit? For those who've long bought into the obnoxious conceit that is the Federal Reserve, to answer this question in the affirmative seems rather dishonest.

As the story of Uber signals rather plainly, plentiful access to resources (credit) is a clear function of the price of resources that reflect the infinite wants and needs of those actually participating in the markets, including those who have access to those resources. Uber succeeds by virtue of allowing the price of its service to fluctuate such that the needs of both its customers and its drivers are met.

Fed officials cannot make a similar claim. The Federal Reserve's meddling with the price of credit at best restrains credit's availability, and at worst, as the book will reveal, destroys it with abandon. Luckily the Fed's relevance in what still remains a market economy continues to decline. Imagine how badly off we'd all be if the Fed were the sole source of credit, or for the purposes of the next several chapters, if its rate setting truly dictated credit costs. Thankfully neither is the case.

Jim Harbaugh, Urban Meyer, and Pete Carroll Would Never Need an Easy Fed

You are what your record says you are.
—Hall of Fame NFL coach Bill Parcells

IF YOU FOLLOW college football and basketball with any kind of intensity, odds are you have the Rivals.com website bookmarked. Absent talent, teams can go only so far, and Rivals chronicles the recruiting of that talent. Just as entrepreneurs and corporations in pursuit of profits aggressively seek the best engineers, salespeople, and administrators, so too do coaches travel far and wide each year in search of the players necessary to field great teams.

Labor itself is a form of credit, and realistically it's the *most important form*. When CEOs seek monetary "credit" to start or expand a business, they're often borrowing access to labor. College coaches do much the same. The individuals on the field whom they recruit are their ultimate resource.

Applied to college sports, coaches are offering prospective student athletes a free college education along with room and board, a university name they can carry around for life, and, depending on the player, use of the school's resources to boost their chances of playing professionally in the future. College football and basketball recruiting is very much a credit story.

To help rabid fans develop a better sense of which players are the most desirable, Rivals employs a team of analysts that watches hours of player

tape. The analysts also visit high schools nationwide, interview coaches, and generally do everything possible to put a grade on the best players available. The most desirable recruits for teams are the few athletes graded as 5-Star by Rivals. These are the players seen as most likely to thrive on the collegiate level. 4-Star recruits are similarly much coveted. 3-Star athletes are slightly less desirable. You get the picture.

In addition to player rankings, Rivals calculates team rankings on a points basis. 5-Star recruits logically generate the most points, and consequently it's usually the teams who can sign the most 5-Star players that win the annual Rivals recruiting championship. In 2015, the USC Trojans won the national recruiting title after then head coach Steve Sarkisian and his staff scored some late 5-Star commitments.[1]

National Signing Day for college football recruits falls on the first Wednesday of February every year. Going back two months before signing day in 2015, the University of Michigan fired head coach Brady Hoke after an ugly 5-7 season.[2] 5-7 records don't cut it for Wolverine fans used to spending New Year's Day in Pasadena, California, at the Rose Bowl. But what made Hoke's dismissal even more likely was the outlook for Michigan recruiting. According to the Rivals team rankings as of early December 2014, Michigan's 2015 class ranked 96th. Fresno State was one spot behind the University of Michigan at 97th, while Toledo, Army, and even University of Texas *San Antonio* had higher-ranked recruiting classes.

Uncertainty about Hoke's future played into the team's low ranking, but this is still the University of Michigan we're talking about. The school is a magnet for top players (think Dan Dierdorf, Charles Woodson, and Tom Brady, to name but three) who grow up dreaming about wearing the "Maize and Blue." So, even a winless season shouldn't consign the Wolverines to the recruiting basement.

A month later, Jim Harbaugh was named Michigan's new head coach. Harbaugh had been a star quarterback for the Wolverines before a long career in the NFL. But what distinguishes him even more today are his achievements as a head coach. In 2007, Harbaugh inherited a 1-11 Stanford Cardinal team. In his first season at the helm, Stanford pulled off one of the biggest upsets in college football history, when the overmatched Cardinal beat the #1 USC Trojans at the Coliseum.[3] As the fortunes of the Cardinal improved, so did the talent interested in the school. Harbaugh eventually signed a quarterback out of Texas by the name of Andrew Luck.[4] By Luck's fourth season on "the Farm," the Cardinal brought an

11-1 record into the Orange Bowl, where they blew out traditional power Virginia Tech 40-12.

Having turned Stanford into a national football power, Harbaugh moved on to the NFL. In his first three years as head coach of the San Francisco 49ers, he took the team to the NFC Championship Game three times. (The 49ers hadn't sniffed anything resembling greatness since the mid-1990s). In his second year, they went all the way to the Super Bowl. Although the 49ers lost to the Baltimore Ravens (coached by Harbaugh's brother, John) in a game that went down to the final drive, Harbaugh had established himself as one of the better and more innovative coaches in all of football. In short, Michigan's hire of this most "Michigan" of men was a coup. And recruits noticed.

While Harbaugh arguably didn't have enough time or staff to build a big recruiting class for 2015, by National Signing Day Michigan's Rivals' ranking had risen all the way to #50, including fifteen 4-Star recruits and the consensus #1 recruit, Rashan Gary. 2016's class looks even better. As of this writing, Harbaugh can claim the #5 recruiting class, including nine 4-stars. Harbaugh's track record of success screams good credit, and a briefly down-on-its-luck Michigan team has a bright future.

What stands in Harbaugh's way is Michigan's traditional rival, Ohio State. Coached by Urban Meyer, the Buckeyes won't give up their perch at the top of the Big Ten's recruiting and football heap easily. While there are few college coaches with Harbaugh's "street cred," Meyer is one of them.

Meyer took over the head coaching reins at Utah in 2003. Notably, Utah never comes up when fans talk about football powers. But by his second season at Utah, Meyer coached the team to a 12-0 record that ended with a victory in the Fiesta Bowl. After the undefeated season, Meyer was hired as head coach of the Florida Gators. In his second season there, the Gators won the national championship. Meyer added a second national title to his resume in his fourth season.[5] Poor health ultimately forced Meyer to resign.

After a year off, he was named head coach of Ohio State, and it didn't take him long to work his magic. After an undefeated first season in Columbus and a 12-2 record his second year, Meyer's Buckeyes overcame an early 2014 stumble to Virginia Tech to win the national championship in blowout fashion over the Oregon Ducks. Recruiting victories predictably increased with the improved on-the-field fortunes of the Buckeyes. As Meyer told *USA Today*, "I can't wait to go out recruiting. You can't

recruit to this [success] now, you're officially a bad recruiter."[6] Rivals ranked last year's Buckeye class #9 in the country. As of this writing, 2016's class is ranked #1, including two 5-star recruits.

Two great coaches, with brilliant track records, correlates with abundant "credit" in the market for top football talent. On top of past success, the Horseshoe at Ohio State and the Big House at Michigan represent legendary stadiums that aspiring football stars know well. Harbaugh explained it best to *Sports Illustrated* in 2015: "There's no bad time to see Michigan, and no bad way to see Michigan."[7] Not only do the coaches of each school personify credit, but their schools do, too.

But wonderful as the Buckeye and Wolverine traditions may be, there's seemingly always something better out there, something a little bit superior. Odds are even the most ardent Buckeye and Wolverine fans would acknowledge that no school represents on the tradition front as well as the University of Southern California (USC).

The University of Southern California can claim a number of "mosts." It has produced more NFL draft picks, including *first round* NFL picks, than any other college football team. In nineteen of the last thirty-nine years, USC has led the NFL with the most alums in the league.[8] Of course, these stats leave out its six Heisman Trophy winners (seven if you count Reggie Bush), its numerous national titles going back to the 1920s, the Trojan Song Girls, Traveler (the statuesque white horse that gallops around the Los Angeles Memorial Coliseum after each score), the Trojan Marching Band blaring "Conquest" after victories, the movie stars in the stands and at practices, the southern California weather. The list is long. Although the Trojan colors are Cardinal & Gold, USC can arguably lay claim to the bluest of college football blood.

Yet even giants stumble. As the twenty-first century dawned, USC hadn't won a national football title since 1978. The drought was a long one for its faithful fans, and worse, USC wasn't that good in the 1980s and 1990s. Not only had crosstown rival UCLA eclipsed the Trojans, but fellow blue-blood Notre Dame had also come to dominate the intersectional rivalry between the two schools.

So while there's "no bad time to see USC," when Pete Carroll was hired as head coach in 2000, the team had long since lost its luster. The three coaches before him had been fired for having failed to field a consistent winner, despite legendary former Oklahoma coach Barry Switzer's description of Southern Cal as "a great program with great tradition and

something to sell."[9] The University of Southern California's most valuable source of credit was its tradition, but the credit had seemingly run out.

Worse, Carroll hardly seemed like a great hire. Good looking, charismatic, and full of energy, Carroll had a measly 33-31 record in the NFL before USC athletic director Mike Garrett hired him. Carroll had also been fired from both of his head coaching jobs in the NFL prior to USC.[10] At least early on, his past record, along with USC's tarnished brand, reflected in the team's access to the ultimate resource: top high school players.

Carroll's first Trojan team went 6-6 and lost in the Las Vegas Bowl. This was hardly an auspicious start for a team used to playing fellow giants like Michigan and Ohio State on New Year's Day in Pasadena. Carroll did sign fifteen 4-Star players after the season, but his 2002 recruiting class was ranked "only" #13.

The next season ended with an 11-2 record, an Orange Bowl victory over Iowa, and a national ranking of #4. Notable here is that USC's subsequent recruiting class reflected the team's renewed success on the field. Carroll signed two 5-Stars for 2003, and Rivals ranked his class #3.

The Trojans followed a successful 2003 campaign with a 12-1 record, a win over Michigan in the Rose Bowl, and the AP National Championship. Recruiting? Carroll signed *eight* 5-Stars in a 2004 class that Rivals ranked #1. The following year the Trojans demolished Oklahoma in the Orange Bowl for their second straight title. Carroll signed four more 5-Stars after the season, and USC won the Rivals recruiting title yet again. After losing to Texas the next year in its bid for a third straight national title, USC once more claimed the Rivals recruiting crown.[11]

The University of Southern California itself always had credit potential based on its glamorous history. The addition of Carroll's previously unrevealed genius created an unbeatable combination. In the credit sense, lenders lined up to hand USC the best resources from across the country. The college football aristocrat regained its stature as the bluest of blue chips.

Caroll naysayers will doubtlessly point to the Trojan football team being slapped with probation after he left for the NFL in 2010. His two trips to the Super Bowl, including one victory in 2014, indicate that such skepticism is unwarranted. If paying for players is seen as the source of USC's modern success, then what goes unexplained is why the Trojans were so lousy in the 1980s and 1990s.

Nevertheless, USC was hit with probation after Carroll left. Despite this, Carroll's replacement, Lane Kiffin, signed Rivals' #1 recruiting class in 2010. He followed up with the #4 class in 2011 and the #8 class in 2012. Kiffin did this despite severe scholarship limits imposed on the team. Remember, Rivals ranks the classes based on points. Despite being unable to recruit as many players as before, the Trojans continued to sign 5-Stars that kept them in the recruiting title discussion.

Interestingly, Kiffin was fired during the 2013 season. His replacement, University of Washington head coach Steve Sarkisian, signed the #1 class for USC in 2015. But to show the credit magnet that Carroll rebuilt at USC, Sarkisian had but one Rivals Top 20 recruiting class during his five years as head coach of the Huskies.[12]

What's unknown is how long USC will remain a lure for players if the coaches who have followed Carroll continue to underperform relative to this future Hall of Fame coach. As previously noted, Harbaugh observed that there's "no bad way to see Michigan." That describes USC now, and it's a reminder that one person (Carroll) can build up credit that others will continue to access, at least for some time. The question once again is how long this will last. As evidenced by USC's many years in the wilderness while they searched for a head coach to revive their fortunes, USC's AAA credit rating in the recruiting sense may not last very long.

Bringing it all back to Brady Hoke, market forces are rather wise. Despite being able to recruit for a name brand like Michigan, Hoke's inability to field a winner ultimately meant that Michigan was starved of "credit" of the recruiting variety. This was a good thing.

The great Austrian School economist Ludwig von Mises explained this phenomenon in his endlessly insightful book *Human Action*. The entrepreneur who fails to use his capital to the "best possible satisfaction of consumers" is "relegated to a place in which his ineptitude no longer hurts people's well-being."[13] College football coaches are merely pursuing an entrepreneurial venture of another kind, whereby they vie for top athletes in order to field the best team they can. Despite being handed a brilliant resource in the University of Michigan, along with the athletes who line up to play there, Hoke failed. The market responded by starving him of resources and then removing him from a position in which he was failing at his stated goal.

Hoke's story looms large in a credit sense. Pick up the newspaper on any given day, particularly during an economic slowdown, and you will

read economists calling for the Fed to "ease credit" so that struggling businesses can get back on their feet. What a shortsighted point of view.

As opposed to situations to avoid, "recessions" are the market's way of making sure that the allocation of resources to the Brady Hokes of the world ceases. Just as there's a limited number of software engineers and microchips, so, too, is there a limited number of quality college football schools, coaches, and players who merit an expensive scholarship.

The closure of the credit door on Hoke was healthy because it ensured a much more credible replacement in the form of Jim Harbaugh. The "real world" of business should be no different. If the Fed were truly led by wise minds, then they would do the opposite of fighting the market's call for credit rationing that is meant to ensure the bankruptcy of poorly run businesses and the replacement of bad managers with better ones.

With the above scenario in mind, we should be thankful that the Fed is not the sole source of credit in the U.S. economy. If it were, Brady Hoke would still be coaching Michigan to the detriment of the school, the players, and the alums, and a lot of businesses would be operating at a fraction of their potential. Happily, however, and despite the Fed's naiveté, the allocators of credit similarly continue to relieve bad managers of positions that allow them to waste resources.

The free market is infinitely smarter than the wisest collection of Fed minds on their best day. So, when we hear about central bankers working to blunt healthy market activity through credit "ease," we should quickly conclude that rather than expanding credit, they're at best *destroying it*. As the ensuing chapters will reveal, market forces quite thankfully reject alleged Fed medicine, and to the economy's certain benefit.

||

CHAPTER THREE

||

In Hollywood, the Traffic Lights
Are Almost Always Red

There is a strange idea abroad, held by all monetary
cranks, that credit is something a banker gives to a man.
Credit, on the contrary, is something a man already has.
—Henry Hazlitt, *Economics in One Lesson,* 43

IN 1984, the now-classic film *Splash* was released to critical and box-office acclaim. It was the #1 grossing U.S. movie in its first two weeks of release, and, at the time, it was the fastest moneymaking film in Disney history.[1]

To this day, *Splash* views quite well. Some will disagree, but this film directed by Ron Howard and produced by Brian Grazer arguably presented John Candy (Freddie Bauer) at his comedic best. The late actor went against his eventual fumbling type as the fast-talking, womanizing brother of Tom Hanks (Allen Bauer). Likewise Eugene Levy, who, while achieving greater critical renown in later years, owing to his work in the Christopher Guest films (*Best In Show* most notably), shone as the eminently quotable Walter Kornbluth: "What a week I'm having!"

Before *Splash*, Howard and Grazer created the very funny *Night Shift* (formerly the Fonz, Henry Winkler played against type à la John Candy in *Splash*). Since then, this duo has reeled off a string of critically acclaimed movies, including *Parenthood, Apollo 13, A Beautiful Mind, Frost/ Nixon,* and *Rush.* These films don't begin to tell the story of their productivity, not to mention what Grazer and Howard's Imagine Entertainment

has done for television, with shows like 24 and *Arrested Development*. Best friends, Grazer and Howard have a track record that is the envy of Hollywood.

What is notable about *Splash* is that, as Grazer recalls in his 2015 book *A Curious Mind: The Secret To a Bigger Life*, "only a thousand people in Hollywood told me we couldn't make a movie about mermaids." A movie "about love, about finding the right love for yourself, as opposed to the love others would choose for you" was viewed as unmarketable. It was seen on the surface as an unrealistic film about a human (Hanks) pursuing romance with a mermaid, played by Daryl Hannah. From the initial idea to its eventual release, *Splash* took more than seven years to produce. Grazer recalls that even Ron Howard wasn't initially interested in making the picture.[2]

What does Grazer's story about a classic film tell us about credit? Quite a lot, actually.

While the Federal Reserve can lower the fed funds rate with an eye on rendering access to the economy's resources (credit) easy, credit is nearly always tight in the movie industry. Outwardly about creativity, the film industry wouldn't exist in its present prosperous form if movies were easy to finance. To understand this better, it's worthwhile briefly migrating away from Grazer to discuss some of the career highs and lows of A-list actor and auteur, Warren Beatty.

Beatty's track record, while not as impressive as Grazer's, merits respect. In 1967, he was a costar in *Bonnie and Clyde*. The film was ahead of its time in the late 1960s, and it still influences directors today. In the American Film Institute's rankings of the top 100 movies of all time, *Bonnie and Clyde* sits at #42.[3] In 1975, Beatty starred in the enduring classic *Shampoo*. In 1978, he starred in and directed *Heaven Can Wait*. All three were box-office and critical successes, but Beatty wasn't done.

In 1981, he directed *Reds*, a biopic of John Reed, the journalist who chronicled the Russian Revolution in his book *Ten Days That Shook the World*. The film received an Academy Award nomination for Best Picture, and, while it didn't win, Beatty took home an Oscar for Best Director.

Beatty could seemingly get easy financing for any film at any time. Actually, not quite. By the late 1980s, he'd added to his resume a road picture made with Dustin Hoffman called *Ishtar*. The movie was awful, and the $51 million invested in it "evaporated."[4] Then there was *Town & Country*.

A movie about the midlife crisis of a rich New Yorker, Porter Stoddard (Beatty), *Town & Country* probably seemed like a good idea at the time. The cast included funnyman Garry Shandling, an up-and-coming Josh Hartnett, and female leads Nastassja Kinski, Diane Keaton, and Goldie Hawn. Noted director Paul Mazursky observed that perhaps what attracted Beatty to a project his friends were telling him to pass on was "all the gals."[5]

It couldn't have been the mostly limp script, though in fairness to Beatty and the rest of the *Town & Country* crew, the making of a movie is often the artistic equivalent of the famous quote about how "no battle plan survives contact with the enemy." No less than François Truffaut observed that making a film is like taking a stagecoach west. The ride starts out great, but by the end you'll be satisfied if "you just reach your destination."[6] There's a reason good directors are paid so well. They're constantly staring monumental failure in the face as they desperately try to turn a concept into something real, let alone watchable.

By September 1999, 1.3 million feet of film had been shot, but the producers knew they had a disaster on their hands. The film wasn't finished, yet Diane Keaton, having negotiated a "stop date," left production altogether. *Town & Country*'s director literally shot scenes purported to include her but that in fact were her body double from the side.[7] The release date kept being pushed back.

Finally, on April 27, 2001, *Town & Country*, a production that had gone, by some estimates, 200 percent over budget, was released onto 2,200 screens nationwide.[8] Box-office receipts after a month in the theaters were $6.7 million. Unfortunately, production costs for New Line, the film's producer, were *$85 million*.[9] Beatty had morphed from an eminently bankable star who could get films "green lit" to box-office poison.

Interestingly, Beatty once commented, "I believe that I can get any movie made. I have always felt that and I've never had a movie I couldn't get made"[10]—impressive words that were true for a time but also hopelessly dated. The credit required to produce a film was once easy for the legendary Hollywood ladies' man. Not anymore. *Town & Country* was released in 2001. While he presently has another film in production, Beatty hasn't made a movie since.

Access to credit (meaning access to the resources required to make a film) in Hollywood is informed by the busts like *Town & Country* far more than by the box-office successes. Grazer is proof of that. Although

his track record when it comes to both film and television is impeccable, finding financing for his projects remains difficult to this day. It took Grazer *sixteen years*—and the help of Mick Jagger—to get the James Brown biopic, *Get On Up*, onto movie screens in 2014.[11]

As Grazer explains, "I know just how often people get told 'no' to their brilliant ideas—not just most of the time, but 90 percent of the time." Grazer writes that Hollywood is the land of "no," and 90 percent of ideas are rejected. "Instead of spelling out the word H-O-L-L-Y-W-O-O-D in the famous sign in the Hollywood Hills, they could have spelled out: N-O-N-O-N-O-N-O!" He further points out, contrary to a popular assumption in the industry that no one ever says "no" to him, "Everybody *still* says 'no' to me."[12]

Credit is tight in Hollywood *even for Brian Grazer*. With his acknowledged struggles with financing in mind, what the Fed presumes to do in fiddling with interest rates is, on the surface, of little consequence. No matter the Fed's obnoxious conceit about how easy or hard it should be to access credit, financing a movie is difficult.

What economists and politicians too often miss is that an economy is nothing more than a collection of individuals. These individuals frequently make mistakes. As a consequence, the personal "recessions" people endure, whereby credit becomes difficult to attain, are actually quite healthy.

Consider Robert Downey Jr., best known for the *Iron Man* films. Thanks to this highly profitable movie franchise, Downey is the world's highest paid actor, with earnings of $75 million per year.[13] As one media account put it, Downey "is a walking, talking multi-billion-dollar business."[14]

What might surprise readers it that 2015's highest paid actor couldn't even get a movie made when the twenty-first century began. Downey's addiction to drugs and alcohol led to jail time, rehab, fights in prison, and even a 911 call from a neighbor who found an out-of-sorts Downey asleep in her eleven-year-old child's bed. Amid his self-inflicted race to the bottom, Downey couldn't make movies because the costs involved were too steep. Movies are expensive to make and difficult to finance even for the top producers, and Downey's habits rendered him wholly unreliable. No sane insurance company would write a policy for a production that had him attached. Put simply, Downey was too much of a credit risk.[15]

This lack of credit turned out to be a blessing for Downey. The expensive credit that rendered Downey unemployed is what forced him to kick

his various bad habits and clean up his life. Absent doing so, no source of film finance was going to risk its capital on a talented actor who personified unreliability.

Never forget that credit is the resources created in the actual economy. For that reason alone, wise minds should rejoice that "recessions" shrink our ability to senselessly waste those resources. No amount of Fed ease would have made it possible for Downey to work. His personal "recession," whereby he fixed problems of his own making, is ultimately what freed up his access to credit. Credit had to become expensive for Downey *so that* it could become cheap. This is happily true for everyone in the movie business.

Returning to Grazer, it's worth pointing out that not all of his films have been hits. His resume includes duds such as *Fun with Dick and Jane, The Cowboy Way*, and *Cry-Baby*. If credit were always easy—as in if the Fed could wave a magic wand to shower us with money capable of commanding resources—then we'd never learn from our errors, because we wouldn't be forced to. That would be unfortunate, mainly because failure is a great teacher.

Imagine if failure weren't allowed to instruct, if government officials constantly excused our errors through bailouts and easy credit. We film lovers would have already aggressively avoided seeing *Gigli II, Ishtar Goes Down Under*, and *Town & Country: Getting Lucky in the Retirement Home*. Worse, credit is not finite. To the extent that wasteful economic activity continues to attain funding without regard to market or critical verdict, good, prudent, and artistic variety must get by with less funding. Failure that is propped up is also perpetuated. Moreover, it deprives the productive of the credit they need to fulfill actual market wants. Everyone loses under such a scenario.

Thankfully, what I have described above isn't real. The Fed's role in the economy is surely a negative one. But as the film business makes clear; the Fed's control over who gets credit is in no way absolute. Thank goodness there are red lights everywhere in Hollywood.

In Silicon Valley Your Failures
Are Your Credit

I believe so strongly in people that I think talking to the
individual is much more important than finding out
too much about what they want to do.
—Venture capitalist Arthur Rock

FOR SEVERAL YEARS, FailCon was a popular annual event in San Francisco. Attendees were technologists who would get together to talk—you guessed it—about their stupendous failures.

While Hollywood film directors run as fast as they can from their mistakes—Alan Smithee is the pseudonym directors use to erase their participation in the truly lousy—in Silicon Valley a failed start-up amounts to a badge of honor. Indeed, the frequency of company-crushing errors led to the discontinuation of FailCon in 2014. The confab was cancelled not because it was hurting the ability of technologists to attract venture funding but because, as FailCon founder Cassandra Phillipps observed, discussion of one's mistakes in the tech sector is superfluous. As she stated in a 2014 interview: "It's in the lexicon that you're going to fail."[1]

All of this raises a fairly basic question: Why do box-office disasters in the film industry place those attached to them in credit purgatory, while technologists proudly tout their errors to colleagues and potential investors? More specifically, why does the proverbial credit window shut so quickly for money-losing directors yet remain open for entrepreneurs who preside over imploding start-ups? At a first glance, the obvious

answer is that Silicon Valley start-ups generally don't have $85-million budgets to lose. Assuming *Town & Country* had cost $10 million, it's fair to say that Warren Beatty's reputation in the eyes of film financiers wouldn't have suffered so much.

Second, and of much greater importance, tech has a higher upside than film does. The number of movies that can claim box-office receipts of more than $1 billion can generally be counted on one hand *in a very good year.* By contrast, companies valued at $1 billion or more are increasingly the norm in Silicon Valley.

The term used to refer to these billion-dollar companies is "unicorn." As of August 2015, there were 124 unicorns in Silicon Valley.[2] When the potential for outsize returns is grand, credit sources are more adventurous and more forgiving of past mistakes.

Despite technology's upside, which makes it a credit lure, let's not totally delude ourselves. Credit in Silicon Valley is *very expensive.* We know this because we're aware of all the rich venture capitalists who grew that way by virtue of putting money behind eventual tech behemoths, along with employees who have attained wealth that can be measured in the tens of millions thanks to stock options. What this tells us is that to attain credit to grow, tech entrepreneurs must give up not insignificant ownership stakes in their companies for the privilege.

Beyond that, the nature of entrepreneurialism must be taken into account. The great Austrian economist Joseph Schumpeter aptly described the entrepreneur as the individual whose work "consists precisely in breaking up old, and creating new, tradition."[3] In a world of consumers who are frequently resistant to change, the entrepreneur intends to offer the consumer or business a product or service they didn't know they wanted. That is no easy feat.

Schumpeter further described entrepreneurialism as the "opening of a new market, that is a market into which the particular branch of manufacturer of the country in question has not previously entered."[4] Entrepreneurs are doing something entirely new, something that has never been tested by the markets before. By that very description, such ventures are most often going to end in failure.

Billionaire venture capitalist Peter Thiel earned his initial fortune as a cofounder of PayPal. However, his most famous investment success to this day was the $500,000 he invested in Facebook in 2004.[5] His PayPal wealth meant that he had money to lose, and odds were the then largely

unknown social network would not succeed. That his stake would eventually be measured in the billions is all the evidence we need to prove that he risked losing his entire investment. If investors had viewed Facebook as a sure thing back in 2004, Thiel's $500,000 would have bought him a much smaller portion of the company's shares. In such a scenario, founder Mark Zuckerberg could have declined to accept Thiel's money in the first place.

Importantly, Thiel is willing to lose on investments. As he explained in his 2014 book *Zero to One*, "Most venture-backed companies don't IPO or get acquired; most fail, usually soon after they start."[6] Venture capital firms allocate credit to a variety of different entrepreneurial concepts well aware that most will wind up defunct. It's the rare Facebook-style success that investors are constantly seeking. As evidenced by the billions of credit coursing around Silicon Valley in pursuit of innovation, one big score can paper over a lot of investment mistakes.

Such is the culture of the technology world, and it's long-standing. Thomas Edison, one of the original innovators, famously quipped, "If I find 10,000 ways something won't work, I haven't failed. I am not discouraged, because every wrong attempt discarded is just one more step forward."[7] Edison's definition of success was how many experiments he could fit into a twenty-four-hour period. His success was all about a frenzied pursuit of knowledge through experimentation; failure was frequently the source of knowledge that would eventually bring success. Importantly, Edison's tinkering with seemingly everything set him up for eventual global renown as an inventor. From his mistakes he learned a great deal, at which point his knowledge was matched with capital in the form of banking magnate J. P. Morgan.

It's not uncommon among elite thinkers to disdain inherited wealth. However, such a point of view is shortsighted when we consider what it means for the beneficiaries of it. Wealth, in a sense, is freedom. Some obviously abuse it, just as those who inherit nothing frequently waste their natural talents. But in Morgan's case, the fact that he had a rich father, Junius Spencer Morgan, meant that J. P. Morgan, like Thiel in 2004, *had money to lose.*

This truth should not be minimized. While there's nothing wrong with investing that's focused on wealth preservation or achieving predictable returns, major entrepreneurial advances don't often emerge from defensive investing. Big advances that truly expand the amount of

economic resources in a society (as always, credit) are, as George Gilder puts it, the result of "surprise."[8]

Edison's innovations that led to the electric light bulb and a company that thrives to this day (General Electric) were the definition of surprise. Indeed, Junius Morgan, a keen allocator of capital himself, advised his son against tangling with Edison. As Thomas Kessner wrote in his 2004 book *Capital City*, Junius "wanted to have nothing to do with the eccentric inventor and his bulb experiments."[9] Thankfully, J. P. Morgan was wholly enthralled by the idea of electric light, and his backing of Edison has had a profound economic impact.

It's important to note that there was credit in the economy that was controlled by patient investors like J. P. Morgan. He was willing to lose a great deal on a daring entrepreneurial idea long before Silicon Valley came into existence. Even better, Morgan bet on an individual who didn't hide from his numerous dry holes.

In modern times, Edison is most often compared to the late Steve Jobs. Most readers know Jobs as the person who not only founded Apple Computer but who, upon his return to Apple in 1997, oversaw the creation of jaw-dropping innovations such as the iMac, iPod, iPhone, and iPad.

What often goes unappreciated is that Jobs, like Edison, experienced plenty of failure on the way to success. When Jobs stepped down in 2011 as CEO of Apple in order to fight an unsuccessful battle against cancer, Nick Schulz penned a brilliant article, "Steve Jobs: America's Greatest Failure." Schulz wrote:

> Jobs was the architect of Lisa, introduced in the early 1980s. You
> remember Lisa, don't you? Of course you don't. But this computer—
> which cost tens of millions of dollars to develop—was another
> epic fail. Shortly after Lisa, Apple had a success with its Macintosh
> computer. But Jobs was out of a job by then, having been tossed aside
> thanks to the Lisa fiasco.
>
> Jobs went on to found NeXT Computer, which was a big nothing-
> burger of a company. Its greatest success was that it was purchased
> by Apple—paving the way for the serial failure Jobs to return to his
> natural home. Jobs's greatest successes were to come later—iPod,
> iTunes, iPhone, iPad, and more.[10]

When Jobs returned to Apple the former Silicon Valley highflyer was hurtling toward bankruptcy. Thankfully, Bill Gates, the founder of Micro-

soft, had money to lose, and he invested $150 million with Jobs and Apple despite the former's string of losses and the latter's apparent troubles.[11] Thus a great company was reborn; interest rates manipulated by economists in Washington were clearly not much of a factor in Gates' decision. For the talented in technology, credit is often available.

So while stumbles in the technology sector don't send those who commit the errors straight to credit hell, it's worth noting that success is a capital magnet, too. The investors in possession of credit don't grow rich by virtue of making a habit of searching for those prone to mistakes.

Richard Noyce and Gordon Moore were Silicon Valley pioneers from the earliest days. In a preview of the "cheap revolution" that personifies the technology sector to this day, they and their cofounders at Fairchild Semiconductor sold microchips to early adapters for less than they cost the company to make them.[12] The idea was to give their customers an incentive to incorporate Fairchild's "chips" into their products. That the founders of Fairchild grew rich validated their strategy.

By 1968, they were ready to try something new. When Noyce and Moore approached venture capitalist Arthur Rock (the original investor in Apple Computer[13]), Rock immediately asked, "What took you so long?"[14] Given Noyce and Moore's sterling track record, Rock couldn't wait to invest with these two visionaries in what became Intel. Rock was so confident in them that, according Walter Isaacson, author of *The Innovators*, "He barely asked what they were going to make." As Rock later explained, "It was the only investment that I've ever made that I was 100 percent sure would succeed."[15]

Success is a magnet for credit, interest rates be damned. While it's true that the credit constantly migrating to Silicon Valley is of the most courageous kind, truly easy credit is always attainable for those who have already earned their investors a return.

Thinking about all of this in terms of the Fed and its various attempts to fine-tune access to the economy's resources, its movement of the fed funds rate up or down twenty-five basis points is of little consequence. The logical response is that potential returns shrink as the cost of credit rises. But as the story of Silicon Valley investing makes plain, most companies that attract capital still implode. It's already accepted by these intrepid investors that the majority of the time they'll get nothing back for the credit they offer. The few investments that succeed do so at levels that make prior losses easily digestible.

The Fed's machinations are ultimately irrelevant to a sector of the economy that, as Tim Harford wrote in *Adapt: Why Success Always Starts with Failure* (2011), "has been built on failure after failure after failure."[16] So, while the Fed's activity certainly negatively affects the monument to wealth and credit creation that is Silicon Valley, it doesn't in the way that most would presume.

Did You Hear the One about Donald Trump Walking into a Bank?

"Is not commercial credit based primarily upon money or property?"

"No sir," replied J. P. Morgan. "The first thing is character."

"Before money or property?"

"Before money or anything else. Money cannot buy it. . . . Because a man I do not trust could not get money from me on all the bonds in Christendom."

—H. W. Brands, *The Money Men*

IN MANY WAYS, Donald Trump is best known today for his high-profile 2016 run for the office of president of the United States. But back in the 1980s, Trump was most famous for his skills in the area of property development. Those skills made him very rich.

What is interesting about the 1980s is that even though charitable giving grew from $77.5 billion in 1980 to $121 billion in 1989,[1] some in the commentariat dismissed those years of robust economic growth as the "Decade of Greed." Trump's unapologetic advertisement of his great wealth helped fuel their misplaced disgust.

Notable about Trump, and this shouldn't be read as a pejorative, is that his accounting of his net worth was not necessarily how others perceived it. More to the point, Trump and those from whom he wanted to borrow did not share the perception of his creditworthiness.

I can't repeat enough that for every borrower there is a saver. Furthermore, when an individual borrows "money," he is not seeking dollars so much as pursuing the economic resources (credit) that dollars can command in the marketplace. In Trump's case, he sought credit in the late 1980s in order to fund the revival of the Ambassador Hotel in Los Angeles.

A once grand hotel in the Wilshire District, a few miles from downtown Los Angeles, the Ambassador's notoriety then had to do with something extremely tragic. On June 6, 1968, Democratic presidential candidate Senator Robert F. Kennedy was assassinated in the kitchen of the Ambassador.

In the aftermath of the assassination both the hotel and the surrounding area fell into long-term decline. But an entrepreneur sees potential where others see failure. That's what makes the entrepreneur so central to positive economic evolution. Trump saw potential in a hotel and an area of Los Angeles that others had given up on, and he needed credit to animate his vision.

That's where Security Pacific Bank came into the picture. The Los Angeles–based bank was the fifth largest in the United States at the time, and Trump sought a meeting with its newly appointed CEO, Robert H. Smith.

Smith was no stranger to big names in the world of business. Given the size of Security Pacific, and its lending potential based on that size, major players from various business sectors regularly courted him and the bank he ran. A few years earlier, Peter Ueberroth had approached Security Pacific about loan financing for an airline idea he had. Smith and his colleagues probably should have ended the discussion right there, when we consider the historical correlation between airlines and bankruptcy.

The fact that they didn't speaks to a truism about credit that can never properly be explained by Fed officials playing around with interest rates. Ueberroth had an outstanding reputation. Having already built and sold a successful travel business, he perhaps had a sense of airlines that the average dreamer did not. His service as Commissioner of Major League Baseball increased his stature. He also oversaw the highly profitable 1984 Summer Olympics in Los Angeles.[2] Well connected, handsome, and in possession of a great track record, Ueberroth was the definition of good credit.

Yet he wanted a large loan to purchase Hawaiian Airlines. Airlines were, and remain to this day, heavily regulated. Additionally, volatile fuel

prices substantially impact their profits, because oil is priced in a floating dollar that lacks definition. Stated plainly, airlines are the definition of bad credit. Their history is in many ways a history of bankruptcy.

Ueberroth planned to put a seasoned airline executive in charge of his purchase, partner up with a major airline, and eventually sell at a profit. It all seemed simple. And as Smith recalls, there was a strong desire among senior Security Pacific executives (including its then CEO, Richard Flamson) to do business with a prominent southern California personage like Ueberroth.

Ueberroth's argument in favor of the deal was a classic credit story. As he explained it to Smith, Flamson, and others, "I'm pretty sure that the name alone—Peter Ueberroth—can pull the deal through with one of the major airlines. That's the key."[3]

So while the bank's loan to Ueberroth didn't measure up to its internal credit standards, it was made nonetheless. As Smith explained, "Security Pacific was paying a premium to be linked to the Ueberroth name, and there was a powerful windfall from such a prestigious involvement."[4]

Unfortunately for Ueberroth and Security Pacific, the seemingly foolproof plan never lived up to expectations from a profits standpoint. The airline's planes remained rather empty, the partnership with a major airline never materialized, and the odds of Ueberroth paying back what Security Pacific had loaned him plummeted. Smith referred to the deal as Security Pacific's *Heaven's Gate* (referencing a famous Hollywood film bust),[5] and the bank eventually sold its loans for a fraction of their initial worth. Security Pacific had, in the words of Smith, bought into "the Peter Ueberroth name; the charisma, the stature, the pizzazz."[6]

It was Smith's experience with Ueberroth that informed his dealings with Trump a few years later, after his promotion to CEO. Having recently been burned by charisma, reputation, and track record, Robert Smith was a different man when Trump visited him than he was with Ueberroth a few years before. "When I first met with Trump he had already been heralded as a genius and seemed to be at the leading edge of everything," Smith wrote. "Trump had a Clintonesque aura around him, the effervescent divinity of a studied deal-maker, and a categorical ability to communicate and inspire the belief of others in his personal vision. He no doubt could have been an evangelist."[7]

Trump sought a $50 million loan (Security Pacific's "house limit") for his Ambassador Hotel revitalization plan. Although Smith didn't explic-

itly reject Trump's request, he was skeptical. After the meeting he relayed his misgivings to bank executives who were perhaps understandably bowled over by this most charismatic of businessmen. They wanted to figure out a way to finance Trump, given the prestige that would result from being his banker. Smith didn't budge.

Smith said, "When a guy like Trump gets into trouble, he can no longer borrow, because no institution will lend to him." He added, "As a lender, no matter how glamorous the person on the other side of the table is, you look to the borrower to have both primary and alternate sources of repayment. And, while Trump presented a financial statement with many million dollars of net worth, the ability of him to bail even this one project out was limited—because it was leveraged on an *illiquid base of questionable value.*"[8] Smith ultimately lamented his failure to clearly communicate his skepticism about Trump's creditworthiness. Remember, he didn't explicitly turn him down. Apparently eager to do business with The Donald, other executives within the bank secured $10 million for Trump as part of "an initial study on the feasibility of restoring the Ambassador Hotel." Smith "raised holy hell," and with good reason. The property market swooned during the early 1990s, and as Smith predicted, Trump wasn't able to make good on what he had borrowed. Smith went on to recall: "Two years later we wrote the whole thing off. It was a loss."[9]

Fast-forward two decades, and Trump is claiming he's worth $10 billion.[10] That is certainly possible, but as Smith makes plain, value is subjective. It's also no major insight to point out that value is biased.

In Trump's defense, Trump understandably believes that the projects he's involved with or has a stake in are winners. If he didn't have an unshakeable belief in what he's doing, then it's probably safe to say he wouldn't have the net worth (or outsize reputation) he has today.

While observable and empirical logic dictates that Trump's net worth is quite high (*Forbes* estimates $4.5 billion), the same logic should also cause us to question the $10 billion that Trump regularly cities. Naturally, Trump's valuation of his various ventures is not going to resemble outside estimates. Again, if he lacked a powerful belief in his projects, then they wouldn't be projects in the first place.

It is not possible to know what's on, or the value of, Trump's balance sheet. Yet, Smith's recall of Trump's subpar creditworthiness is another reminder of the obnoxious conceit that drives economists at the Fed to presume to set the price of access to the economy's resources. They can

decree credit "easy," but banks and other sources of credit don't have to comply.

Trump can claim a net worth that would make loaning to him an apparent no brainer, and the Fed can flood banks with dollars (more on this in Parts Two and Three of this book). But banks, like any other business, would not remain in business for long if they lent in the way the Fed blindly presumes to set rates: as though we are all the same in terms of our ability to pay loans back. Accessing credit shouldn't be the same for everyone, nor is it. The cost of access is different for every individual and every business. It's difficult to tell how easily Trump could get a loan today. Still, Smith's memory of lending to him in the late 1980s is a reminder that even the banks, heavily regulated by the Fed, don't always march to the beat of the Fed's simplistic drum rhythms.

Even better, new sources of credit constantly innovate around the Federal Reserve. While this will be discussed in greater detail in future sections of this book, for now it's worth migrating to a form of finance that reached full flower around the same time that Trump rocketed to his early fame, high-yield finance. Readers may better know "high-yield bonds" as "junk bonds," the latter being the pejorative members of the media attached to them long ago. Readers needn't worry. There's nothing complicated here.

To understand "junk" or "high-yield" debt, let's first imagine you have $10,000 lying around. Next, imagine that actress Jennifer Lawrence asked to borrow it. As the world's highest-paid actress, with 2015 earnings of $52 million,[11] you would be willing to lend her the $10,000 at a pretty low rate of interest. With earnings like hers, there would be little to no risk involved. Lawrence could secure the $10,000 repayment almost by virtue of getting out of bed in the morning.

But what if the high school son of a neighbor asked to borrow the $10,000 to buy lawnmowers for his new business venture? Eager to expand to several underserved neighborhoods quickly, he needs the credit for lawnmowers that he'll then lend to contract workers who will pay him for their use.

It may be a great idea, but it's also possible that the borrower could lose interest or grow discouraged quickly. Figure the borrower has no credit to speak of other than his business idea, and odds are he lacks a track record of success, which Lawrence has in spades. The risk of lending the $10,000 to him is logically much greater. The loan may well be

made (figure Lawrence would have all manner of credit sources lining up to lend to her), but only at a rate of interest that reflects the risk involved. That, in its most basic form, is high-yield finance.

Enter Michael Milken. His name was needlessly sullied in the 1990s for having spent time in prison for alleged violations relating to "insider trading" (something the SEC, Congress, and the courts still can't even define[12]). Yet Milken would be one of the faces on any Mount Rushmore meant to lionize the greatest capitalists ever.

Without getting into too many details, it is worth quoting *Payback*, by Daniel Fischel, a professor of law at the University of Chicago: "There is no evidence that [Milken] did [commit any crimes], and certainly no evidence that he engaged in any conduct that had ever before been considered criminal."[13] Economic growth depends on information, and those who possess information that others don't should be cheered on for making markets more informed by virtue of trading on it. But government officials, most notably future New York City Mayor Rudolph Giuliani, eventually secured a plea deal from Milken for acts that had never before been considered criminal. (He was worried about family members whom the feds were going after.) Yet, the government could never produce any notable evidence of wrongdoing in the first place. But I digress.

Before the government forced Milken out of the investment industry altogether, and before he went to work for Drexel Burnham, a third-tier investment bank, Milken attended the University of Pennsylvania's Wharton School of Business. While at Wharton, the performance of "low-rated" corporate bonds came to fascinate the MBA student. In particular, he discovered that Jennifer Lawrence–equivalent corporations with powerful track records were overrated in terms of creditworthiness relative to newer companies that lacked a long earnings history. Basically, he found that lawnmower start-up equivalents were less risky than was broadly assumed. And so a market was discovered.

While top-tier banks and investment banks continued to secure finance for blue-chip companies like Exxon, AT&T, and GE, Milken went to work finding credit for newer, lower-rated companies. He also found investors willing to invest in their riskier debt in return for a higher interest rate of return. Basically, Milken found finance for the lawnmower concepts.

His discovery that past performance wasn't always a predictor of future performance (remember when Renée Zellweger and Cuba Good-

ing were A-list actors?) meant that he could bring investment banking services to the blue chips of tomorrow. As Fischel describes, "Whole industries—including gambling, telecommunications, and healthcare— were financed in significant part with high-yield bonds."[14] The list of companies that were the result of Milken securing them access to credit includes MCI, CNN, Turner Broadcasting, and Occidental Petroleum.[15]

What's important here is that while the Fed seeks to influence credit by exchanging dollars for bonds held by banks, which can then lend the dollars, Milken was sourcing credit for companies that banks traditionally passed over. As of 1988, at which time "junk bonds" had a much better reputation, these high-yielding instruments were but 1 percent of savings and loan assets.[16] More than 95 percent of corporate debt for companies with earnings greater than $35 million (and a 100 percent of debt for companies with earnings less than $35 million) is rated "junk." Milken's innovation was securing more credit for them to grow.[17] A banking system that the Fed interacts with, and that is naively seen as the source of economy-wide credit, hasn't historically tangled with this aspect of the credit market, which suggests that banks are increasingly irrelevant to our economic health.

Importantly, Milken was not done. Thanks largely to financing from traditional banks and investment banks, U.S. corporations had purchased all manner of companies unrelated to their core mission. Others had become top heavy in terms of unaccountable executives enjoying excessive executive perks and had consequently grown somewhat flabby by the 1970s. Milken's innovation involved backing upstarts largely shunned by the blue-chip banks (think Carl Icahn, T. Boone Pickens, Reginald Lewis—the first black CEO of Fortune 500 company Beatrice Foods) eager to restructure corporations that were operating at a fraction of their potential. This included "breaking up" large-for-large's-sake corporations by selling pieces to investors with a stated objective of running the business lines purchased more effectively. These "hostile" takeovers performed by Icahn, Pickens, and other outsiders were similarly shunned by establishment banks, mainly because the blue-chip firms these "corporate raiders" eyed for necessary restructuring were often the banks' clients. Milken had created yet another market, and he was a magnet for credit.

Milken was so successful at discovering companies worthy of both finance and take over that investors lined up to participate in his deals. Fischel writes:

Drexel became known as a firm that could, if necessary, finance a takeover bid by raising billions of dollars within a matter of hours. Its reputation was so formidable that a Drexel-backed deal for billions of dollars could go forward even if no money had been raised. All that was necessary was a letter from Drexel announcing that it was "highly confident" the funds would be available when needed.[18]

Although Milken frequently backed companies and individuals who lacked a track record, his own track record of financing the companies of tomorrow and the fixers of the companies of today made him a brilliant credit risk. So confident with Milken were the sources of credit that they would back his deals based on his word alone.

With Milken, reputation coalesced beautifully with talent such that he was the ultimate credit risk. Milken rates discussion not only for how willing sources of credit were to entrust him with billions worth of access to the economy's resources but also because he was raising money for the breed of business entities for which traditional bank credit was either always "tight" or not available at all.

The Fed lives in an unreal world in which it believes it can render access to resources cheap almost literally by waving a magic wand. But as we know from the first chapter, when those in government, projecting power that is not their own, decree the prices of anything artificially cheap, scarcity is the inevitable result. Thankfully, the Fed's power over credit is not remotely absolute. If it were, geniuses like Milken who financed those for whom credit was never going to be easy wouldn't have been able to access it at all.

Ben Bernanke's Crony Credit

In my career, the Fed has a 100 percent error rate in
predicting and reacting to important economic turns.
—John Allison, retired Chairman & CEO of BB&T Bank

IN 2015, Chicago-based hedge fund Citadel hired former Federal Reserve Chairman Ben Bernanke as an outside advisor. What's interesting about the hire is that the founder of Citadel, Ken Griffin, is said to have a net worth of $7 billion.[1] What Griffin's financial worth clearly reveals is that he's a rather brilliant investor.

In that case, why hire Bernanke? Griffin's immense wealth signals that he has been right when it comes to predicting the future more often than he's been wrong. And as John Allison has observed, the Fed is always wrong.

One guess is that Griffin hired the former Fed Chair with an eye on betting against his economic predictions. Stranger things have happened. While at Goldman Sachs, in a previous career, this writer was made aware of clients who would ask what Goldman's economists were forecasting, only to build investment positions contradicting those forecasts.

More realistically, Griffin was likely buying access to Bernanke's connections at the Fed. Although he is no longer in the Fed's employ, it's no major reach to say Bernanke can easily get anyone there on the phone at any time.

This matters, because what the Fed does can profoundly affect market prices. The Fed, in seeking to influence the federal funds rate that banks charge one another for overnight loans, is frequently a "size buyer" of Treasury bonds held by banks.

To use but one example, on August 19, 2015, the Fed released its "minutes" to various news organizations, including *Bloomberg*. The minutes reveal the thinking of the Fed officials whose decisions affect the buying of U.S. Treasuries. Knowledge of what those inside the Fed feel about the economy is valuable to asset managers and hedge funds that trade Treasuries based on this information.

There was nothing abnormal about what the Fed did. News organizations regularly receive the central bank's minutes ahead of their release to the general public so that reporters can have a story ready once the Fed officially makes them public. Until then, reporters abide by the embargo rule: They don't publish any information about the minutes until the Fed has released them.

The problem this time was that *Bloomberg* sent to its more than 325,000 clients a headline about the minutes twenty-four minutes ahead of the agreed-on end of the "embargo," at 2:00 p.m. The headline made plain that Fed officials were leaning toward an increase in the fed funds rate such that Treasuries took a dive.[2]

Without getting into why the price of Treasuries fell, what's important is that the Fed's desire to influence the cost of credit has a substantial impact on what's a large market for U.S. government debt. Knowing this, readers can see why Bernanke is valuable to a large hedge fund like Citadel despite his lousy track record as a forecaster. Lest we forget, it was Bernanke who said in June 2007, "The troubles in the subprime sector seem unlikely to seriously spill over to the broader economy or the financial system."[3]

Bernanke's value to Citadel or to any hedge fund isn't his knowledge of the economy or where he thinks markets are going. If he had a clue about the latter, he wouldn't have spent a career as an academic and a central banker. He would be a billionaire himself.

As evidenced by how even the musings of Fed officials can "move" the market for Treasuries, what's important here is Bernanke's knowledge of what's on the minds of the officials inside the central bank. The ability to get anyone on the phone there at any time is his "credit." Bernanke commands hefty private-sector earnings because he can offer real investors

information about what the Fed he used to oversee will do next. That's his "advisory" role.

Furthermore, Bernanke's earnings don't end there. As a *New York Times* article from November 2014 reported, "On Tuesday, Ben S. Bernanke spoke in Abu Dhabi, on Wednesday, he was in Johannesburg. By Friday, he was in Houston." The article went on to report that while he earned roughly $200,000 per year as Fed Chairman, "Now he makes that in just a few hours speaking to bankers, hedge fund billionaires and leaders of industry."[4]

Much as Bernanke's Citadel pay has nothing to do with his talent as an investor or economic forecaster, neither do high achievers come to hear him speak with an eye on actually learning something. What could they possibly learn? The economy mostly limped along while Bernanke was at the Fed. The Fed oversees the largest U.S. financial institutions, yet a little less than three years into his tenure a number of them teetered on the verge of collapse. And while the Fed's impact on the value of the dollar is vastly overstated (this will be discussed in greater detail in Part Three), the dollar fell substantially during Bernanke's tenure as Fed Chairman.

Interestingly, Tennessee senator Bob Corker, during a Senate hearing in February 2013, accused Bernanke of being a "dove" on monetary policy. Bernanke replied, "My inflation record is the best of any Federal Reserve Chairman in the postwar period—or at least one of the best."[5]

Okay, allowing once again for the truth that the Fed's power over the value of the dollar is overstated, a dollar bought 1/570th of an ounce of gold on his arrival at the Fed. By the time of his famous remark to the Tennessee senator, a dollar purchased a measly 1/1600th.[6] Bernanke, however, defines inflation not in the traditional way, that is, as a decline in the value of the currency, but as the result of too much economic growth. If we view inflation in the odd, rather backward, way that he does, his assertion to Corker may, in fact, have been true. The economy never boomed while he ran the U.S. central bank.

But I digress. Bernanke was not successful while at the Federal Reserve, and his post-Fed earnings are not a function of his economic knowledge or skill as a central banker. Bernanke has people much more accomplished than he is hanging on his every word simply because a lot of money can be made by knowing what the Fed might do before it does it. Bernanke's "credit," which showers him with highly paid speaking and

"advisory" fees, doesn't spring from his talent as an investor but from his inside knowledge of an institution that lives on *our credit*. The Fed presumes to manipulate the cost of access to what we produce in the real economy. And Bernanke's access to abundant economic resources has nothing to do with whether the Fed is "easy" or "tight." Rather, it's a function of him *knowing* whether the Fed will ease or tighten.

While Bernanke's access to the economy's resources is largely unearned, others in the hedge fund world are creditworthy for all the right reasons. As for John Paulson, what's interesting about him is that his presently sterling reputation as an investor, such that he oversees billions in client funds, wasn't always so grand.

According to *Forbes*, John Paulson is worth more than $11 billion today.[7] The major source of his wealth was a timely bet against mortgages in 2007 and 2008. Convinced that mortgages were in trouble thanks to lending standards that were much less than lax, Paulson bought insurance on mortgages that he expected to decline in value. When they eventually did, he had his multi-billion-dollar fortune. Notable, and I will discuss this in more detail later, is that Paulson's billions were a godsend for the economy. The rush into housing, in many ways, exemplified credit destruction. Paulson's successful wager against mortgages signaled to market actors that more housing "investment" was a lousy idea. But we're getting ahead of ourselves.

What's important for now is that while he has $19 billion under management in his various funds today, his credit was extremely weak when he started Paulson & Co., in 1994. Although he was a millionaire many times over by then, he had a bit of a reputation as a playboy. In 1989, he was arrested for driving while intoxicated.[8]

Reputation matters a great deal when it comes to "credit." In the investment world, and to those with money to invest, Paulson didn't have a great reputation. His wild past didn't much recommend him, and neither did his limited track record. When he conducted a major mailing to announce Paulson & Co., no one responded with an offer to invest with him. In 1996, he had only $16 million under management.[9]

For the longest time, Paulson was a nobody in the investment sector, and that's why, when he eventually sought to raise a fund to bet against mortgages, he struggled to find investors. To the individual at Goldman Sachs who booked his trades meant to profit from mortgage weakness, "he was a third-rate hedge fund guy who didn't know what he was talking

about."[10] His coverage at Morgan Stanley said about his mortgage idea, "This guy is nuts."[11] Even though Paulson wanted to build a billion-dollar fund, so mocked was his view about housing's looming troubles that he was able to raise only $147 million.[12]

But, as mentioned before, Paulson was proven right about the dodgy nature of mortgages on the way to fame and great fortune. No amount of Fed "ease" would have made him a good credit risk for the first thirteen years of Paulson & Co. Now, his track record will open the door of almost any investor, bank, investment bank, Arab oil sheikh, you name it. Paulson's "greatest trade ever" netted him billions, and it means those *with means* will always take his call, and perhaps invest with him, too.

Eric Mindich, on the other hand, experienced the opposite of what Paulson did when he opened Eton Park Capital in 2004. While Paulson searched far and wide for investors, and even waived his $1 million minimum investment requirement only to have investors still turn him down, Mindich *chose* who would invest with him.

As Gregory Zuckerman, author of *The Greatest Trade Ever*, describes it, upon opening Eton Park, Mindich "shared few details of how he would operate, acknowledged that he hadn't actually managed money for several years, and said investors would have to fork over a minimum of $5 million and tie up their cash for as long as four and a half years to gain access to his fund." Despite all this, Mindich raised more than $3 billion in a few months, all the while *turning down numerous disappointed investors*.[13]

What explains the seeming ease with which Mindich ramped up so quickly? The simple and best answer is that Mindich can lay claim to being the youngest partner in the history of Goldman Sachs. Mindich was named partner at the storied investment bank in 1994 at the age of twenty-seven.[14]

About Mindich's success, some will respond that Goldman Sachs should be called "Government Sachs" for the close ties that many of its top partners have with the federal government (not to mention all the ex-GS employees at Treasury and the Fed). Others will point to a bailout of the bank in 2008 and to another alleged bailout in 1994. Fair enough, but without excusing the firm's bailouts and crony ties, Goldman remains the most competitive and talent-laden major investment bank on Wall Street.

That Mindich made partner at such a young age was a stunning accomplishment. But don't take my word for it. A major theme of this book is that markets are wise, and they render rough judgments about

people and businesses all day and every day; the Fed's meddling is almost an afterthought. That Mindich raised more than $3 billion so quickly on such stringent terms is a market signal that he'd accomplished something special. That made him very attractive to investors in 2004.

What's interesting about all this is that while Paulson repelled credit sources in 1994, and Mindich had to swat them away in 2004, it's fair to say that in 2015 it's Paulson who is the more accomplished of the two. Track record is important, but it doesn't always predict the future.

At the minimum, Paulson's 1994 struggles speak to the counterproductive nature of the Fed's attempts to decree something easy or tight. The reality is that Paulson's track record when he began his hedge fund didn't rate easy credit. Conversely, Mindich's reputation from his years at Goldman Sachs was so pristine that he probably could have found ready credit sources in 2008.

The Fed presumes to meddle with a price that almost as a rule is going to be different for everyone. It cries out for relevance and attention when market forces mock its pretense.

The great monetary writer Walter Bagehot observed in his classic book *Lombard Street*, "A very high pay of *prestige* is almost always very dangerous. It causes the post to be desired by vain men, by lazy men, by men of rank."[15] Bagehot was expressing concern as early as the late nineteenth century about giving central banks too much power, and too much majesty. He was wise, and surely prescient.

Viewed though Bagehot's prism, the Fed's enormous amounts of prestige come from feckless political leaders, obsequious economists hoping to be noticed and employed by it, and a clueless media. Those in charge have responded in kind. They want to manage the economy and heroically bestow on all of us easy access to the economy's resources. But they can't, because serious economic actors set access to credit. Said actors would never be so adolescent as to want to fix prices, let alone waste their time at a central bank. For that we should once again rejoice. The markets judge each of us individually, without regard to what the overbought officials at the Fed think.

At the same time, we should express concern about the story of Bernanke's earnings that began this chapter. Despite being in many ways irrelevant, the Fed remains in some ways too powerful. Its swagger is not its own, yet we ultimately own its errors.

What the Supply-Siders and Hillary Clinton
Sadly Have in Common

Washington is where the money is.
That's generally what keeps people here.
—Former senator Trent Lott (R-MS)

AT THIS POINT, readers hopefully have a somewhat new or modified view about what credit is. It bears repeating that credit is not "money" per se. If it were, the Federal Reserve and other central banks could simply decree it abundant by virtue of creating lots of dollars, euros, yen, yuan, ringgits, and so on.

Credit is what individuals create in the real economy. Credit is buildings, desks, computers, tractors, airplanes, and most of all labor. It's human ingenuity that turned the previously mentioned concepts into capital goods that individuals and businesses have accessed to produce even more.

In that case, it's worth repeating that when individuals borrow dollars they are borrowing what dollars can command in the marketplace. There are no entrepreneurs without capital, so the pursuit of credit is actually the pursuit of the resources (buildings, factories, desks, computers, tractors, airplanes, etc.) necessary for entrepreneurs and businesses to turn concepts into reality.

Precisely because the creation of the resources mentioned isn't costless, rates of interest logically can never be zero in the free marketplace. Forget the unreal and opposite of a free market world that the Fed resides

in as it reduces the fed funds rate to zero; in the real economy, the Fed's attempts to alter reality are largely ignored.

As the previous chapters explained, credit is always tight in Hollywood, even for the most accomplished of moviemakers. It's perhaps less tight in Silicon Valley given the potential upside involved. But as evidenced by the many rich venture capitalists there, along with their rich employees, entrepreneurs regularly exchange big portions of their business concepts with venture capitalists and company employees so that they can attain the access to the resources necessary to give life to their ideas. Credit is never costless, because it represents access to real economic resources.

Hedge-fund managers do not make anything per se, but by investing the money they've raised they're putting a price on credit sources that ultimately leads to more of it. Sometimes, as in the case of John Paulson's long struggle to attain resource access in order to expose the faulty nature of mortgage lending, their profitable trading activity signals to markets *where* credit will be destroyed (or at the very least, underutilized) if more flows in that direction. Other hedge funds trade government debt, and while government spending is generally evidence of credit destruction, because it taxes real economic activity, it's the hedge funds trading that government debt that will signal to us when the "flight to quality" safety that government debt sometimes represents is no longer safe.

So, repeating again that "credit" is real economic resources, we turn now to supply-side economics. This chapter will reveal the downside of supply side, one that in many ways pairs the school of economic thought with Hillary Clinton and other members of the political class.

Up front, it should be said that I'm unquestionably a supply-sider. To me, supply-side economics is a tautology. It states the obvious: Production is greater when the barriers erected to it by government are reduced. My first book, *Popular Economics*, is about the immense prosperity that will be ours if we reduce or completely remove the tax, regulatory, trade, and monetary barriers to production that governments have created.

Simply put, to consume we must produce first. If readers doubt this, try avoiding work for several weeks or several years. Unless someone else who is productive is willing to lend you the monetary fruits of their production, or someone in Washington is willing to relieve the productive of their own monetary fruits in order to give it to you, you will starve. To clothe yourself, feed yourself, and put a roof over your head, you must

produce something of value first to exchange it for all that you desire. Production is what fulfills your wants as a consumer.

While *Popular Economics* gets into much greater detail, here is a summary of its argument: Income taxes are a penalty placed on production; regulations are rules that invariably don't work and force producers to waste the time and resources they could otherwise devote to production; tariffs on trade shrink the division of labor that amplifies production by fostering individual work specialization; unstable money renders investment in the advances that boost production less likely.

Thinking about all of this in terms of the economic resources that amount to credit, supply-side policies are pro credit creation simply because they're defined by removing the barriers to production. Credit is abundant in the United States because Americans are very productive. Just the same, the amount of credit in the United States would increase exponentially if the aforementioned governmental barriers to production disappeared.

But first, let's discuss the aspect of supply-side theory that subtracts from its overall greatness. Specifically, it's time to talk about tax cuts and government revenues. Supply-siders have long argued, correctly, that reductions in the rate of taxation generally sufficiently boost incentives to produce to offset any falloff in the government's revenue intake. More optimistically (and this optimism is warranted), supply-siders' basic argument is that governments can *raise tax revenues* by reducing the tax rate.

Importantly, they provide evidence backing their claims about the revenue impact of tax-rate cuts. The great supply-side thinker Warren Brookes wrote in his classic book *The Economy in Mind* (1982) that between 1921 and 1925 the income tax rate was cut "four times, by a grand total of 66%, from a top range of 4%–73% to a final range of 1.5%–25%." Brookes added, "Despite the enormity of these cuts, the actual revenues to the Treasury from the income tax actually rose every year except in 1923 (when there was a recession)."[1]

In his masterful two-part biography of Ronald Reagan, *The Age of Reagan*, the brilliant Steven Hayward helped set up the certain genius of the Reagan tax cuts with a revenue argument, too. In particular, he cited a speech by President John F. Kennedy (his tax cuts were actually passed by Lyndon B. Johnson after Kennedy was assassinated): "In short, it is a paradoxical truth that tax rates are too high today and tax revenues are too low and the soundest way to raise revenues in the long run is to

cut rates now."[2] Since Kennedy remains a hero to many on the American Left, it's almost sport among supply-siders to spout JFK's quotes on taxes in order to tweak Kennedy-loving lefties who shudder at the notion of tax cuts. Kennedy correctly understood that a reduction of the penalty placed on production would lead to more production.

Where supply-siders have gone off track is in their emphasis on the revenue argument. Moving to the 1980s, and the Reagan tax cuts that ultimately brought the top rate down from 70 percent to 28 percent, supply-siders have often taken criticism for the federal budget deficits that were the norm during the Reagan years. In response, they've generally offered a variation of the argument Stephen Moore made in a 2004 op-ed for *National Review*:

> The Reagan way was spurned throughout the 1980s as "voodoo economics" (one of George Bush Sr.'s few memorable comments). Many college textbooks to this day even argue that Reagan's economic policies were flawed because they created record budget deficits. But the textbooks don't mention that as the national debt rose by $2 trillion, national wealth rose by $8 trillion. They also don't mention that the Laffer curve worked: Lower tax rates *did* generate more tax revenues at the federal, state, and local levels. Federal tax collections rose from $500 billion in 1980 to $1 trillion in 1990.[3]

Moore, like Hayward and the late Brookes, is fabulous. One could learn a great deal by reading his columns and books. But here, with his revenue defense of the Reagan tax cuts, he along with other supply-siders goes off track, and maybe off message.

First up is his mention of "record budget deficits" on the federal level. The obvious problem there, which Moore would doubtless acknowledge, is that governments have no resources. They can spend only what they've taxed or borrowed from the real economy. By that measure, *all* spending by the federal government is deficit spending, even the spending that goes toward its accepted, constitutionally allowed functions. The federal government is able to spend based on the wealth it taxes from its citizens, but it's also able to borrow the dollars it spends because, backed by productive American workers, the federal government's credit is good. More on that in a bit.

Moore then adds in his correct defense of Reagan's economic policies, namely, that federal tax collections doubled between 1980 and 1990. A

cursory online search verifies that claim, but supply-siders often forget that all we gain from the federal government collecting more tax revenues is a bigger federal government. Indeed, the size of the federal government grew in the 1980s, and it continues to grow. Congress has power over the federal purse, so when revenues surge, so does government spending.

So while supply-siders (and for that matter all economists, politicians, and pundits) should focus on reducing the tax burden, they should also emphasize reducing the amount of revenues taken in by the federal government. Politicians exist to spend, so when the federal government collects abundant revenues, something quite contrary to supply-side philosophy reveals itself. There is more consumption of the economy's wealth through excessive spending by Paul Ryan, Nancy Pelosi, Harry Reid, and Mitch McConnell. Stated simply, rising tax revenues allow the barrier to productivity that is government to grow. More broadly, Americans as a whole despise Congress,[4] yet surging tax revenues empower Congress to spend with abandon the wealth that citizens have created.

One interesting thing about a bigger federal government is how it impacts the power and wealth of existing and former politicians. The answer shouldn't please supply-siders. Just as former Republican senator Trent Lott has stuck around Washington, D.C., because it's "where the money is," so most ex-pols and the politically connected keep close to Washington in a literal and figurative sense. They want to influence where all the wealth that is taxed and borrowed by Congress is ultimately spent.

In an odd way, supply-siders' unhealthy focus on federal revenue puts them in the camp of no less an enemy than Hillary Clinton. Bill Clinton, too. According to numerous media accounts in May 2015, the formidable political couple had earned at least $30 million in speaking fees since 2014.[5] And just as Ben Bernanke's wealth is a function of his ties to the powerful Federal Reserve that he used to lead, so is the Clintons' wealth rooted in the size and scope of the federal government. In short, *it's not their wealth*. It was transferred to them by others thanks to the power of the federal government over the U.S. economy. The Clintons are maybe who President Obama was talking about when he famously uttered, "You didn't build that."[6]

The Clintons are extraordinarily rich not because Bill discovered a cure for cancer, or because Hillary has a knack for resuscitating companies that are on the proverbial deathbed, or because both excel as Ford,

Rockefeller, and Steve Jobs did at mass-producing former baubles of the rich. No, the Clintons are rich for having been lucky enough to make a profession of politics in the richest, most innovative country on earth. Without a hint of hyperbole, the wealth they enjoy is the result of the federal government confiscating it from its actual creators. The Clintons are posh and supercilious, but their grand lifestyle is directly attributable to the ability of the political class to plunder America's truly productive.

To be fair to the Clintons, they're hardly alone. This isn't a Democrat or Republican thing. It's a national politics thing. Former Republican House Speaker Dennis Hastert had millions to bribe a wrestler he used to coach not because he entered the *productive* private sector after retiring from Congress. His wealth was rooted in his ability to lobby the free-spending Congress that he used to lead. Politicians claim to enter their profession with "public service" in mind, but their soaring net worth in and out office plainly reveals that men and women enter politics in the United States to get rich. As evidenced by their earnings, the Clintons are merely the best at a game played by Democrats and Republicans alike.

Bill Clinton is seemingly a great speaker, and both Bill and Hillary are presumably quite book smart. But if they weren't born in the United States such that they could play politics at the highest of levels, no one would pay them six and seven figures for their speeches. The Clintons oddly decry the very inequality that creates a taxable bonanza each year for the U.S. Treasury, the resulting federal spending being the source of all the fawning treatment they receive from people who are surely "fascinated" by what they have to say on the stump.

Reduced to the basics, there aren't many rich people in Bangladesh. Consequently, there aren't many influential people seeking favor with their politicians. Politicians from Bangladesh are oddly not as interesting or insightful as American politicians are. They're also not as rich. There's no bustling and ritzy K Street equivalent in Dhaka. If not for the immense taxable wealth in the United States, and the Clintons' ability to move substantial portions of that wealth around, few would give the Clintons the time of day.

In short, the Clintons aren't much to behold absent the tax revenues that we the people shower on the federal government every year. These revenues are the source of their power. The swagger of the world's foremost political couple, like that of Ben Bernanke, has been borrowed on our credit.

In modern times, and alongside an increasingly flush federal government, Washington, D.C., has become rather fancy. When politicians talk up "stimulus" spending, it is realistically code for a redistribution of the economy's resources by a political leviathan that is being enriched on the backs of the American people. That's what's on the surface, what I'll call "the seen."

The "unseen," however, is all the cancer cures, transportation innovations, and software advances that aren't being invested in because Washington consumes so much of the wealth we create. When supply-siders extol empirically true revenue increases that result from reductions in the rate of taxation, they're imposing massive new taxes on the American people. Those revenues increase the tax that is government spending, whereby Congress allocates huge portions of the credit created by the private sector; these taxes are growing by leaps and bounds with each increase in federal revenues.

To use but one example, consider Medicare. Signed into law by President Johnson on July 30, 1965, as part of his misnamed "Great Society" expansion of the tax that is government, Johnson excitedly spoke of the "seeds of compassion and duty which have today flowered into care for the sick." The idea was to make medical care affordable for the elderly.

The budget for Medicare in its first year was $3 billion. In 1967, the House Ways and Means Committee naively forecast that the program would cost taxpayers $12 billion by 1990. But as Pacific Research Institute president Sally Pipes reported in a July 30, 2015, op-ed for the *Wall Street Journal*, Medicare costs had soared to *$110 billion* by 1990, $511 billion in 2014, and are expected to increase to *$1 trillion* by 2020. Added to the nosebleed costs has been what Pipes describes as "fraud and other improper payments" that amounted to more than $60 billion in 2014 alone.[7]

Something is wrong with the ugly picture Pipes painted for her readers. Lest we forget, capitalism is about turning scarcity into abundance. Capitalists grow rich by virtue of turning obscure luxuries enjoyed solely by the rich into low-cost, common goods enjoyed by the nonrich. *And it delivers.*

In the 1960s, IBM manufactured the first mainframe computer, which cost more than $1 million.[8] Today, computers that are exponentially more capable and powerful sell for a few hundred dollars. In 1983, Motorola manufactured the first mobile phone. The DynaTAC 800X was the size

of a brick, offered half an hour of battery life, had terrible reception, and had calling that cost a fortune: all this for the princely sum of $3,995.[9] Today, even the poorest Americans enjoy mobile phones that would have blown away the richest technology billionaire just a few years ago. As another example, consider something as basic as the ballpoint pen. Reynolds International introduced the ballpoint pen in 1945, and the cost of owning just one was $12.50.[10] Fast-forward to the present, and an individual in the market for ballpoints can purchase a box of sixty from Paper Mate for $5.89.

Capitalism is all about delivering the formerly expensive at low prices. That fact is undeniable. So, in light of capitalism's brilliant track record, why do we allow government to spend so much of our money to deliver healthcare? How could we be so foolish and shortsighted? Can anyone seriously say that healthcare is a different kind of good that can't be left to market forces? Even if some persist in believing the latter, they might do a better job of explaining why government is a better and more necessary provider of healthcare than private actors. (Pipes adds, "three in 10 seniors on Medicare struggle to find a primary-care doctor who will treat them."[11])

Given the enormous sums of tax dollars spent on a program that has failed to deliver consistent access to healthcare, we must ask: How much different would access to healthcare be for all Americans had government not consumed such substantial credit on a program that has failed in its stated objective? All this must be considered through the prism of this odd dance between supply-siders and the left that amounts to the former saying to the latter, "If you let us cut taxes, we'll give you trillions to spend." Indeed, as top Kennedy advisor Walter Heller explained (and it was as if revenue-obsessed supply-siders were whispering to him as early as the 1960s), economy-boosting tax cuts generate "a better economic setting for financing a more generous program of federal expenditures."[12] Supply-side has unwittingly paired aspects of itself with government-expanding Keynesianism.

The late Nobel Laureate Milton Friedman didn't get everything right on the economic front, as future chapters will reveal. However, he was quite correct in asserting that when tax cuts lead to higher federal revenues, taxes haven't been cut enough.[13] The Laffer curve, which correctly asserts that a lower rate of taxation leads to greater growth and higher

federal revenues, is a tautological reality, as the 1920s, 1960s, and 1980s make plain.

At the same time, it's well past time to consign the Laffer curve to the proverbial dustbin of history. While the fiscal focus should always and everywhere be on reducing the tax burden, it should be on reducing it so much that revenues actually decline. If they don't, then stringent rules must be put in place to ensure that the revenues are returned to the taxpayers, used to pay off any existing federal debt, and so on. If these revenues are handed to politicians, the singular result is more economy-sapping federal spending that grows and grows. Odds are Arthur Laffer would agree with this. As the next chapter will explain, government can't be a good investor or allocator of the economy's abundant credit. It can only waste it.

In that case supply-siders must rewrite a portion of their otherwise correct message. Government is a barrier to production, and its waste enriches the political class, all the while destroying limited credit that would otherwise fund huge economic advances. Higher federal revenues represent a hideous bug in the supply-side tax-cutting argument, not a feature.

It's time to cut taxes to a rate that actually pushes revenues well below the Laffer curve.

Why "Senator Warren Buffett" Would Be a Credit-Destroying Investor

It is the leap, not the look, that generates the crucial information.
—George Gilder

BACK IN THE EARLY PART of the twentieth century, when the automobile industry was in its infancy, there were more than two thousand car companies in operation. Notably, only around 1 percent of them survived.[1]

This statistic from over a century ago is worth bringing up, in light of what was discussed in the previous chapter—it, and the frequent, *and very lazy*, use of the word "bubble" by market pundits. It would be hard to find a word more devoid of meaning than this modern adjective that those who comment on the markets use constantly. Seemingly lost on the serial users of this waste of breath is that if there's a "bubble" to speak of, it concerns the excessive use of the word "bubble" to describe any market move upward.

Had today's pundits been around when cars began their ascent, "bubble" would surely have dominated the primitive headlines. Who cares that the car was a staggeringly transformative innovation that birthed incalculable human progress. The fact that most auto firms failed would have fit neatly into their indolent approach to major economic leaps that almost by definition leave a lot of failure in their wake.

Furthermore, the car was then and remains today a good example of credit. It's a resource produced in the real economy that, at its inception, not only expanded the range of places where individuals could work but

also greatly expanded the markets that entrepreneurs could sell to. Stated otherwise, the capital that is an automobile isn't just a consumption item.

Instead, the dawn of the automobile meant that the business owner in a remote locale wasn't limited to selling to fellow townsfolk; he could deliver his goods to customers far and wide. More recently, the car has turned consumers of automobiles into capitalists of a different kind. Thanks to Uber and the "sharing economy," cars that we purchase for personal use are increasingly an economic resource we can charge people for rides in.

Speaking of computers, does anyone remember brands such as Kaypro, Commodore, and Tandy Corporation's TRS-80 Micro Computer? Those of us born in the 1960s and 1970s might recall all three from the 1980s, when visionary entrepreneurs started to mass market these items to consumers. None are around today, and RadioShack, where the TRS-80s were sold, filed for bankruptcy in February 2015. (Sprint has salvaged some of RadioShack's stores.[2])

All of this early failure in the computer space didn't create a "technology crisis," and there was no "computer bubble." Failures forced a positive evolution of the computer industry such that today most Americans own a number of them. Like the car, computers allowed businesses to produce even more with less on the way to even greater wealth creation.

Fast-forward a little more than a decade to the period during which the word "bubble" reached full flower: the Internet "bubble" in the 1990s. The simple truth is that the Internet, much like the computer and the car before it, was a transformative economic advance. Readers need only to think back to how people lived, worked, communicated, and watched movies and television in 1990 versus today. The difference is staggering, and because it is, it was only natural that all manner of unsuccessful ideas received funding in the technology space. When we consider what the Internet "bubble" wrought, including a shallow downturn as the markets were cleared of some admittedly bad ideas, the only sane response would be to wish for more of these "bubbles" every few years.

Indeed, as George Gilder notes in his masterful *Knowledge and Power,* "Crises may be growth spasms." Gilder's point is that economic advancement is about the leap, and it was during the Internet boom that massive amounts of saving and investing gifted the marketplace with voluminous information; some of it good, some of it great, most of it profitless. But all of it provided investors and entrepreneurs with greater clarity in

their relentless pursuit of returns. We're better off because there was an Internet boom marked by stupendous failure. The same holds true for the 99-percent failure rate among automobile companies in the early twentieth century that fostered a major leap forward in transportation technology.

All three "bubbles" are better described as "credit surges." Economic resources migrated in impressive fashion to entrepreneurs, and the result was a massive amount of experimentation. In the Internet space, Webvan and eToys have long since vanished. However, the world is a better place for their attempts at success.

Evidence supporting the above claim springs from the chapter on Silicon Valley. The Internet has shrunk the world such that an entrepreneur with a computer in Shanghai can sell to and work alongside another individual in possession of a computer in Spokane, Washington. In brief, it is increasingly within reach for someone with a vision to start a global business. All of this is the result of an aforementioned credit surge that produced numerous resources that are accessible to entrepreneurs. The oft-mentioned "death of distance" is real.

What's also important about all three of these credit surges is that there were no government initiatives hatched to bail out the myriad failed companies in these periods of frenetic experimentation. Instead, the resources controlled by the failures were released to entrepreneurs and businesses with a stated objective to better deploy them. This is important in light of our definition of credit as economic resources. Those who are misusing or underutilizing resources deprive others of usage that might prove quite innovative and profitable. Failure is a *feature* of capitalism, not a bug. Markets aren't perfect as much as they're constantly in search of perfection. Failure furthers the search.

Of course, all of this is one reason why politicians are bad investors. Irrespective of party, politicians are "conservative" in their investing style. This is true simply because of the public outcry that would result from truly exotic leaps with taxpayer funds. By contrast, entrepreneurs and the investors who fund their visions are almost as a rule exotic. In search of the kind of profits that can emerge only from something different, they're generally looking not to duplicate the known so much as to do something entirely different, or better yet create a "new known."

There's also the question of talent. A great investor is never going to toil as a politician. The pay isn't good enough. Whatever the perks of

being in Congress, or for that matter being an ex-politician, great investors can earn billions. So it's no major insight to say that if Hillary Clinton, Joe Biden, or Marco Rubio had a clue about what companies and business concepts were going to prosper in the future, they would not be members of the political class.

Simply put, wealth in the hands of politicians is not the same as wealth in the hands of Bill Gates, Warren Buffett, Peter Thiel, or Jeff Bezos. Government can't spend or invest us to prosperity for reasons of talent alone.

My sermonizing, while true, ultimately amounts to shooting fish in the most crowded of barrels. While the talent differential between politicians and successful investors is blindingly obvious, to point it out is arguably to miss the greater point. Undoubtedly, those who properly decry government in its role as venture capitalist can point to the massive government loan to now bankrupt Solyndra as one of many modern examples of how politicians don't know how to invest. Yet political apologists can also point to busts such as Webvan, Globe.com, and eToys (to name but three) as evidence that for-profit investors are fully capable of funding Solyndra-like debacles. Yet *that is* the point.

The quote by George Gilder that begins this chapter explains why. Gilder's words are loaded with essential knowledge about how an economy grows. It doesn't grow based on success. If it did, Silicon Valley would easily be the poorest locale in the entire world. An economy grows based on information, good and bad, reaching investors and entrepreneurs. It's through this constant experimentation that entrepreneurs, businesses, and investors attain essential information about what people desire, what businesses need to grow, what business practices need to be perpetuated, and which ones need to be banished.

There is also a greater argument here, one that historically has not been made. The billion-dollar net worths of Buffett, Bezos, and Thiel certainly mark them as skillful private allocators of capital. But if they were Senators Buffett, Bezos, and Thiel, their investing track records would be lousy, arguably on par with the consistently bad batting average of the political class. More critically, it must be stressed again that it is *impossible* for politicians to spend or invest us to prosperity given the simple truths previously mentioned about Silicon Valley.

Businesses in the private sector don't have an unlimited line of credit with which to continue committing the same capital-destroying errors.

Eventually, investors run out of patience, the business is shut down, and the assets are sold to individuals eager to utilize them in a different way.

Readers should compare this scenario to that of the government, no matter the ideology of the politicians allocating the money. When politicians spend or invest, they do not labor under the same market-driven discipline that private investors do. As the failure rate in Silicon Valley reveals, private investors are quite fallible, and yes, they are all-too-capable of funding egregious Solyndra equivalents.

The major difference is that when Globe.com falters, investors quickly starve it of capital so that it can destroy no more. When politicians spend, they have an unlimited source of funds—you, me, Michael Dell, and Larry Ellison—to tap. They can continue to support that which doesn't work. Stated simply, businesses disappear on a daily basis, but government programs are generally forever.

Since the federal government's "War on Poverty" began, in the 1960s, more than $16 trillion has been spent on the battle.[3] Yet, it seems that both liberals and conservatives miss the real story here. A more reasoned analysis, one driven by market signals, would strongly conclude that the United States conquered poverty back in the *nineteenth century*. That's the case because the most powerful market signal of all—and nothing else comes close—concerns where people choose to live. If the United States had any kind of poverty problem whereby the poor had no means to emerge from poverty, its population would not have grown so substantially since the nineteenth century, nor would foreigners be clamoring to live in the United States to this day.

And there lies the problem with federal spending on poverty, or government investments in ideas meant to cure its worst features. The powerful desire among outsiders to live in the United States is a certain signal that the War on Poverty was long ago won such that the spending isn't necessary. Worse, all government programs develop constituencies. The jobs of individuals who vote are on the line. So even though the calculated rate of poverty[4] is the same as it was when the war began, spending on that which, at least statistically, doesn't work, and that really isn't necessary, continues. In short, the alleged War on Poverty has failed, yet trillions continue to be spent on it. In the private sector such a war would have ended in bankruptcy long ago; that, or the strategy for fighting the problem would have long since changed. But not so in government, where programs once again develop constituencies.

What about market items like shoes, televisions, watches, and bikes? Can any reader realistically claim detailed knowledge about how each is made? Likely not. Yet, all four are available for purchase in all manner of shapes, sizes, colors, and brands. The free market provides—and this includes providing today's poor with luxuries that formerly only the elite could enjoy, even though we don't know how it does it. The market simply *is*. What we want is already available, that which is too expensive will eventually be cheap, and that which we don't even know we want (but will one day be unable to live without) will soon enough be available, if markets are left free.

Along these lines, do any readers know how the electricity they consume reaches them? No, but in the United States we take it for granted that wherever we choose to live, electricity is available at a market price. And yet the Tennessee Valley Authority (TVA), a federally funded Depression-era relic founded by President Franklin D. Roosevelt, still exists, and it provides electricity to seven million Americans in nine different states.[5] Even though private sources of electricity would ably fill the TVA's government-created role, it continues to operate on the taxpayer dime. The TVA is yet another example of how government spending on a program or project, once begun, rarely meets its end.

Not long before he was elected president of the United States, Barack Obama correctly criticized The Export-Import Bank (Ex-Im) as "little more than a fund for corporate welfare."[6] He was right. It exists to lend taxpayer funds to foreign companies interested in buying U.S. exports. Since reaching the White House, Obama has changed his position on the Bank. As of this writing, even a Republican-controlled Congress is still struggling to fully close this monument to crony capitalism.

The existence of Ex-Im, along with the TVA and the War on Poverty, shows why supply-siders are so wrong when they sell income tax cuts to the political class as a way to get politicians more money to spend. That all three programs and subsidies still exist is a reminder that surging federal revenues morph into a major tax on future growth as politicians divine new ways to spend the money; the ideas hatched are exceedingly difficult to sunset. Consider always the "unseen": the advances that never attained funding because surging federal revenues allowed Congress to spend and borrow with abandon.

From an investment perspective, while Silicon Valley ruthlessly kills off its capital-destroying losers so that better ideas can receive funding,

government, no matter the party in power, continues to support its duds. If politicians managed the technology sector, Friendster would still rule the roost in a sleepy social media sector, we'd be accessing the Internet in dial-up fashion with NetZero as our provider, and our computers may well be TRS-80s.

The debate about government spending has too often focused on breathtakingly dumb programs and wasteful subsidies. This misses the point. Many government programs are dumb, just as many private-sector creations are laughable. The difference is that Berkshire Hathaway's Warren Buffett must eventually sunset his bad ideas, while a Senator Buffett would face no such constraints.

Some will point to the 693,518-percent gain in Berkshire Hathaway shares since Buffett took over the holding company in 1965 (versus the S&P 500's 9,841-percent increase)[7] and claim that Buffett's keen eye for companies wouldn't desert him in the Senate. Maybe not, but what *would* be taken from him is the ability to fix the corporations he invests in. While Buffett is known to "buy and hold," he doesn't allow the businesses he owns to operate like charities. As he acknowledged in a 2015 op-ed for the *Wall Street Journal*, job loss in the modern economy is normal. It is "simply a consequence of an economic engine that constantly requires more high-order talents while reducing the need for commodity-like tasks."[8] Buffett knows well that for businesses to thrive, they must sometimes reduce head count. But as Senator Buffett, his ability to discipline flabby corporations would be severely limited by politicians who are eager to protect their constituents' jobs.

Buffett doesn't always "buy and hold." Despite the lousy investment reputation of airlines, Buffett once took a large position in what was then U.S. Air.[9] While he ultimately cashed out of the airline, had he been investing taxpayer funds, doing so would not have been as simple. Just as Senator Buffett wouldn't be able to force the kinds of restructurings that companies require, so would it be politically impossible for him to sunset bad investments. A track record that is golden in the private sector wouldn't be so hot in the public domain, simply because bad ideas are never allowed to die. Instead, and thanks to the lack of market discipline that defines government spending, bad ideas continue to attain funding. Remember Medicare from the previous chapter? Do Social Security's returns excite you? Would the latter still be in operation were it run privately in the way it's run publicly? Certainly not. In the private sector,

investors run out of patience. Not so when government is writing the check with someone else's money.

For investors to be successful, there must be losers. Politicians almost never lose, and for that reason they'll never be good allocators of the precious resources they've extracted from the economy. Warren Buffett would be a credit-destroyer were he investing government money, not because attaching "Senator" to his name would make him a fool but because he would never be forced, let alone allowed, to correct his errors.

Government "credit destruction" is a redundancy of the highest order. Government as a rule destroys resources created in the private sector, and the result is that entrepreneurs must compete for the resources not destroyed and neutered by politicians. We all suffer the government's conceit that shrinks the private resource access necessary for economic progress.

The Credit Implications of
the Fracking Boom

In order that one industry might grow or come into existence,
a hundred other industries would have to shrink.
—Henry Hazlitt, *Economics in One Lesson*, 78

IN HIS 2011 BOOK *Adapt*, Tim Harford of the *Financial Times* begins with a discussion of the simple toaster. Invented in 1893, in between the light bulb and the airplane, the toaster is today a basic item found in most kitchens. A quick Amazon search reveals numerous makes and models at a variety of price points, from $29 all the way to $249.

At this point in our abundant, developed world, we can happily take it for granted that if we desire a home toaster, we'll have countless choices to fulfill the want. Such is the genius of trade.

Still, Harford did some digging and in the process came across a graduate student by the name of Thomas Thwaites at the Royal College of Art in London. Thwaites wanted to see how easily he could build his own toaster from scratch. He soon realized that the task would be extraordinarily difficult. As he found, even the most medieval of versions required at least four hundred different inputs:

Copper, to make the pins of the electric plug, the cord, and internal wires. Iron to make the steel grilling apparatus, and the spring to pop up the toast. Nickel to make the heating element. Mica (a mineral a bit like slate) around which the heating element is wound,

and of course plastic for the plug and cord insulation, and for the all-important sleek looking casing.

Eventually, he plugged in what Harford described as a "toaster-shaped birthday cake," and "two seconds later, the toaster was toast." Thwaites concluded, "If you started absolutely from scratch, you could easily spend your life making a toaster."[1]

Harford's opening subject was, in many ways, a tribute to Adam Smith's brilliant book *The Wealth of Nations*, and more modernly, to Leonard Read's *I, Pencil*. In the former, Smith opens with an essential point: "The greatest improvement in the productive powers of labour, and the greater part of the skill, dexterity, and judgment with which it is any where directed, or applied, seem to have been the effects of the division of labour."[2]

Smith goes on to describe something as basic as a pin factory. He found that ten men pursuing their specialty in the manufacture of pins could together, through this division of labor, make up to 48,000 pins per day. At the same time, he found that if these ten men had worked independently, "they certainly could not each of them have made twenty, perhaps not one pin a day."[3]

There, in a nutshell, is one of the best endorsements of free trade ever recorded. When we divide up the work to accentuate individual specializations, the productive results are grand. But if we try to do everything on our own, whether it is making a pin or a toaster, we could spend many days or even our whole lives producing but one good. Absent the division of labor that defines the developed world, we would, as the toaster example makes plain, live lives of unrelenting drudgery.

What about something much more advanced, such as the automobile? The manufacture of an American car demonstrates how much global cooperation, through the division of labor, makes for better and more plentiful autos for us to drive. Consider Dartmouth College professor Douglas Irwin's description of the various inputs that go into the final products that roll off U.S. assembly lines:

> 30 percent of the car's value is due to assembly in Korea, 17.5 percent due to components from Japan, 7.5 percent due to design from Germany, 4 percent due to parts from Taiwan and Singapore, 2.5 percent due to advertising and marketing services from Britain, and

1.5 percent due to data processing in Ireland. In the end, 37 percent of the production value of this American car comes from the United States.[4]

Here again we see that work specialization and openness to inputs from around the world leads to more of what we desire. If all we did was work and produce for ourselves, our living standards would be hideously low.

Looked at through the prism of credit, a world of individuals working alone would be utterly bereft of credit. Life would be brutal. If something as seemingly simple as a toaster could require a lifetime of solitary work to manufacture, imagine what it would take to make more advanced capital goods like tractors, computers, cars, and airplanes.

Again, the desire for credit is actually the desire for resources created in the real economy. A world without a division of labor would not be characterized by abundant credit. There would simply be nothing for anyone to borrow.

What does all of this discussion about the division of labor and immense production have to do with fracking? Quite a lot, actually.

It must be acknowledged that the perfection of this technique for extracting oil and natural gas is a classic story of entrepreneurialism. Entrepreneurs, as always, are seeking resources to do something differently. Here is how oil historian Gregory Zuckerman described the contemporary pioneers of this craft:

> These modern-day wildcatters ignored the skepticism and derision of experts, major oil companies, and even colleagues to drill in rock they believed was packed with oil and gas miles beneath the earth's surface. These men have altered the economic, environmental, and geopolitical course of the world while scoring some of the richest windfalls in history.[5]

Impressive stuff for sure, from an entertaining writer. At first glance, fracking is a great credit story. Oil is an essential economic input, and, when we consider that wind and other forms of green energy realistically had their heyday in the thirteenth century,[6] it's not unreasonable to claim that oil is the ultimate alternative energy. That fracking techniques have unearthed a great deal more of it seemingly amounts to a surge in the availability of the economic resources that we view as credit.

But despite the above, it's more realistic to say the fracking revolution has reduced the global supply of credit. Importantly, this presumption is not rooted in environmental worries of the global-warming variety.

As I argue in *Popular Economics*, while there are many credentialed scientists who claim that the failure to curb global consumption of fossil fuels will lead to a worldwide environmental catastrophe that will put coastal cities under water, market signals indicate that this narrative is false. Scientists are doubtless smart, but markets are quite a bit smarter, and able to see the future. That's what prices in the marketplace represent; the combined view of the future by market participants.

Let's assume, for the moment, that the use of fossil fuels, which shows no signs of abatement, represents an environmental hazard set to wipe away some of the world's richest and most economically important cities. In that case, it's fair to say the market valuation placed on land, buildings, houses, and companies with coastal addresses would be in freefall—a reflection of our unwillingness to curb our consumption. That they're not falling, but most often rising, is a market signal that fears of an environmental calamity related to oil consumption are vastly overdone.

Instead, the nature of my argument about why the fracking boom has been anticredit is monetary. Specifically, it's about the value of the dollar.

For some simple background, we turn to Adam Smith, who made a critical observation in *The Wealth of Nations*: "The sole use of money is to circulate consumable goods."[7] There's nothing abnormal or intimidating about Smith's quote. As readers know by now, if money were actual wealth or itself a commodity, we'd all be rich. We could simply create lots of dollars.

But money is not wealth. Money is a measure of wealth. I have bread, but I want the vintner's wine. The problem is that the vintner doesn't want my bread; he wants the butcher's meat. Since there's rarely a "coincidence of wants" among producers, money was created as an accepted measure of value to facilitate trade among producers. If the dollar is broadly accepted, and for that matter if the euro, yen, and yuan are broadly accepted by producers, economics writers, like this one, who love Whataburger can exchange our compensation for writing with a Whataburger outlet that has no interest in what we have to say about economic policy.

When we produce, we're demanding the money that is exchangeable for all we do not have. We produce for money, but money is just the lubri-

cant that makes all sorts of trade possible. Ultimately, we're producing for money that we can exchange for what we want but don't have.

The obvious problem with what's been described is that for money to best serve its "sole use"—that is, as a facilitator of exchange—its value must be stable. Absent stability of value, trade is less likely and certainly less mutually enriching, because a dollar today may not have the same exchangeable value as a dollar tomorrow; hence the historical use of gold to define the value of the measure that is money.

Why gold? Historically, it's been the commodity that is least variable in terms of value. Gold is the "constant," as it were. Or as George Gilder put it in his 2015 monograph *The 21st Century Case for Gold*, "Gold is the monetary element that holds value rather than dissipates it."[8] About money, he wrote: "It is not a commodity. It is intrinsically a unitary measure of value."[9] Money defined in gold terms serves its singular purpose as a measure, or more simply, as a ruler.

Beginning in the early 2000s, the value of the dollar, which has not been tied to gold since 1971, fell in gold terms. Imagine if the inch or foot floated in length the way the dollar floats in value. What if the length of the foot declined by half? Six-foot-tall individuals would suddenly stand twelve feet tall, without any change at all in their actual height.

When it came to oil in the 2000s, the dollar ruler declined, or shrunk. A dollar that bought 1/260th of an ounce of gold in January 2001 increasingly bought much less. Commodities such as oil are measured in dollars, and the price of oil predictably soared as the value of the dollar plummeted. This wasn't the first modern instance of a falling dollar giving the illusion of oil scarcity, or for that matter, abundance. For background on volatility in the price of oil, it is worthwhile to take a trip back to the 1970s and 1980s. We begin with a press conference staged in 1981 by newly elected President Ronald Reagan.

Asked about the falling price of oil, Reagan's answer was non-traditional to say the least:

> One economist pointed out a couple of years ago—he didn't state this as a theory, but he just said it's something to look at—when we started buying oil over there, the OPEC nations, 10 barrels of oil were sold for the price of an ounce of gold. And the price was pegged to the American dollar. And we were about the only country left that still were [sic] on a gold standard. And then a few years went by, and

we left the gold standard. And as this man suggested, if you looked at the recurrent price rises, were the OPEC nations raising the price of oil or were they simply following the same pattern of an ounce of gold, that as gold in this inflationary age kept going up, they weren't going to follow our paper money downhill? They stayed with the gold price.[10]

Reagan's point was that falling crude prices weren't a function of a supply glut as so many assumed. Rather, they were a function of a rising dollar that revealed itself in a major decline in the price of gold that was and is priced in dollars. As the above quote clearly shows, oil's decline thanks to a stronger dollar neither confused nor surprised Reagan. He was arguably the most economically astute individual to ever reside in the White House.

As Warren Brookes observed in *The Economy in Mind*, likely in reference to the same Reagan press conference, "In fact, in February 1981 President Reagan scooped the experts when he predicted that oil prices would soon fall because the price of gold had dropped over 20% since his election." As Brookes more plainly put it, "From 1970 to 1981 the price of gold rose 1,219%—the price of oil 1,291%. That's no coincidence."

In 2006, Steve Forbes alluded to much the same thing in a column for the magazine that bears his name. As he explained it, "When the dollar was fixed to gold between the mid-1940s and 1971, the price of oil barely fluctuated."[11] Stated otherwise, when the value of the dollar is stable in terms of gold, so has the price of oil been stable. All three great minds were offering a variation of the same point: the dollar is a measure, like a ruler; when it shrinks, the price of oil rises, and when it expands, the price of oil declines.

Fast-forward to the present, and with all of the above in mind, it's no coincidence that oil has fallen substantially from the highs of more than $100 per barrel that were the norm as recently as the summer of 2014. While the dollar is no longer defined in gold terms, the price of gold continues to reflect the dollar's actual value. While the ruler had shrunk to as little as 1/1900th of an ounce of gold in August 2011, it has since expanded to roughly 1/1100th of an ounce.[12] A rising dollar value has reduced the dollar cost of oil.

For deeper background on this, on August 15, 1971, President Richard Nixon made the fateful decision to cease defining the dollar in terms

of gold. This was a signal on his part that his administration wanted a weaker dollar (a smaller ruler as it were), and markets complied. The dollar fell and gold subsequently soared. So did oil.

Since 1971, U.S. presidents have generally gotten the dollar they wanted. With the Nixon, Ford, and Carter administrations all in favor of a weak dollar, oil priced in dollars was the beneficiary. With the dollar weak in the malaise-ridden 1970s, oil was expensive in dollars.

For now, what the falling price of oil indicates is the irrelevance of the Organization of the Petroleum Exporting Countries (OPEC) to the price of oil. Lest we forget, OPEC formed in the 1960s but had no impact on the per barrel price. Furthermore, the oil "shocks" of the early and late 1970s similarly had nothing to do with OPEC. As Robert Bartley, the late editorial-page editor of the *Wall Street Journal*, explained in his spectacular 1992 book about the Reagan revival, *The Seven Fat Years* (in which he put "oil shocks" in mocking quotes): "The real shock was that the dollar was depreciating against oil, against gold, against foreign currencies and against nearly everything else."[13]

Bartley pointed out, "In the confusion of the 1970s, no one noticed that OPEC officials told us plainly what was going to happen after the closing of the gold window." Bartley was far from confused, and he even provided readers of *The Seven Fat Years* with Conference Resolution XXV.140 of the Organization of Petroleum Exporting Countries. This resolution explicitly pointed out what remains true: OPEC doesn't control the price of oil, but "Member Countries shall take necessary action and/or shall establish negotiations, individually or in groups, with the oil companies with a view to adopting ways and means to offset any adverse effects on the per barrel real income of Member Countries resulting from the international monetary developments as of 15th August 1971."[14] August 15, 1971, was the day that Nixon delinked the dollar from gold, and in doing so, devalued it. The oil-price spikes of the early 1970s were explicitly a dollar phenomenon, and had nothing to do with OPEC, beyond those countries understanding well that a decline in the dollar measure that oil is priced in would lead to a higher price of crude itself.

The decades since the 1970s have continued to expose OPEC's irrelevance when it comes to the price of oil. To believe otherwise—namely, to promote the falsehood that simple oil scarcity, or OPEC countries, or even non-OPEC countries like Russia, controls the price of oil—is to presume they were simply feeling generous in the 1980s and 1990s when the

price of oil collapsed. It also presumes that they coincidentally became "greedy" again in the 2000s based on oil's spike. In truth, U.S. presidents, once again, get the dollar they want. Reagan and Bill Clinton were strong-dollar presidents as the low prices of gold and oil revealed in living color. George W. Bush got the weak dollar he wanted, as evidenced by the spike in the prices of gold and oil since 2001. We didn't suffer "oil shocks" in the 2000s; we suffered the weak-dollar policies of President Bush, and during his first term, of President Barack Obama.

In a replay of modern history, Bartley added, "When the price of oil shot up, the most fashionable sectors of American opinion persuaded themselves the world was running out of energy." We heard much the same in the 2000s as the silly notion of "peak oil" became popular. Without detracting from the impressive U.S. fracking advances in the oil patch, just as the supply argument wasn't true in the 1970s, it also wasn't true in the 2000s. Evidence supporting this claim comes from *Wall Street Journal* reporter Gregory Zuckerman, author of a laudatory history of fracking, *The Frackers: The Outrageous Inside Story of the New Billionaire Wildcatters.*

Zuckerman also promoted the supply/demand narrative about the oil price, but what he left out is that in the seven years leading up to July 2008, when crude hit a nominal all-time high, the price of a barrel of oil in euros rose 198 percent, in Swiss francs 216 percent, and in dollars *459 percent.*[15] What these numbers unquestionably tell us is the oil-price scarcity narrative that prevailed in the 2000s was almost wholly a dollar story (the euro and franc were declining versus gold, too, albeit not as much as the dollar). But despite this tautology, Zuckerman never tied the two together.

More to the popular supposition about supply, Zuckerman wrote that by 2013 "the United States was producing seven and a half million barrels of crude oil each day, up from five million in 2005."[16] Despite a 50-percent daily increase in U.S. oil output beginning in 2005, when a barrel averaged $50, by 2013 the average had risen to $89. Despite this new supply, the price of crude was rising amid a much weaker global economic outlook. The answer to this seeming riddle was that the dollar experienced its most impressive weakness during this timeframe, as the price of gold in dollars plainly shows.

Why the lower gold price of more recent vintage that signals a stronger dollar? It's always difficult to know, but one place to look for the answer

is the Obama administration's relative—and correct—quietude about imports from China that resembled the Clinton Treasury's approach to Japan. In the 1990s, this quietude signaled that the Clinton administration's support of a strong dollar was more than verbal, and it does the same today. While the Fed's role in the value of the dollar is once again overstated, the Obama administration's correct decision to not reappoint Ben Bernanke to a third term at the Fed could be taken as another positive signal to investors that a weak dollar is no longer part of the policy mix. Whatever the answer, it's the stronger dollar revealed through gold that has told the tale of lower oil prices, not a weaker OPEC, fracking innovations, or a still limping global economy. History is fairly clear here.

How does this brief discussion of oil-price history fit into a broader narrative about credit creation? The answer lies in the basic truth that the dollar, whether fixed to gold or floating, is always and everywhere a "ruler"—a measure of value.

Bartley, Brookes, and Reagan made basically the same point: that the price of oil in dollars tends to revert to one-tenth, one-twelfth, or one-fifteenth of an ounce of gold. This is important because, as Forbes noted in 2006, during the last period of dollar-price stability, whereby the greenback was defined as 1/35th of an ounce of gold, the price of oil hardly fluctuated. With gold stable in dollars, so was the price of oil stable in dollars.

Indeed, monetary economist Nathan Lewis has pointed out that from 1982 to 2000, "the dollar's value was crudely stable vs. gold around $350/oz."[17] What is interesting about the period he describes, one in which the global economy boomed, is that there were no notable advances in oil-extraction techniques. The low price of oil during the 1980s and 1990s meant there wasn't a lot of investment in oil extraction. As Zuckerman reported about the 1980s alone, "An estimated 90 percent of oil and gas companies went out of business and the bulk of the industry's petroleum engineers left to try their luck in more promising businesses."[18] It didn't matter. With the dollar strong and stable, oil was rather cheap in dollars, hitting a low of $10/barrel in 1998.[19]

Let's imagine for a moment that the Bush Treasury, in the 2000s, continued the Reagan/Clinton policies of dollar strength and stability. It's not a reach to say that, based on the ratios offered up by Bartley, Brookes, and Reagan, the price of oil would have settled somewhere in the range of $23 to $35 per barrel. To put a finer point on it, had Bush mimicked the

dollar policies of Reagan and Clinton, the American people would never have had to suffer the gasoline price shocks that were a function of the weak dollar.

Looked at through the prism of the fracking advances that unsurprisingly appeared during this period of intense dollar weakness, odds are we never hear of them. Legendary fracker Harold Hamm freely admitted to *Forbes*, "Rates of return get pretty minimal below fifty dollars. You wonder if we ought to be doing it or not."[20] As *USA Today*'s Rick Jervis noted in the fall of 2014, when the price of oil began to decline, the "break even" point in terms of profitable oil extraction was $40 per barrel in Pennsylvania's Marcellus region, $60 per barrel in the Eagle Ford region of Texas, and $70 per barrel in North Dakota's Bakken region.[21] Absent the weak dollar, heavy investment in oil extraction almost certainly never takes place. More to the point, oil's scarcity in the 2000s was wholly a monetary illusion.

Those who believe otherwise ignore voluminous oil-price history and simple business logic. How is it that entrepreneurs generally grow rich? Historically it's been because individuals figured out ways to mass market formerly obscure items through relentless price cutting. Silicon Valley is the richest region in the world, and a magnet for investment, not because the entrepreneurs who toil there strive to drive up prices but precisely because they excel at pushing them down.

Logic dictates that investment follows success. If the frackers had solved a supply problem, then a fall in the price of oil would have drawn even more investment to the oil patch. But when oil began to dive in 2014, and continued to fall in 2015, the opposite occurred. Oil field service giants like Baker Hughes and Schlumberger announced layoffs,[22] and bankruptcies for drillers like WBH Energy began to occur.[23] It's been popular to suggest that the frackers were *too successful*, that their skill at extracting oil put them out of business. But to believe this point of view is to consider oil a unique industry where its success is its downfall. Not likely. Oil was, once again, never scarce in the first place.

From a borrowing perspective, the fracking boom meant that oil and gas companies took on lots of debt. Since 2010, they have borrowed almost $200 billion alone.[24] Thanks to an oil-price illusion wrought by a weak dollar, the energy industry was a magnet for enormous amounts of economic resources, including labor. Simply put, the money illusion made the industry a magnet for credit.

The argument that the rush into energy represented credit destruction can be explained by the quote that begins the chapter. As Hazlitt pointed out in *Economics in One Lesson*, "In order that one industry might grow or come into existence, a hundred other industries would have to shrink." Put plainly, we can't do everything. The limits to credit are a function of how much the economy was producing. A weak dollar meant that a lot of credit found its way to a problem of "scarcity" that was a mirage.

Oil was already plentiful, yet the most advanced economic nation on earth devoted massive amounts of human and mechanical resources to extract what was only expensive insofar as the dollar was cheap. Worse, it represented a backward move economically. All that is required to understand the previous assertion is to list the OPEC member countries.

Its members include countries with primitive economies, such as Angola, Iran, and Nigeria. Is it any surprise that the U.S. oil renaissance occurred amid slow growth for the U.S. economy overall? The weak dollar that gave the U.S. energy industry its life authored a reorientation of credit into economic pursuits that are ably engaged in by countries as tragic as Venezuela, as corrupt as Russia, and as impoverished as Equatorial Guinea.

Oil is essential. It's the ultimate alternative fuel. But as evidenced by how many Third World countries extract it and sell it on the world market, it's no longer an advanced industry.

What is unknown is the exponentially greater output from U.S. industry (credit creation is about the creation of resources) that would have occurred had a weak dollar not sucked enormous resources into fixing what wasn't a problem. Production matters, because it is the source of credit. But sometimes, lousy monetary policy fosters the production of resources that are unnecessary, or already being provided by other economic actors.

Lest we forget, we're part of a global economy that is thankfully defined by an ever-growing division of labor. What this means is that we can increasingly focus on the kind of production that most animates our skills. Other less developed countries have engaged in the extraction of oil so that we in the U.S. (and other advanced countries as well) can pursue even higher value modes of production that will gift the economy with exponentially more credit.

We can extract oil stateside, but only if we want to mimic the undeveloped world. Our weak-dollar rush into oil extraction was an economy-

sapping pursuit. In short, during the 2000s major amounts of credit migrated toward the creation of the proverbial toaster.

The energy renaissance was a credit destroyer of the 1970s variety as always-limited resources migrated toward the production of that which was already plentiful and away from the credit-boosting economic advances that mark actual economic progress. To be blunt, in the 2000s, much like in the 1970s, the U.S. economy moved backward.

Conclusion: Sorry Keynesians and Supply-Siders, Government Is Always a Credit-Shrinking Tax

Credit given by dealers to unproductive consumers
is never an addition, but always a detriment,
to the sources of public wealth.
—John Stuart Mill, *Principles of Political Economy*, 483

IT IS PERHAPS difficult to imagine, given the sheer size of the old Soviet Union, not to mention the number of its inhabitants, but as recently as the year 2000 there were fewer paved roads in the entire country than in the state of Ohio alone.[1] This little known fact carries importance beyond illustrating how lousy life was under Communist, and even post-Communist, rule.

What is interesting here is that big-government apologists frequently tell us that thriving entrepreneurs and businesses utilize the roads and freeways created by politicians and governments. Absent these government creations, they say, the private sector would be a fraction of its abundant self.

But that's not true. Governments do not create roads, just as they didn't create a primitive and unmarketable version of the Internet. Those who work in government aren't uniquely gifted with a road-making skill that those of us who toil in the private sector lack.

More realistically, governments build roads with resources (credit) produced in and taxed away from the private sector. Governments plan and create roads with credit we produced in the private sector first.

In a country like the old Soviet Union, where private property was illegal, there logically wasn't much in the way of wealth creation. With no incentive to be productive, because the state controlled everything, the citizenry logically produced little. Substantial government barriers to production meant that the U.S.S.R. was largely bereft of credit. With the people having no incentive to produce, why would there be an incentive to seek credit?

For those who still believe that credit is money as opposed to real resources—that people work for dollars, yen, and euros, as opposed to what all three can command—they need only consider the former Soviet Union. It will relieve them of a false understanding of money and credit. Credit is always and everywhere real resources. When we borrow or work for dollars, it's resources (televisions, cars, labor, etc.) that we're seeking.

For evidence, we need only contemplate the hideous living conditions in the old Soviet Union. As Hedrick Smith pointed out in his endlessly interesting account of life there, *The Russians*, private savings increased "from 91 billion rubles ($127 billion) in 1975 to 165 billion ($231 billion) in 1981."[2]

Savings are surely brilliant, and society wouldn't advance at all without them. As Adam Smith correctly understood, savers are conferring a major benefit on society: "Capitals are increased by parsimony, and diminished by prodigality and misconduct."[3] There are no entrepreneurs without savings, and those who save are providing entrepreneurs with the resources to advance society economically.

However, people in the former Soviet Union weren't saving with a future rainy day in mind. In their case, they quite simply had nothing to buy. As Hedrick Smith described the Soviets, "They turn up their noses at the quality of Soviet goods and leave them piling up in stores, hoarding their money instead."[4]

So, with the state ruling the U.S.S.R. with an iron fist, there logically was minimal wealth being created, and thus there was limited wealth for politicians to tax away in order to build roads. Governments have no resources other than what they tax or borrow from the private economy. A nearly nonexistent private economy in the old Soviet Union meant that

resources weren't exactly plentiful for politicians to access with an eye on building roads. Additionally, the impoverished state of Soviet society meant that few people had cars in the first place.

What this story hopefully conveys is the backward and bankrupt state of the Keynesian school of economics. The disciples of John Maynard Keynes sincerely believe that government can spend us to prosperity.

But the government *can't*. Governments once again can spend only what they have taken from the private economy first, and they deploy those confiscated resources much less productively. This isn't speculation or ideology; it's fact.

Talented investors are not going to toil for the pay enjoyed by even the most on-the-take politicians. And the simple truth, as my chapter on Warren Buffett explained, is that for investors to be successful, they have to have failures. Much the same, they must stare failure in the face with every investment, so that they have an incentive to fix what's wrong with what they've committed capital to.

Private-sector investment is essential not because the private actors are always right but precisely because they're often wrong. In the private sector, investors eventually run out of patience and pull funding from that which makes no sense. Those economic resources are then redirected to better concepts. It is *because* private businesses face the real possibility of investors losing patience that they, as a necessity, seek to efficiently utilize resources allocated to them (thus freeing up credit for other private actors to utilize). Stated simply, private businesses strive to avoid being shut down.

With government, there's no incentive to do any of the above. In fact, the incentives driving government spending are the exact opposite. Government rewards failure. That's why Medicare costs hundreds of times more today than it did in 1965, despite its ongoing failure to achieve universal primary-care coverage for its alleged beneficiaries.

Think about something as basic as sugar. In 1934, the federal government decided to subsidize sugar production on what was supposedly a "temporary" basis. More than eighty years later, sugar is subsidized to the tune of $1.9 billion annually to the supposed benefit of roughly 4,500 sugar farmers. Windsor Mann aptly described all of this in *National Review*: "As often happens in Washington, 'temporary' came to mean 'forever.'"[5]

The problem is that "forever" in the real world generally speaks to stagnation. If "forever" were the norm in sports, then Brady Hoke would

still be coaching the Michigan Wolverines instead of Jim Harbaugh, and Mike Shula would still be leading Alabama's Crimson Tide onto the field each Saturday instead of Nick Saban. In Silicon Valley, forever would mean all of us would be logging into Friendster instead of Facebook. Absent failure, Silicon Valley would be destitute, and Alabama's football team would be terrible.

It doesn't matter who works in government. Government cannot spend or invest us to prosperity because there's nothing forcing government to shut down what doesn't work. Instead, what makes no sense—like a 5-7 football coach at Michigan—continues indefinitely.

The old Soviet Union was evidence of Keynesianism in the extreme, given that the state was the allocator of everything. The result was a society almost totally bereft of credit. Considering the state of the United States, and of other mixed economies, it's clear that our federal government has not yet figured out the right amount to spend in order to stimulate the economy. In truth, government spending is the *opposite of stimulation*. It is a tax on real resource creation, and that's why, in my chapter on supply-siders, I was so adamant that they must change their message with regard to the good of tax cuts.

Specifically, supply-siders must cease their excitement about tax cuts providing government with more revenues. They must, because promoting the revenue narrative unwittingly supports the fallacious Keynesian desire to grow the economy through spending.

Keynesians willingly admit their belief in government spending as stimulus, but as basic logic reveals, government spending (even on constitutionally necessary functions) is a tax on growth and credit creation because it is not subject to market discipline. The hearts of supply-siders are in the right place with regard to wanting a reduction in the tax prices placed on work and investment. But in designing tax cuts that shower the federal government with more revenues, they are imposing massive new taxes on the American people through spending programs (Medicare, sugar subsidies, TVA, etc.) that never end. Rising revenues from tax cuts neuter the genius of tax cuts by virtue of fostering an increase in the tax that is government spending.

Interestingly, members of the Austrian School of economics would likely agree with much of what I've already argued about government spending. Clear in their view that government spending is a tax, thus their nonalignment with the disciples of Keynes, many Austrians also

find fault with supply-siders. As Grove City College professor Mark Hendrickson put it, "Every dollar that the federal government spends is, in its fundamental identity, a tax."

In the same op-ed, written for RealClearMarkets.com in 2015, Hendrickson acknowledged that the supply-side movement, having been born in the 1970s and 1980s, was "a timely and much-needed alternative to the prevailing Keynesian orthodoxy that placed government in the role of trying to manage 'aggregate demand.'" Still, the "supply-siders failed us all by not making a case against leviathan government."[6]

Hendrickson's point is the one I'm making here. I perhaps take it further, by suggesting that supply-siders' cheering of government revenues has actually rendered them another leg of the Keynesian chair. Supply siders' veneration of rising government revenues wrought by economy-boosting tax cuts greatly expands the credit-destroying tax that is government itself. As one prominent member of the school once put it, "I love the smell of tax revenues in the morning. Smells like victory."[7]

Supply-siders are 100 percent right about the need to reduce the penalty placed on work that is taxation. But they are defeating their own case for growth when they design tax reductions that boost federal revenues. Once in Washington, politicians spend additional revenues to grow the tax that is government more and more.

What is interesting about all this is while Hendrickson and the Austrian School will likely agree with my critique of the Keynesian and Supply-side schools, they probably won't like my argument in Part Two on banking. Specifically, I'll make a case that modern Austrian theorizing about "excess" or "easy credit" from central banks or government is a Keynesian argument on par with the one supply-siders unwittingly make about cutting taxes to boost government revenues.

But before moving to the next section, I want to conclude the discussion of roads with which I began this chapter. The roads in the old Soviet Union were logically sparse and of poor quality because they were in a credit-starved (meaning resource-starved) country. Since the private sector creates the resources that governments utilize to build roads, it is only logical that a country like the United States (where private-sector actors are freer to create wealth) would have better, and exponentially more plentiful, roads, despite being a geographically smaller country.

So, with readers having hopefully accepted the simple truth, ignored by government apologists, about why we have roads, it's fair to say that if

governments did not build roads, we'd still have them. Politicians don't make our shoes, televisions, or cars, yet we have all three in abundance. Why do we? Who knows? That's the beauty of a free, market-based society. Entrepreneurs figure out what we need and even what we do not know we need, and they produce it for us. It is rather beautiful.

Why should roads be any different? Let's assume that governments refused to have any role in road construction. Can any reader say with a straight face that unpaved dirt paths would connect Los Angeles and San Francisco? Capitalism provides. It is a resource creator par excellence, and since we desire roads to drive on, and to transport goods on, capitalists would produce roads.

Now, here's where it gets interesting. What does capitalism do best? The answer should be easy at this point, particularly for those who read *Popular Economics*, but even those who've read only this book now know that capitalists grow rich by virtue of turning that which is obscure and expensive into that which is ubiquitous and cheap.

In that case, consider a 2015 study conducted by Texas A&M's Transportation Institute. It found that commuters in Washington, D.C., Los Angeles, San Francisco, and New York suffer an average of 79.5 hours per year of rush-hour traffic congestion.[8] Let's face it, time spent in traffic is expensive not only in terms of hours missed working but also in terms of time lost that could have been spent with family members or on leisure activities.

What does capitalism do best beyond turning scarcity into abundance? It removes unease from life. What if governments got out of road building altogether? Logic dictates that the traffic gridlock we despise would soon enough disappear as entrepreneurs set about experimenting with ways to design roads and road usage to erase the scourge that is traffic. Oh, well, one can dream.

Until then, readers will see that credit is not money but actual resources. Those resources are created in the private sector exclusively, and that's why economically free societies almost as a rule have credit in abundance. They are rich in credit because private actors, disciplined by the profit motive, are actively producing what the markets desire. Those businesses that don't satisfy market demands are starved of the resources they're attempting to deploy so that someone more skilled can replace them.

Government cannot create credit, but it can destroy it, as the descriptions of government spending reveal. Since governments aren't disciplined

by profit and loss, the bigger they are the less credit there is in the economy, because governments can't possibly utilize resources effectively. Simply put, plentiful credit is a function of bad ideas dying, but with government the latter is exceedingly rare.

As I will discuss in Parts Two and Three, neither governments nor central banks can create credit. They can't even render it easy, as the chapters on coaches, Hollywood, Silicon Valley, and Wall Street explain. But they can make the credit created by the private sector easier for some (while greatly shrinking the total amount accessible to all), and that's dangerous, as Part One has shown and Parts Two and Three will continue to reveal.

PART TWO
BANKING

NetJets Doesn't Multiply Airplanes, and Banks Don't Multiply Money and Credit

Banks borrow money in order to lend it.
—Ludwig von Mises, *The Theory of Money and Credit*, 295

IT'S ALWAYS EXCITING to remind readers that the best way to understand how we'll all live in the future is by observing how the rich live today. Arguably one of the more desirable luxuries the rich enjoy to the exclusion of the rest of us is access to private flight. This is particularly true in the age of the TSA.

What's exciting is that we don't have to worry about how private flight will be turned into a common good; we can just wait for entrepreneurs to deliver it. Odds are the wait won't be a long one. And with more and more talk about the promise of self-driving cars, can self-flying jets be too far off?

There are many arguments for reducing government meddling in the economy and the allocation of credit, but private flight is perhaps one of the more visibly appealing of them. If government is consuming less of the economy's resources, then entrepreneurs will have more credit to access and utilize in their attempts to turn the luxury that is private flight into a common good.

Arguably, the best-known provider of private air transportation is Net-Jets. Based in Columbus, Ohio, and owned by Warren Buffett's Berkshire Hathaway holding company, NetJets sells fractional ownership of the jets in its fleet of seven hundred planes.

The benefits to the customer are fairly apparent. Whether they buy fifty hours of flight time per year or four hundred, they have guaranteed access to the plane they've purchased a fraction of with little notice required. Obviously, the bigger the fraction they buy, the more annual flight time they have. NetJets oversees the maintenance of each plane, makes sure the pilots are well-trained and licensed, and houses the planes. All of this means that fractional owners don't have to take on all the expensive busy work that comes with traditional jet ownership.

But as the word "fractional" reveals, the owners don't own 100 percent of these jets. There are others with claims on the same plane, and they also have guaranteed access to it on short notice. This raises an obvious question: What happens if there's a run on a specific NetJets plane?

NetJets has more than seven hundred planes in its fleet and keeps adding to that number. If the jet partially owned by a customer is in use, the NetJets rule is they offer their customers another aircraft that is the same or similar to the one the customer partially owns, or, for that matter, a larger one in their fleet that's not being used.

What if there's a rush on all the planes in the NetJets' fleet at the same time? If so, just as hotels have overflow deals with other local hotels, so can NetJets access private air transportation outside its fleet for its well-heeled customer base. It's neither the only owner of high-end aircraft nor the sole fractional-ownership jet company.

What needs to be stressed is that despite multiple-person ownership of its planes, NetJets isn't multiplying them. Even though NetJets has many multiples of seven hundred plane owners with guaranteed access at quick notice to the roughly seven hundred planes it its fleet, NetJets is not playing a trick on its customers.

Without presuming to do its complicated math for it, I wager that NetJets understands probabilities. While all of its owners have guaranteed access to private flight in a timely manner, the company is well aware that they're not all going to need to fly at once.

Something similar is at work in banking. Banks pay for deposits (liabilities) and then almost immediately create loans (assets) with the money they borrow from depositors. Banks are not warehouses for cash, and if they were then it's certainly true that depositors would *pay them* for the privilege of watching their money.

Instead, banks borrow money from depositors at an agreed rate of interest. They're able to pay that rate by virtue of lending the money

deposited to a borrower at a higher rate of interest. Importantly, and this repetition is by design, per the Austrian School's Ludwig von Mises in his brilliant *The Theory of Money and Credit*, "He who tries to borrow 'money' needs it solely for procuring other economic goods."[1]

It can't be repeated enough that we do not seek credit so that we can stare lovingly at dollars. We borrow dollars for what they procure. Stated otherwise, it's the consumption and capital goods that dollars can be exchanged for that we're borrowing. Credit is just a name for real economic resources. That's why credit is plentiful where production is plentiful, and it's near nonexistent where there's no incentive to produce.

Much like the fractional owners of NetJets' planes are guaranteed quick access to them, bank depositors are generally free to withdraw all the money they have deposited at any time. Yet at the same time, banks are actively and almost immediately lending out the funds deposited with them. Banks can't pay to stare at or warehouse dollars—they would quickly go out of business or be acquired—so logically they lend them.

Yet, depositors can once again walk in and demand all or part of what they've deposited at any given time. What's happening here?

Banks understand probabilities in the way that NetJets does. They know the odds are slim that all of their customers will demand their money at once, so they lend the majority of funds deposited to others who have near-term uses for what the borrowed dollars can procure. Also, assuming a rush of depositors comes to withdraw the monies deposited all at once, banks, like NetJets, can access other sources of credit. Not only are loans they've previously made constantly being paid off, banks can also borrow from other institutions (including other banks) that have a near-term excess of cash in their vaults just as NetJets can borrow the use of planes outside of its fleet. There's nothing mystifying about this. Banks borrow from one another all the time. The interest rate set by the Fed—the funds rate—is the rate at which banks lend to one another.

But the main point is that well-run banks, with good assets on their books, needn't worry about an unexpected rush of withdrawals, given the wide range of institutions looking to make short-term loans to them. Well-run banks have widespread access to credit, and of great importance, they *never* go out of business owing to a lack of money. With good assets, they can always borrow money if for some reason depositors come in all at once to withdraw the funds they have deposited.

For the purposes of simplicity, let's say banks generally keep 10 percent

of the monies deposited on hand, while the other 90 percent becomes assets, as in the money deposited has left the bank altogether in the form of loans. Remember, banks are paying depositors (including you and me) for our own access to credit. To stay in business, a bank must find a borrower who desires access to the economy's resources, and who will pay a higher rate of interest for the access than the bank is paying depositors. The "spread" between the two rates is the profit for the bank.

What the above first indicates is the embarrassingly incorrect nature of the Keynesian view that savings are economically harmful since savers allegedly aren't consumers. In fact, their production *is* their consumption. The act of saving merely shifts the saver's ability to consume to someone who will pay for the privilege to move up his consumption, or for that matter, his creation of a new business. Since banks can keep the lights on only insofar as they lend out the deposits they take in, money saved is money that is immediately lent. One man's saving of $10,000 is another man's borrowing of $10,000 in order to buy clothes, a car, or maybe capital goods like office space to start a business. The act of saving never subtracts from demand, despite what is said in economics textbooks.

Of course, all of this reminds us why the political act of wealth redistribution is so destructive to credit creation and real economic growth. Whether it's the small-time saver making a $10,000 deposit, or Taylor Swift depositing tens of millions in various accounts, money saved in the private economy is money lent. The difference is that politicians use our wealth to perpetuate what is wasteful and thus bad for the real economy, while private credit sources must lend with an eye on being repaid.

Of course, not all private loans are well thought out, or paid back. But lousy private lenders, like misguided businesses, are eventually shut down. The highly unfortunate bailouts of poorly run banks in 2008 will be discussed in a future chapter. Fear not.

For now, what must be understood is that banks, per von Mises, "borrow money in order to lend it." That's why we call them banks, and not cash warehouses.

Yet here's where it gets complicated. Over the years, certain economic thinkers have demonized the "fractional lending" just described. They say the process whereby banks lend out the majority of funds entrusted to them is fraudulent, that it multiplies money in a destructive, inflationary fashion. Perhaps surprising is that members of the free-market Austrian school are the biggest critics of banks lending out the majority of deposits

they take in. As the late Murray Rothbard, a true-blue Austrian, long ago put it, "Fractional reserve banks . . . create money out of thin air. Essentially they do it in the same way as counterfeiters."[2]

Underlying Rothbard's assertion is a fanciful belief that the alleged "money multiplier" is fact. It's fiction. Wise minds quickly understand that there's no such thing as a "money multiplier." Bank A cannot take in $1,000,000 and lend out $900,000 to an individual who deposits at Bank B, which then lends out $810,000 to an individual who deposits at Bank C, only for Bank C to lend out $729,000 such that $1 million in deposits miraculously turns into nearly $2.5 million.

In truth, just as there are no sellers without buyers, there are no borrowers without savers. The whole notion of a money multiplier is rendered moot by its own illogic. $1 million doesn't multiply into $10 million if it changes hands enough times. Someone can borrow only if someone else is willing to cease using money in the near term. That such an absurd notion has transfixed some of the bright minds in the largely brilliant Austrian School is one of life's great mysteries. So while banks doubtless commit all manner of errors—capitalism after all is about both failure and success—the fact that they lend out the funds put in their care does not make them counterfeiters.

To develop a better understanding of why this is much ado about nothing, sit at a table with four friends. Ask one of them to bring $100. Have this person lend $90 to his table neighbor, who then lends $81 to his neighbor, who lends $72.90 to his neighbor. What you'll soon discover is that there's still $100 sitting at the table after all the frenzied lending. Nothing changes; likewise, there's nothing magical about banks.

Naysayers argue that banks can borrow from the Fed. Well, for one, banks go to great lengths *not* to borrow from the Fed, but that's really of no consequence. Businesses that aren't banks borrow dollars from each other all the time; they deposit those dollars, but they're not being multiplied. For someone to lend that someone or business must give up, at least in the near term, the resource access that those dollars represent.

If readers still aren't convinced of the absurdity that is the "money multiplier," they should recreate the above table scenario, only *without* the 10-percent reserve cushion that each individual in the previous example is abiding by, and that banks roughly abide by. This is how my great friend Hall McAdams (Hall owned Union Bank of Arkansas, which was purchased by what became Bank of America in the early 1990s) likes to

explain it to those who have bought into the myth. Let's say the owner of the $100 lends $100 to his neighbor, who lends $100 to his neighbor, and so on. If we are to believe the "money multiplier" mysticism, we'd have to believe that $100 magically turned into $400 within seconds. Applied to a bank, or any business for that matter, the money multiplier without any kind of reserve requirement would quickly turn the smallest amount into trillions of dollars, or better yet, infinity money! Except it wouldn't. Money doesn't multiply by being lent.

Remember, it's not dollars that are borrowed but the real economic resources that dollars are exchangeable for. If banks were truly multiplying money in the way their critics suggest, then logically most borrowers would get nothing in return for their dollars. Credit is real resources, and real resources are finite. To presume that banks, for lending out the dollars deposited with them, are in fact multiplying them is tantamount to believing that most people borrow dollars only to stare at them lovingly with no expectation of getting something in return. Such a presumption defies logic. The "money multiplier" is an unfortunate myth that is sadly promoted by one of the great schools (Austrian) of economic thought.

What makes this all the more puzzling is that one of the fathers of the Austrian school, Ludwig von Mises, was quite clear about why people borrow money: "He who tries to borrow 'money' needs it solely for procuring other economic goods."[3] It's worth reiterating that no sane person borrows money to hold dollars or marvel at their crispness. When we borrow money it's because we have a near-term use for the capital goods that money can secure for us.

Even if banks, working closely with the Fed, were truly multiplying dollars, those dollars would quickly disappear from the market because they would have no exchangeable value. If this is doubted, consider the most famous instance of supposed "money multiplication" in history: Germany's post–WWI hyperinflation. It's popular for the historically minded to talk about severely devalued Deutsche marks (the mark declined to 4.2 billionth of a dollar) being pushed around in wheelbarrows. In fact, the collapsed mark was rather scarce, and with good reason.

Indeed, what correct-thinking producer would engage in productive labor only to receive in return a currency that was diving in value, and as such had little exchangeable value (remember the purpose of money: it's a facilitator of the exchange of real wealth)? It turns out German producers weren't terribly eager to use the mark with the latter in mind. As Adam

Fergusson explained it in his 1975 book about Germany's hyperinflation, *When Money Dies,*

> At home in Germany, where people were resorting to trade by barter and *progressively turning to foreign currencies as the only reliable medium of exchange,* new Orders were brought in relating to the purchase of foreign bills and the use of *foreign exchange* to settle inland payments.[4]

Amid the hyperinflation a young Ernest Hemingway was working for the *Toronto Daily Star* in France. One day he crossed into Germany with his wife, along with ten French francs. He too found the supposedly plentiful marks increasingly scarce. Once again, *logically.* Horrid, severely devalued money serves no economic purpose. Yet Hemingway's francs, worth .90 cents in Canadian money, funded a full day's activities.[5]

Perhaps most interesting was Fergusson's account of German citizen Hans-George von der Osten's experience with a U.S. dollar in Berlin. It reveals the extent of Germany's hyperinflation while ably exploding the myth that devalued money is plentiful and that producers actively use for exchange what is worthless:

> Those with foreign currency, *becoming easily the most acceptable paper medium,* had the greatest scope for finding bargains. The power of the dollar, in particular, far exceeded its nominal rate of exchange. Finding himself with a single dollar bill early in 1923, von der Osten got hold of six friends and went to Berlin one evening determined to blow the lot; but early the next morning, long after dinner, and many nightclubs later, they still had change in their pockets. There were stories of Americans in the greatest difficulties in Berlin because no-one had enough Marks to change a five-dollar bill."[6]

Without defending the U.S. Treasury's modern oversight of the dollar for even a second, if the dollar were truly being multiplied in hyperinflationary fashion, as bank critics believe it is, it would have no exchangeable value. It would have long ago disappeared as a measure in the way the mark did in the 1920s. That the dollar remains the world's currency is a signal that its economy-weakening destruction, which has occurred thanks to post-1971 instability, has not been as horrid as broadly stated by what we'll call "modern" Austrians. Money that is mostly good is heavily

in supply where production is taking place. As Ludwig von Mises himself put it, "What is usually called plentifulness of money and scarcity of money is really plentifulness of capital and scarcity of capital."[7] Those are wise words from a very wise man.

Following chapters will discuss this fact in greater detail, but it suffices to say that money flows to production. Money that is allegedly "multiplied" by a banking system would quickly have no value. It would be nowhere near production, simply because those who produce would not exchange the fruits of their labor for that which has no value.

Austrians may well reply that what I've just described has already happened, that the dollar has been multiplied into a fraction of its 1913 value. Logic dictates that they've mistaken cause for effect. For one, if the "money multiplier" were real, then it's certainly true that the dollar would be worth exponentially less than it is now.

Second, what we call "money" would not be plentiful in Beverly Hills, Greenwich, Manhattan, and Silicon Valley, where some of the most economically productive people in the United States and the world live. They wouldn't exchange all of their commercial brilliance for dollars being rapidly destroyed by banks. This isn't so much to excuse the dollar's periodic weakness since it was robbed of its definition by President Nixon in 1971 as it is to say that the modern Austrian attempt to correlate what is a mirage—the "money multiplier"—with inflation is flawed.

We exchange our labor for money, because money is broadly accepted as a medium of exchange. By extension, money secures consumption and capital items, which explains why we borrow it. Its weakness and instability in modern times is a horrid truth that has deprived money of its singular function as a measure meant to facilitate exchange. But this instability can't be blamed on the banking system. If banks were truly the agent of hyperinflation, or "counterfeiters" as Rothbard and other modern Austrians assert, they wouldn't be found where the rich congregate. Rich people generally didn't become that way by being stupid about money. So, if the lending of money were truly a way to multiply it into worthlessness, then the rich wouldn't have so much money in the first place. They would have long since measured their wealth in terms of something different. Money would be what poor people possess.

Yet, the story doesn't end there. As the previous chapter made plain, the brilliant Austrian School's modern adherents, while reverential toward supply-side economics (as am I), point out the obvious inconsistency in the

supply-side argument. Although reductions in the tax rate are always a good thing, the supply-siders have erred mightily for not loudly making the case for constantly reducing the size and scope of government.

Instead, supply-siders have almost made a pact with the Keynesian left by somewhat implicitly saying, "If you let us cut taxes, we'll give you more government revenues to spend." To be clear yet again, the goal should always be to reduce the direct tax burden. However, the supply-siders neutered the genius of their approach by not focusing on reducing government spending, too. Government spending is a tax that the economy suffers immediately by virtue of politicians allocating resources over the free marketplace.

What this hopefully reveals to readers is that Austrian thinkers have a real problem with the Keynesian ideology, and they do for the same reason that some feel the supply-siders blew it. While supply-siders said little as the size and cost of government grew, the Keynesians actively seek to increase government spending based on their view that it's stimulative. Austrians correctly know that this view is false.

Governments have no resources other than what they've taken from the private sector first. So when governments spend, the economy is naturally weakened. Indeed, it's comical to hear those focused on budget deficits decry the massive burden we're leaving to our grandchildren. All government spending should be viewed as deficit spending (even that which is constitutional) simply because governments are consuming what they've extracted from the private sector first. More to the point, government spending is what we suffer in the here and now.

The burden left to our grandchildren isn't budget deficits but a much less evolved economy. Government consumes credit that would otherwise flow to cancer cures, transportation innovations like private jets, and technological innovations that would make the Internet seem quaint. Deficits are just finance, another way of government arrogantly presuming to allocate finite resources first created in the private sector. The lack of market discipline wrought by failure means government spending is doomed to economy-sapping waste. Goodness, our federal government will always be able to "deficit" spend, because it can borrow on the real credit of the most productive people on earth. Deficits miss the economy-sapping, and freedom-sapping, government-spending point.

Austrians know this very well. Intimately even. Austrians have been some of the biggest critics of Keynesians for believing the fantasy that

government spending is stimulative. By extension, Austrians find fault with supply-siders for not doing more to limit the massive tax that is government itself. They know that government spending cannot grow the economy.

Yet that's what is so puzzling about the Austrians when it comes to credit. Credit is real economic resources—ships, cars, computers, desks, workers, and so on. Austrians know well that government spending, which is merely government allocation of ships, cars, computers, desks, and workers, is not the source of even a short-term economic boom. It's an immediate tax on production and on the subsequent creation of real economic resources. It's anti the very information that the great George Gilder (not an Austrian) correctly says is necessary for economic growth, because government spending goes on forever without regard to its effect.

Austrians know all this, yet in more modern times, and in a surprising way, they've become another leg of an increasingly sturdy Keynesian chair. As they see it, periods of booming economic growth, such as the Roaring Twenties, were the result of "government policies" that "ballooned the quantity of money and credit."[8] Ron Paul, arguably the most famous politician associated with this great school of thought, believes much the same thing: real production does not cause economic booms as much as "low reserve requirements actually enable banks to create trillions of dollars of credit out of thin air" that leads to an economic boom phase that can last many years.[9] Writing on LewRockwell.com, a website that promotes Austrian thought, contributor Eric Margolis attributed a transformative building boom in China to "a sea of credit . . . created by the [Communist] Party's banking system."[10]

Implicit in Margolis's reasoning is that the former Soviet Union was impoverished and an utter failure simply because its Communists didn't do as China's did and create a "sea of credit." As for Ron Paul's passage, along with the one from the Foundation for Economic Education's *Excuse Me, Professor*, about the Roaring Twenties, fairly explicit in their arguments is that money is credit. But it's not. When we borrow money we're again borrowing real resources, per the most famous Austrian of all, Ludwig von Mises.

Worse, the unreason exhibited by Paul suggests that Say's Law—whereby production is the source of demand—is a myth. He's fairly explicitly saying that governments can create credit and demand—meaning resources—out of thin air, much as Keynesians say governments can con-

jure demand out of thin air. This is incorrect. All governments can do is shrink economic resources by virtue of trying to manage their allocation.

Of course, that's the most disturbing thing of all about the modern Austrian view of credit and credit's alleged role in booms: Austrians know well that government spending can't author economic booms, yet they're making a slight variation of the Keynesian argument in attributing decades like the 1920s to government issuing "excess credit." Just as government spending represents the opposite of a boom, so must government allocation of credit. As for "excess," that notion is impossible per Say's Law. Credit *is* economic resources. There can never be a scenario where the economy produces "excess" resources. Certainly government can't create the "excess." Fairly explicit in the Austrian argument is that wealth lays idle and that absent the Fed's supposed creation of "excess credit," resources created in the economy would lay idle. That is quite simply nonsensical. Producers don't produce for no reason, and government entities certainly once again can't themselves create the alleged "excess." We know this because government can't wave a magic wand and create resources by command. See the former Soviet Union.

Perhaps even more interesting about the Austrian critique of the Fed in the 1920s, and the strange supposition that it was the cause of the Roaring Twenties boom, is that in isolation, the Fed was "tight." This isn't to say that credit created in the real economy sat idle thanks to the Fed, but it is to say that the Fed itself, worried in Austrian fashion about too much credit creation, actually attempted to slam on the brakes. As economic historian Benn Steil recalls about the 1920s Fed in *The Battle of Bretton Woods* (2013), a history of the steps that led to the post–WWII gold standard:

> Unlike the Bank of England in the late nineteenth century, the U.S. Federal Reserve of the 1920s simply did not follow the cardinal rule of the gold standard—that is, to expand credit conditions when gold flowed in, and contract them when gold flowed out. It frequently did the opposite.[11]

The availability of credit in an economy is a function of production in same, and investor excitement about production in same. The United States experienced abundant credit conditions in the 1920s *precisely because* its people were acting in productive fashion, not because the Fed was magically able to create resources for them to access out of thin air.

The modern Austrians mistake cause and effect. And that's what makes Margolis's argument about China so puzzling. As Robyn Meredith wrote in *The Elephant and the Dragon* (2007), "In 1978, Shanghai had just 15 skyscrapers. By 2006, there were 3,780 and counting, more than Chicago and Los Angeles combined."[12] To visit Shanghai today is to know that the number cited by Meredith is quite dated. Shanghai's skyline continues to grow in amazing fashion.

Yet, Margolis wants to attribute this growth to "a sea of credit" created by the Communist Party of China? Has the State suddenly become expert at allocating credit on the way to immense prosperity and shimmering skylines? If so, shouldn't destitute countries such as Haiti, Peru, and Zimbabwe try to emulate the Chinese government's creation of "a sea of credit"? Wouldn't it be nice? Even if illusory, as some want us to believe, wouldn't the China of today trump the destitution of Haiti by many miles?

What Margolis misses is that the Communist Party of China has a "sea of credit" to create only insofar as China's booming private sector has created it—and become a magnet for it globally—in the first place. In an odd lurch toward Keynesianism, modern Austrians seem to be saying that governments can create credit in such abundance that decades-long (China) and years-long (Roaring Twenties) booms are the result. But once again, they can't. Credit is real resources, and governments not only have no resources but also can't issue them or create them out of thin air.

Undoubtedly, governments can allocate resources. However, the act of doing so would logically be, per the Austrian school, *the opposite of stimulative*. Looking at China since its embrace of markets, which has truly transformed the country, to the extent the Communist Party has played "credit fairy," it has logically *reduced* the amount of credit in the country, not expanded it, as some Austrians presume.

While the Keynesians are up front about their belief that governments can expand the economic pie through excess spending, Austrians increasingly argue that governments can do something similar, through the issuance of "excess" credit. Quite simply, they can't. Just as governments can spend only what they've taken from us first, similarly they can issue credit—meaning real resources—only that they've taken from us first. Whether it is by the government or the Fed, any attempt to boost credit amounts to its shrinkage, thanks to its *mis-allocation*, not its expansion. And it's anti economic growth, not the source of booms, as some Austrians think.

Good Businesses Never Run Out of Money, and Neither Do Well-Run Banks

Businesses, like people, seldom if ever fail solely
because of a lack of money.
—Warren Brookes, *The Economy in Mind*, 172

IN JULY 2015, global Internet retail giant Amazon.com announced a profitable quarter. It registered a $92 million profit on $23.18 billion in sales.[1]

What is notable about the announcement is that since opening its doors in 1994, Amazon has regularly reported losses. Indeed, in its early days, in the midst of the first technology boom of the late 1990s, sarcastic commentators took to calling the company Amazon.org.

But, despite frequent quarterly losses, Amazon can claim a market capitalization of $296 billion.[2] And even though it regularly loses money, its patient investors have in no way pulled their funding.

Amazon founder Jeff Bezos is engaged in constant experimentation. He employs thousands in what is called Lab126 who are charged with devising ways to improve the Amazon customer experience.[3] Many experiments fail, such as the Amazon Fire mobile phone that proved undesirable to its massive customer base. Yet, investors have not lost faith in the Seattle-based company, as evidenced by its rich valuation.

In *Zero to One*, billionaire investor Peter Thiel noted, "The value of a business today is the sum of all the money it will make in the future."[4] Amazon carries a high valuation today because investors see all the

experimentation in the present, not to mention Amazon's willingness to lose money in the present, as positioning the retail innovator for a grand future of abundant earnings.

While things could change, Amazon, despite its earnings record, will not run out of money. Investors presently line up to fund Amazon's commercial advances, based on their optimistic view of the company's long-term potential. Investors appreciate Bezos's vision, but if they ever decide he is moving in the wrong direction, his ability to access credit will plummet.

Still, it will never be a lack of money that fells Amazon. Only a lousy strategy will take it down.

Why feature Amazon in a chapter on banking? Because similarly banks never simply run out of money. Lack of investor patience is what causes them to file for bankruptcy, or to be swallowed by competitors.

Of course, that's why the ideal banking scenario is one without requirements to keep 10, 5, or 3 percent of deposits in reserve, assuming a rush of depositors. Banks shouldn't face any reserve requirements because well-run banks don't need them.

If NetJets experiences a situation where more jet owners want to fly on their jets than it has available, NetJets can easily borrow access from other commercial entities (including plane manufacturers themselves) with an excess of planes. So can banks borrow excess cash from other banks, assuming their depositors come in en masse to take out some or all of their money.

Those who borrow from banks are constantly paying down loans they've taken out, but of greater importance is the fact that the deposits (liabilities) that banks turn into interest-paying loans are their assets. When a bank experiences a near-term cash shortage, it isn't necessarily insolvent or bankrupt. If well operated, the bank that is short on cash can show its assets (collateral) to other banks, or for that matter to any kind of business, and subsequently borrow from them in the near term to honor all customer withdrawals.

Banks aren't the only businesses that do this. Any business has rent to pay, bills related to equipment required to operate, and payroll, too. Businesses regularly seek financing for their daily operations, because sometimes the payments to them for services rendered don't arrive in concert with their bills. As a result, businesses borrow from financial

entities to finance daily operations, and their collateral is the invoices (assets) on their books.

All this is worth discussing, because one solution for the banking system's troubles in 2008 was to require banks to hold more cash in reserve. On its face, this is not terribly objectionable. If banks are known to be flush with cash, odds are they'll have less trouble working their way out of financial difficulty, assuming another 2008, whereby a lot of their loans go south. Given a second glance, however, the idea seems unwise.

For the sake of discussion, let's assume a standard 20-percent reserve requirement on funds deposited for all banks. It's easy to see how such a rule would weaken banks overall.

First, banks are not receiving deposits for free. They're paying for them. So, if they can't lend out a percentage of deposits at a higher rate of interest, then their profits will be shrunk by the regulation itself.

This is important, because profits are what attract talented people in the first place. Profits are what determine income, the value of equity options, and bonuses. If regulations reduce them, so will they reduce the quality of talent that migrates to banking.

At present, some of the world's brightest minds are taking their talents to Silicon Valley. The passion to innovate certainly factors into this decision, but the potential to achieve staggering wealth can't be minimized as a major driver of this modern gold rush. What is notable here is that the frequency of failure in Silicon Valley also means the sky is the limit in terms of potential wealth gains.

For the sake of comparison, consider Detroit. It was the Silicon Valley of the first half of the twentieth century, based on how failure was the norm. That its carmakers now largely owe their existence to government is a signal that not a lot of staggering wealth is being created there. "Government Motors" is the sad reality that speaks to a lack of upside. Hence, talented people generally aren't moving to Detroit. Applied to banks, rules meant to limit profitable activity will have a negative impact from a human capital perspective.

So while bank failure is not what caused the financial crisis—banks have been failing for centuries, and this is healthy—simple logic tells us that driving the skilled away from banks won't enhance their ability to compete, thrive, and survive. You'll just have lesser-skilled financial minds making and approving loans.

It also can't be forgotten that banks have shareholders to please. Assuming limits on their ability to profitably loan out customer deposits, this will repel the very investors who bring with them not just capital but also expertise in the area of running a business well. Investors have many choices about where to invest, and stodgy banks limited by government will surely lack appeal.

All of which brings us to the globalization of the dollar itself. As the *Wall Street Journal's* Craig Karmin pointed out in his 2008 book, *Biography of the Dollar*, "about two-thirds are held abroad."[5] What this should tell us is that the ability of U.S. banks to pay a competitive rate of interest on deposits is a natural function of their ability to profitably loan the dollars deposited. If U.S. banks are limited in this regard, then financial institutions that are not hindered by reserve requirements will become more attractive than banks, as will non-U.S. banks. Put simply, they'll be able to offer higher rates of interest to potential depositors.

About this, readers shouldn't fear too much. While it's true that two-thirds of dollars have a foreign address, it's in the United States where the dollar is most accepted as a medium of exchange. Assuming a scenario whereby overregulated U.S. banks were no longer competitive for deposits, this in no way would mean that the entities (domestic and foreign) that fill in for them would suddenly shift their lending outside the United States. What it would mean is that any presumed limits on the ability of U.S. banks to pursue profits would ultimately weaken them. Depositors, like investors, have options.

The perhaps understandable argument is that in the aftermath of 2008, banks need to be more careful with how they lend; abundant reserves are a way to limit their intrepid nature. But this logic is backward.

Implicit in such a view is that failure is bad. Wrong. Failure is a virtue of capitalism. Failure is a feature. It simply means that poorly run banks will be exposed much more quickly and acquired by better banking institutions. Failure signals a positive evolution. Banking will suffer from any attempts to limit failure.

Any attempt to foist one-size-fits-all rules on banks presumes that all banks are equal. But they're not, just as Mark Sanchez isn't equal to Tom Brady. Free markets should apply to banking just as they do to any other industry sector. That means it is best to expose the average as quickly as possible so that the more talented can acquire what is being underutilized.

Another understandable reply to the argument that banks should not

labor under reserve limits is that the deposits within them are federally insured. Banks must operate within federal constraints, because the taxpayer is on the hook for their inevitable failures. Such an argument adds insult to the injury of reserve requirements.

If regulators are worried about bank failure, what they're actually worried about is talentless bankers committing big blunders with the money of others. Yet that's exactly why there should be no reserve requirements. The lack of restraints on banking activities will serve as a lure to talented lenders who see the potential for large incomes. But if profits are limited by regulatory fiat, what regulators fear will stare them in the face: the best financial minds will leave banking. The replacements will invariably lack their predecessors' skills.

As for federal deposit insurance, the insurance itself is the problem. To see why, readers need only ask themselves how much due diligence they conduct on banks before depositing with them. Odds are very little. Why bother? The deposit is insured. Citibank is regularly in trouble; a former Fed official told this writer that it's been bailed out five times in the last twenty-five years. But have its depositors ever suffered the bank's incompetence? Obviously not. The "moral hazard" is we!

In that case, an ideal world would have neither government-dictated reserve requirements nor the FDIC. Just as insurance companies insure against all manner of other calamities, so will they insure bank deposits.

For banks with a reputation for sound lending practices, the cost of insuring one's account would be rather small. It would reflect the insurer's confidence in the bank. For newer banks with less of a lending history, the cost of private deposit insurance would be greater, but the interest paid to the depositor would be more; the latter a reflection of the bank's lack of a track record. As for poorly run banks, expensive insurance on deposits would represent a market signal that its executives aren't trusted by the markets, and the bank would become a target for a takeover by a better-run financial institution.

As opposed to government-backed deposits largely bereft of market discipline, insurance on deposits would reflect the marketplace itself. Insurance companies aren't in business to lose money, which tells us they would skillfully regulate the banks. Indeed, most bank examiners don't rate jobs at the banks they presume to regulate. As Dick Flamson, longtime CEO of Security Pacific Bank, once said about bank regulators, "If they were any good they'd have real jobs, and not just be regulators."[6]

Removing limits on lending, along with abolishing the FDIC, would redound to banking. Of greater importance, it would redound to the overall economy. Lest we forget, banks lend not money but access to real economic resources. To ensure the best possible economic outcome, it's ideal to have the sharpest financial minds allocating access to the economy's resources. That won't be the case so long as barriers to profit in the banking industry repel the talented.

Others, like Hoover Institution scholar John Cochrane, argue for higher bank capital requirements. In this case, rather than keeping a greater percentage of customer deposits on hand, banks would issue more shares in order to raise money. Notable here is that they wouldn't use the funds to expand their footprint, acquire talent and/or competitors, or enhance the customer experience; instead the funds raised would be invested in highly liquid, largely risk-free securities (think U.S. Treasuries) so that the money could be accessed amid a "crisis" or "bank run." Banks would have a "cushion."

The problems with this idea are many, however. For one, the capital raise would dilute existing shareholders owing to the issuance of new shares, all the while doing nothing to enhance the bank itself. Remember, capital would be raised solely as a cushion to be accessed in an emergency when credit is "tight."

Similarly, with shareholders in mind, capital is expensive. This would again be a dilution without any tangible positives. One positive to some would be the capital cushion to help a bank weather troubled times, but again, well-run banks would never need such a cushion in the first place. Lest we forget, most banks in 2008 were fully healthy and not in need of bailout funds. Capital requirements are superfluous.

Lastly, we can't forget the global nature of finance. Impositions like this placed on banks would and will render them less competitive relative to domestic and international competition that is similarly in search of deposits.

Still others have called for a reintroduction of Glass-Steagall, the Great Depression–era law that split up the activities of banks and investment banks. In modern times the lines between the two activities—lending and investing—have increasingly blurred. But the argument in favor of Glass-Steagall similarly fails.

For one, consider shareholders yet again. Global financial institutions not based in the United States have "banks" that offer traditional banking

and investment banking services. Just the same, U.S. banks have historically offered both outside of the United States. All Glass-Steagall's erosion meant was that U.S. banks were for the most part doing domestically what they'd long done outside of the United States.

And then there's the question of talent. As evidenced by the high pay offered at investment banks, they have at least historically attracted bright financial minds. Why, then, would regulations be written to keep top financial minds from toiling at banks? How would that render them sounder financial institutions?

Lastly, Glass-Steagall's revived popularity is rooted in the idea that its erasure at the end of the twentieth century led to 2008. The obvious problem there is that it was exposure to housing and housing loans (activities already long associated with banks) that got banks into trouble to begin with. Second, it was the hybrid bank/investment banks operating post Glass-Steagall fashion (think J. P. Morgan and Bank of America) that were best positioned to weather the 2008 crisis. The Glass-Steagall argument doesn't stand up to the most basic of scrutiny.

Returning to the beginning of this chapter, banks, like all well-run businesses, don't implode from a lack of cash. Instead, they're starved of cash when poor judgment on the part of their executives renders their balance sheets unworthy of operating loans in return for the collateral they can offer. Well-run banks won't suffer a frozen market for credit; their balance sheets would make them worthy of credit. Banks that are unable to obtain short-term operating credit would find themselves acquired by their betters in the industry. The desire among regulators and politicians to erase failure is logically one of the biggest barriers to overall banking health.

Somehow in modern times, banks have taken on mystical qualities such that market forces, which propel the positive evolution of other industries, don't always apply to them. It doesn't take a banker to see the flaws in this view. The best industries are routinely marked by failure, because that's the only way to starve the credit destroyers of their ability to destroy more of it. Its sporting equivalent is keeping Brady Hoke in the Michigan job over Jim Harbaugh.

Banks need to have the Brady Hokes of the sector exposed as quickly as possible so that greater talents can replace them. Reserve requirements and other regulations merely delay the inevitable, thus neutering the banking system and an economy somewhat reliant on skilled bankers. As

Hall McAdams frequently points out, "For the well-run bank any reserve requirement is too high, but for a poorly run bank no reserve requirement is high enough." Let's expose the bad ones quickly.

All of this raises an important question. Assuming the death of banks at the hand of thousands of regulations, do we really need banks in the first place? That question is the subject of the next chapter.

Do We Even Need Banks?

Consumers and businesses are increasingly moving away from
traditional banks to meet a majority of their financial needs.
—Jeffrey Sampler, Adjunct Professor of Management at
China Europe International Business School

IN JULY 2010, amid a tighter credit market for small businesses, Wal-Mart's Sam's Club chain of warehouses announced a new banking service for its customers.[1] With banks and other sources of credit still chastened by what had taken place in 2008, new providers of credit like Sam's Club emerged.

In economic terms, Sam's is engaging in the "substitution effect." When existing businesses fail to meet customer needs, substitutes enter the picture to fulfill them. With loans and other forms of finance, the substitution effect has long been the rule.

From 1900 to 1910, 70 percent of corporate funding was generated internally. As for banks themselves, by 1913 71 percent of all banks were nontraditional, and they held 57 percent of all U.S. deposits.[2]

To this day, traditional history tells us that the Federal Reserve was chartered in 1913 to serve as a lender of last resort to banks that were allegedly essential to a sound economy but were experiencing near-term cash shortages. While it is technically true that the Fed began as a last-resort lender, the broader truth is much less elegant.

The Federal Reserve was created to prop up the biggest banks in the United States that were increasingly being made irrelevant by nontraditional forms of finance. In brief, the Fed was chartered to block the natural, market-driven erosion of traditional banking.

In an atmosphere of a loss of deposits to banks outside of New York and other centers of finance, the Fed was created to insulate traditional banks from market forces that were making them anachronistic. The Fed would essentially perpetuate a form of finance that free markets were leaving behind.

When we consider the Great Depression, modern commentary from both the Left and the Right contends that bank failures were one of its major causes. But as the evolution of finance decades earlier proves, there is simply no way that bank failures caused the Depression. Finance had long before evolved away from traditional banks.

All of this is important in light of the handwringing that revealed itself amid the banking sector's struggles back in 2008. With many traditional banks on the verge of collapse, hysterics on the Right and the Left said that if the federal government did not save them from their mistakes, the economy would grind to a halt thanks to a disappearance of credit.

The Fed predictably stepped in to lend false credibility to this narrative. As then Fed Chairman Ben Bernanke said to Nancy Pelosi about the supposed need for bank bailouts: "I spent my career as an academic studying great depressions. I can tell you from history that if we don't act in a big way, you can expect another great depression, and this time it is going to be far worse."[3] Great political theater for sure, but wholly unrealistic.

As an October 2008 Minneapolis Fed study revealed, around the time of the crisis 80 percent of borrowing among businesses took place outside of the banking system. And for those who claim now that lending disappeared in the fall of 2008, surely it did for bad credit risks and insolvent institutions. A healthy development for sure! But according to the same study, as of October 8, 2008, there was no evidence of a decline in business and consumer loans.[4]

What the Sam's Club story proves is that when market rates of interest rise to high levels and lending becomes scarce, businesses outside of the traditional banking system receive a marketing signal that their entrance into finance will be rewarded. Think back to chapter 1. When demand for transportation outstrips supply, Uber institutes "surge pricing" to create an incentive for drivers to get themselves on the road, and in certain

places serving customers. Sam's Club was doing much the same, substituting itself as a credit provider much like Uber does when cabs regulated by government-created cartels prove scarce. Interestingly, Sam's, a retailer of consumer and business items in bulk, H&R Block, known for its tax preparation services, Quicken, known for its software, and Harley-Davidson, known for its motorcycles, all have lending arms at present. What is exciting for all of us is the happy reality that new forms of credit continue to sprout up in the marketplace all the time.

For instance, consider the story of Shweta Kohli. A straight-A student at San Francisco State University, where she paid her own way working forty hours per week as a waitress, Kohli didn't have much of a credit history. When she applied for a credit card after graduation, she was turned down.

Thankfully, markets exist to constantly fulfill unmet needs. In Kohli's case, she joined what is called a "credit circle." Overseen, ironically enough, by a nonprofit called the Mission Asset Fund, it's funded by individuals who deposit money into it each month in order to lend to one another interest free. Kohli borrowed money from the fund, always made her payments on time, and, having built a credit score through the fund, was ultimately able to build a credit rating for herself that made it possible for her to engage in traditional borrowing.[5]

Moving to the for-profit space, consider Lending Club. It bills itself as "the world's largest online marketplace connecting borrowers and investors." Call it Uber for lending. As of this writing, the Club has lent more than $11 billion dollars to individuals and businesses in need of credit. It offers personal loans up to $35,000 and business loans up to $300,000.[6]

How does it do it? Lending Club rates the individuals and small businesses that come to it for credit and then lends to them at a rate of interest commensurate with their credit history. But as we know well by now, there are no borrowers without savers. Someone out there must be willing to lend in order for someone else to borrow.

Importantly, Lending Club is seen as having a good system for vetting borrowers. Thanks to its quality reputation, individuals and banks seeking returns on savings and deposits increasingly place their money with Lending Club. Lending Club does all the work of rating the borrowers, at which point its investors commit capital to the loans it is making. Interest rates paid to the lenders are a function of how Lending Club rates its borrowers; the riskier the loan, the higher the interest rate paid. All

businesses outsource to a varying degree, as do individuals, and in this case the banks and individuals with credit outsource the lending process to entities like Lending Club that are seen as skillful in assessing those who need credit.

USAA is an insurance company founded in the 1920s by U.S. Army officers to help one another secure car insurance. Seen as a high-risk group, members of the military (and eventually their families) were to attain insurance on their autos. Modernly, USAA insures its customers in all manner of ways, offering, among other things, life, renters, and homeowner's insurance.

What began as an insurance company has morphed into a full-service financial services company. USAA offers car loans to its customers, has in the past offered home loans, and currently operates as a bank in addition to its other operations. It does all this without the traditional branches operated by the banks to which some of us have perhaps grown accustomed. As Robert H. Smith, former CEO of Security Pacific Bank (since acquired by Bank of America, but as of the early 1990s the fifth largest U.S. bank), described USAA:

> In addition to checking and savings accounts offered free of any service charges, customers also get a free debit card for over-the-counter transactions and also free national ATM usage for cash withdrawals. Deposit and bill payment services are also available remotely from hand-held devices or from home and office computers.[7]

According to Smith, USAA's emergence as a bank "was clearly the revelation of a banking model that makes the traditional branching models look old and out of date."[8] Indeed.

Importantly, the story gets even better. Those who seek banking services have options. Bank of Internet offers checking and savings accounts along with mortgages; E-Loan offers home re-finance, mortgages, and auto and personal loans. My E-Bank and Virtual Bank are part of a long and growing list of such providers. When individuals open up accounts at discount brokers like Charles Schwab, the accounts frequently include "money market" accounts that serve as a savings vehicle for customers. More broadly, in 2014, Wal-Mart made it possible for its customers to open up checking accounts like the ones historically offered at banks.[9]

Any purchase on Amazon.com brings with it an offer for an Amazon credit card. Airlines, carmakers, and clothiers frequently offer an actual

credit card when purchases are made, not to mention that computer makers like Dell provide purchasing credit to their individual and business customers.

What we must logically conclude is that credit is everywhere. The credit card itself is particularly interesting, as the late Walter B. Wriston (long-time CEO of Citibank) noted in his insightful 1992 book, *The Twilight of Sovereignty*:

> The commercial banks should have invented the credit card, but they did not. Kodak, which is almost always at the forefront of technology, was a natural to produce the first instant camera, but it was Dr. Land of Polaroid who brought the idea to market. General Electric should have been the world leader in electronic computers, but it was IBM, without a single electronic engineer in 1945, that saw the opportunity and seized the lead. . . .
>
> In each of these cases, companies with vast stores of expertise and information capital proved dull students of opportunity.[10]

Wriston was making a point similar to the one Smith made in 2014: The traditional bank (or for that matter, any established business) is not necessarily the innovator when it comes to providing credit. Thank goodness, because credit cards not created by banks have been a necessary source of finance at times.

In its early days, ESPN was quite the joke and not expected to survive. While founder Bill Rasmussen eventually secured a $10 million investment from the Getty Oil Trust, at one point prior to the Getty investment he borrowed $9,400 from his Visa card in order to pay the sputtering sports channel's mounting bills.[11] Shifting the discussion to Hollywood, Spike Lee accessed credit cards to help fund his first film, *She's Gotta Have It*. So did Robert Townsend when he made *Hollywood Shuffle*.[12] In Townsend's case, he charged $40,000 onto fifteen different personal credit cards.

Contrary to a popular narrative, banks generally don't swing for the fences with the "money of others" when they issue loans. The reason they don't is that the margin for error within banks is rather small. This will be discussed in greater detail in the next chapter, but housing was seen as a safe loan for banks. (It arguably still is.)

Unlike venture capital firms, which acquire an equity stake in a high number of companies on the expectation that most will fail, banks can-

not take those kinds of risks. As lenders of credit, their income is a function of loans being repaid. As a result, banks must be much more careful than the typical investor.

In that case, it's a good thing that banks are in no way the sole source of credit in the United States. If they were, our economy would be marked by crushing stagnation. Think back to the chapter on "junk bonds": Those financed the kinds of companies—telecom, cable, medical services, casinos, and so on[13]—that banks would not touch. Imagine the U.S. economy without the advances that nontraditional forms of finance provided credit for.

Returning to Spike Lee, his early successes made him bankable in Hollywood. But in 2014, he turned to Kickstarter to attain $1.25 million in financing for *Da Sweet Blood of Jesus*. Kickstarter is a website where the creative go to find investors for their projects. They set a number they'd like to raise, and if successful they find individuals eager to "crowdsource" whatever project it is they seek funds for. The investors acquire a stake in the creative dream of others who need credit to animate their dreams. Capitalism is always and everywhere a two-way street.

Explaining his utilization of Kickstarter to *The Economist*, Lee observed that traditional movie studios "are looking for tent-pole movies, movies that make a billion dollars, open on the same day all around the world. This film isn't what they are looking for."[14] Lee has historically made risky films that banks wouldn't touch, and that movie studios in search of the next blockbuster sometimes similarly resist. Again, credit is everywhere, though not necessarily accessible to all from careful banks that have no choice but to be a bit more conservative with depositor funds.

Going back to 2008, the very Fed that predictably failed in one of its main, and wrongheaded, objectives—that is, to oversee a sound banking system—claimed that absent the banks, we would face the mother of all economic depressions. The view was that absent bank credit, an economy reliant on credit would grind to a halt. The obvious problem with such an assertion was that even in 2008, 80 percent of borrowing took place outside of the traditional banking system.

Fast-forward to the present, and that percentage continues to rise. As of 2014, 85 percent of lending originated from sources that were not banks.[15] Do we need banks? Obviously not. Market forces have spent at least a century, and probably longer than that, innovating around banks as providers of credit.

All of which raises an interesting question. What if the branch banking system we have come to know disappeared altogether? This hasn't happened yet, but it's worth pointing out that since 2010, only one new bank has opened in the United States. It is called Bank of Bird-in-Hand, and it opened in Amish country. Compare this to the three decades prior to the post-2008 regulatory buildup, in which an average of more than one hundred new banks opened per year.[16]

Why the change? Some of it is happily attributable to market forces. As mentioned previously, nonbank sources of credit have been eroding the dominance of traditional banks for more than a century. The Internet has sped up the process of Schumpterian "creative destruction." After that, the increasingly intrusive regulations foisted on traditional banks have rendered them rather weak relative to inventive outside-the-banking-system sources of credit. As Robert H. Smith described it in *The Changed Face of Banking*:

> After 2008 . . . banks came under new scrutiny from Washington involving pressure to reestablish themselves as safer, stronger partners to the financial system. They were implored to stop being inventive and creative and instead to assume a position of steady, safe conformity and consistency. Some say the growing Washington pressure, if it continues, will drive banks to serve as quasi-public utilities mandated to provide selected services on predefined terms, risks, and conditions. The challenge of banks to independently explore opportunities and to promote inventiveness is being lost in exchange for discipline, control, and conformity.[17]

Do we need banks? Realistically, Smith's passage, which reveals the horrid extent to which banks are being smothered today by laws and regulations, tells us we don't. Better yet, we should cheer their disappearance, so long as they're overregulated in the way they are now.

Credit is, once again, real economic resources. If banks are going to be reduced to staid utilities defined by the opposite of innovation, we should be horrified by their continued existence as wards of the state. The allocation of credit is too important to the very prosperity that continues to enhance our standard of living in amazing ways. We can't allow what is not creative and skilled to allocate even 15 percent of the credit we produce, let alone that which may only exist thanks to the Fed propping them up with resources created by us.

What will we do if banks cease to exist? The first answer is we'll hardly notice. As this chapter has hopefully made rather plain, savings vehicles and innovative sources of credit continue to appear well outside of a banking system that is no longer allowed to innovate. If the bank branches some of us still rely on vanish, entrepreneurs will eagerly fill the void.

We don't spend evenings worried about where the shoes, computers, and cars we rely on will come from. In a profit-motivated capitalist society, they simply reach us in varying brands, sizes, and price points in return for our own production.

Savings and borrowing vehicles are no different from shoes, and they'll always be there. They will be because in a largely free society we'll continue to create credit. That's why we get up in the morning. We produce for dollars, but what we're really producing for is what those dollars can command in the marketplace.

Of course, there thankfully are times when the dollar amount of our production well exceeds our needs. Since the latter is true, there will always be a need for us to save our dollars. Our savings will redound to the economy's certain benefit, given the truth that savings, short of being stuffed under a mattress, never lay idle. When we place our savings with credit allocators that are increasingly not banks, they will pay us for the privilege so that they can lend our access to the economy's resources to those that need our credit surplus to pay the bills, buy a car, start a business, or expand an existing business.

In short, if traditional banks cease to exist, other options will be a given. What's exciting is that bank substitutes, by their unregulated nature, will be highly inventive in how they'll allocate credit to the economy's benefit. Some banks may even open up as warehouses for cash to please those who naively think money that's lent is multiplied.

What we should know with certainty is that if banks saved by government exist only to be strangled by that same government, we'll be fine. The history of capitalism is all about entrepreneurs fulfilling unmet needs. Right now, we don't need banks in their present form. Unless government is willing to get out of the way so that banks can compete, while succeeding *and* failing, we should, with the utmost confidence, cheer on their descent into irrelevance.

The Housing Boom Was Not a Consequence of "Easy Credit"

The effect of keeping interest rates artificially low, in fact,
is eventually the same as that of keeping any other price below
the natural market. It increases demand and reduces supply.
—Henry Hazlitt, *Economics in One Lesson*, 186

WHILE THE INTERNET investing that gifted the economy with huge advances took a breather in the spring of 2001, another kind of boom soon followed. Suddenly, housing was all the rage.

What should be made clear at the outset about housing is that it's not investment. The purchase of a house will not do any of the following things; render an individual more productive; open up foreign markets; lead to new software innovations that make businesses more efficient; create new factories; lead to cures for cancer and heart disease.

Housing is consumption, which means it's the opposite of investment. Put more plainly, housing is *anticredit creation*. That housing began to soar in the early 2000s was a signal that the productive, capital-intensive parts of the economy were experiencing a credit deficit as individuals around the world rushed into housing. As Hazlitt explained in *Economics in One Lesson*, "what is saved on consumers' goods is spent on capital goods."[1]

The most common explanation for the housing boom fingers the Federal Reserve as the cause. The great Austrian School scholar Thomas E.

Woods Jr. was not alone when he concluded in 2009 that the Fed provided the gasoline for housing's takeoff thanks to its "extraordinary decision to lower the target federal funds rate (the rate at which banks lend to one another overnight, and which usually drives other interest rates) to 1 percent for a full year, from June 2003 until June 2004."[2]

At this point, readers might read the previous quote with healthy skepticism. As the early chapters on Hollywood, Silicon Valley, and Wall Street reveal, while the Fed presumes to decree a cost of credit that is "cheap," the markets themselves have entirely different ideas about credit's allocation.

No matter what the Fed does, the cost of credit (meaning the economy's resources: those tractors, computers, actors and actresses, cameras, and so on) in the real economy is always detached from what the Fed wishes. In Hollywood, it is incredibly difficult to access credit, no matter one's track record. In Silicon Valley, those who need credit acquire it by trading equity stakes in their concepts with venture capitalists and salary-deprived employees. On Wall Street, it's often about track record, yet Michael Milken found credit for companies that were traditionally ignored by Wall Street and major banks but were willing to pay high rates of interest ("junk bonds") for the privilege.

What this should illustrate is that the Fed can't change the on-the-ground economic reality. This is a good thing. While credit will always be easy for Apple no matter the fed funds rate, it will always be expensive for the up-and-coming company with an idea but little or no revenues. In a market economy, even one that includes a central bank, the price of credit is different for everyone.

Likewise, there's no reason that a 1 percent interbank lending rate set by the Fed would automatically redound to housing. That's the case because, as the previous examples remind us, there are all sorts of investment opportunities on offer for those with access to credit. In that case, logic dictates that allocating credit to a noninvestment consumption item like housing wouldn't be the first, the second, or even the one-hundredth choice for those seeking positive returns on their credit. They could allocate it to all manner of nonhousing concepts that have the potential to drive real advancement.

Woods went on to write, "[The] new money and credit [created by the Fed] overwhelmingly found its way into the housing market, where artificially lax lending standards made excessive home purchases and spec-

ulation in homes seem to many Americans like good financial moves."[3] Readers should once again be skeptical.

They should be because the Fed cannot create "new" or "easy" credit. Credit is what we create. By that simple logic, the notion that the Fed could create the credit necessary to author a housing boom is the Keynesian equivalent of suggesting that Congress can create demand in order to spend us into an economic boom. But not only is Congress incapable of investing us to prosperity (remember, Congress never "fires" or ceases funding its Brady Hoke and Webvan equivalents), it can only spend what it has taxed or borrowed from the real economy first. The Fed is no different. It can't create credit as much as it can re-allocate it toward parts of the economy that it deems worthy. The problem is the Fed, like Congress, can't do this effectively because there's no market to discipline its failures. This truth will become even clearer in chapter 17, on "quantitative easing."

Some will reply that the Fed can create money out of thin air. While that is true, the creation of money is in no way the creation of credit. The two are entirely different. While the Fed's ability to control or direct the supply of dollars is vastly overstated, the Fed could drop trillions of dollars from the sky, and no new credit would be created. It would, at best, reduce the amount of credit—real resources—that the dollar can command. Real economic resources would remain the same and likely shrink, because the dollar would be robbed of its singular purpose as a measure meant to facilitate the exchange of real wealth, and investment in the wealth-producing concepts of the future.

After that, we simply need to be realistic. There's nothing advanced about economics and credit. Recall chapter 1. If Uber tried to mimic the Fed's naive conceit and create "easy credit," it would always offer its customers cheap transportation, but those customers would rarely have access to Uber when they needed it the most. In the real economy, there's always a buyer *and* a seller. During periods of heavy demand, Uber increases the prices it charges its customers not because it's gouging them or because it wants to make access to its transportation "tight." Rather, Uber raises the cost of accessing its transportation because it wants to make access "easy" during periods of high demand. Uber must please its drivers in order to satisfy its customers.

To believe the Fed can make credit easy by decreeing it cheap is the equivalent of believing that Uber can make money by instituting rock-

bottom prices when transportation is scarce, such as after a Taylor Swift concert or during a snowstorm. Uber would look foolish for doing so, and it would soon be out of business if it adopted the Fed's backward-pricing system. Indeed, the Fed appears adolescent for presuming to centrally plan access to the economy's resources without regard to the needs of those who possess access to those same resources.

Reducing all of this to the absurd, imagine if Congress decided that Ferrari dealerships were only allowed to charge $10,000 for their cars. The result would be lots of demand but a nonexistent supply of the sports vehicle. This is how readers should view the Fed. Simple logic dictates that its attempt to centrally plan an artificially low cost of credit in the early 2000s didn't expand the availability of credit. It couldn't have. Credit is, again, real resources created in the real economy. At best the Fed's machinations distorted where certain resources went, but as this chapter will argue, this did not occur nearly as powerfully as is commonly thought.

With respect to the housing boom, recent economic history reveals that the low-interest-rate argument offered up by Woods and many others is a poor one. It also signals that something separate from a low fed funds rate was the source of a growth-sapping rush into housing consumption. Indeed, if a low fed funds rate had driven housing health in the 2000s, then the 1970s, when the rate soared from under 4 percent to more than 17 percent by the close of the decade, would surely have been a disaster for housing.[4] Yet housing skyrocketed in the 1970s, thus raising the question about what really drives housing vitality. The answer lies in the 1970s, when housing roared in ways quite similar to the 2000s. Specifically, the value of the dollar, which the Fed doesn't control, answers the question.

On August 15, 1971, President Nixon made the fateful decision to sever the dollar's link to gold. Explicit in such a move was a desire for a weaker dollar. Presidents always get the dollar they want, and with the dollar no longer linked to gold, the yellow metal began to rise as the dollar fell.

The fed funds rate rose more than 450 basis points between 1971 and 1973, but the housing market was undeterred. Housing, the opposite of intrepid capital allocation because it represents consumption, emerged as the most "dynamic" asset class during Nixon's second term.[5] That housing boomed as rates rose in the 1970s cannot be ignored in light of the popular point of view that a low fed funds rate was the driver of housing strength in the 2000s.

Investment is always seeking its best return; when investors put capital to work, they are buying future dollar income streams. But with the dollar in free fall, stock and bond income streams representing future wealth creation were not as attractive as they historically had been. To put it plainly, why commit capital to future wealth creation if any returns will come back in severely devalued dollars?

When money is losing value, investment flows into hard assets that are least vulnerable to the devaluation. Investment flows into land, housing, art, rare stamps, and anything tangible. Critically, this is wealth that *already exists*. Of course, investment migrating into existing wealth as a protection against dollar devaluation is a strong signal that the wealth and production (new credit) *that doesn't yet exist* will not receive funding. Instances of housing consumption don't describe a credit boom, because the creators of real economic resources are suffering a credit deficit that would author the production.

Devaluation, to be blunt, is a blast to the past whereby investment migrates into riches the economy has already created. Ludwig von Mises referred to periods of devaluation as times when there's "a flight to the real." With the stock and bond markets made unappealing by Nixon's monetary error, housing and other hard assets were the beneficiaries. Housing is tangible, and you can live in it. *It is safe.* But housing soaring above real economic assets is not a sign of excess credit; it is a sign of shrinkage of credit as consumption wins out over investment. That's why the housing boom under President Nixon was such a major negative economic signal.

Moving to Jimmy Carter's presidency, the dollar's devaluation continued. Despite a sharp drop in the value of the dollar against gold and the Japanese yen throughout the 1970s, Carter's Treasury Secretary Michael Blumenthal intimated in a speech in June 1977 that the dollar was undervalued against the yen.[6] This was a fairly explicit signal that President Carter wanted a weaker greenback, and the markets complied. Gold was trading at roughly $140/ounce when Carter entered office in 1977. Gold had risen to $220/ounce by 1979 and to $875/ounce as of January 1980, Carter's last year in office.[7]

It's worth mentioning once again that credit never lies idle. Those who have it don't just sit back and do nothing when governments are wrecking the economy with devaluation. Instead, those who have credit seek out inflation hedges, such as housing. Indeed, David Frum aptly

described the soaring-interest-rate 1970s in his 2000 book, *How We Got Here*: "If you had the nerve to borrow a lot of soggy cash, and then use it to buy hard assets—land, grain, metals, art, silver candlesticks, a book of Austro-Hungarian postage stamps—you could make a killing in the 1970s." Frum noted further that when *Forbes* magazine "published its first list of the 400 richest Americans in 1982, 153 of them owed their fortunes to real estate or oil."[8]

George Gilder observed about the 1970s in *Wealth and Poverty* that while "24 million investors in the stock markets were being buffeted by inflation and taxes, 46 million homeowners were leveraging their houses with mortgages, deducting the interest payments on their taxes, and earning higher real returns on their down payment equity than speculators in gold or foreign currencies." Gilder also cited a 1978 study in *Fortune* magazine in which half the new multimillionaires were in real estate.[9]

At this point, readers might correctly be thinking that the average American doesn't follow the dollar, let alone the dollar's price in terms of gold. That is a great point, but what the average American *does follow* are price signals offered by the markets. Just as stock market booms start a lot of conversations about stocks, the soggy-dollar 1970s revealed a lot of stories about money made in housing. That caused many Americans to reorient their investment into areas that were least vulnerable to the devaluation. Oil, housing, and hard assets soared, while a stock market representing the funding of future wealth creation flattened.

Moving into the 2000s, housing once again emerged as a top asset class as policies in favor of dollar weakness reared their ugly head in a replay of the 1970s. It can't be repeated enough that presidents get the dollar they want. In the case of George W. Bush, his first Treasury head, Paul O'Neill, noted that a "strong dollar" means little in policy terms. His successor at Treasury, John Snow, continued this lurch toward devalued money with a question he uttered at a G-8 meeting in France: "What's wrong with a weak dollar?"[10]

Additionally, the Bush administration imposed tariffs on foreign steel, softwood lumber, and shrimp, all the while pulling a page out of the Carter (and for that matter, Reagan) administration playbook. In Bush's case vis-à-vis China, there were constant complaints about the yuan being too weak. (Carter and Reagan bashed Japan about the yen.) All of this was an explicit signal from the Bush administration that it wanted a weak

dollar, and markets complied. And love or hate the wars in Afghanistan and Iraq, war and good money haven't historically correlated with one another. As Gustav Cassel explained in his 1922 book *Money and Foreign Exchange after 1914*, "Effective warfare under really serious conditions is practically impossible without inflation."[11]

And so the dollar began to decline. It bought 1/266th of an ounce of gold when Bush was inaugurated in 2001, and by July 2008 it bought 1/940th of an ounce.[12] In a sequel to the 1970s, Americans once again started speculating on housing. It offered better returns than the stock market, plus you can live in a house. The rush into housing was a hugely negative economic signal, much as it was in the 1970s. As Adam Smith wrote in *The Wealth of Nations*:

> Though a house . . . may yield a revenue to its proprietor, and thereby serve in the function of a capital to him, it cannot yield any to the public, nor serve in the function of a capital to it, and the revenue of the whole of the people can never be in the smallest degree increased by it.[13]

Housing was all the rage. It was a safe haven against devaluation, and because it was, the real economy lost. Housing is about consumption of wealth, yet economic growth is a function of directing credit into enriching ideas that don't yet exist.

Returning to ideas about what caused the credit-contracting housing boom, it was popular on the Left to say that banking deregulation was the driver. Others pointed to Fannie Mae, Freddie Mac, and the interest-rate tax deduction for those with mortgages. As mentioned previously, most commentary centered on how Alan Greenspan's decision to cut the fed funds rate to 1 percent in 2002 allegedly made credit easy and fed the boom.

About deregulation, that would be an interesting argument if it were true. But as John Allison, former CEO of BB&T Bank, pointed out in his 2013 book, *The Financial Crisis and the Free Market Cure*, "Financial services is a very highly regulated industry, probably the most regulated industry in the world."[14] In the 2000s alone, banking saw even more regulation, including Sarbanes-Oxley and the Patriot Act.

Others on both the Left and the Right pointed to the gradual erosion and near-total abolishment of the Glass-Steagall Act from the 1930s, which separated banking services from normal retail banking. If we ignore that it

was the hybrid bank/investment banks that were the healthiest in 2008—and were in a position to acquire the failed Bear Stearns (J. P. Morgan), the failed Merrill Lynch (Bank of America), and the failed Wachovia (Wells Fargo)—we still can't ignore what is obvious. Banks did not run into trouble because of their exposure to investment banking services or because of their underwriting or dealing in securities (banks are still prohibited from the doing latter).[15] They imploded because of mortgage lending and exposure to mortgages, something they were already allowed to do before Glass-Steagall's partial repeal.

As Gregory Zuckerman pointed out in *The Greatest Trade Ever*, "Rather than rein it all in, regulators gave the market encouragement, thrilled that a record 69 percent of Americans owned their own homes, up from 64 percent a decade earlier."[16] Regulators are always the last to see problems. If they weren't, they wouldn't be regulators. They'd be earning billions on Wall Street shorting the shares of errant banks.

Regarding Fannie, Freddie, and the mortgage-interest deduction, all three should be abolished with great haste. The last thing government should do is subsidize consumption of any market good, particularly one that renders us less mobile. The problem with the view that Fannie, Freddie, and the mortgage-interest deduction caused the housing boom is it ignores the broader truth that the rush into housing was *global* in nature. Housing soared in England, which had neither Fannie Mae nor Freddie Mac, and despite the abolition of its own mortgage-interest deduction in the 1980s.[17] In Canada it's very difficult to obtain a home mortgage, yet housing boomed there as well.

As for the most popular explanation—namely, that a low fed funds rate led to "easy credit"—it's too often forgotten that interest rates were higher around the world and yet the boom was global. That's why Alan Greenspan expressed surprise in a 2013 *Wall Street Journal* interview about all the blame that's been piled on him.[18] He was correct there. Interest rates were a sideshow in the housing boom.

Furthermore, and going back to our discussion of John Paulson from Part One, Paulson ultimately made billions betting against the housing house of cards. The employee who initially brought the trade idea to him had carefully studied interest rates and home prices. In tracking interest rates over the decades, Paolo Pellegrini "concluded that they had little impact on house prices."[19] Readers of this chapter may have so far concluded the same, and with good reason.

Lest we forget, housing soared in similar fashion in the 1970s, when interest rates rose throughout the decade. As Gilder noted about the 1970s housing boom, "What happened was that citizens speculated on their homes. . . . Not only did their houses tend to rise in value about 20 percent faster than the price index, but with their small equity exposure they could gain higher percentage returns than all but the most phenomenally lucky shareholders."[20]

So what caused the credit-destroying migration into housing? Our weak dollar policies were mimicked around the world, and as always happens when money is devalued, housing is one of the safer places to go.

History is littered with instances of individuals rushing into housing amid periods of monetary devaluation. Housing is the classic inflation hedge. As Adam Fergusson wrote in *When Money Dies*, "Anyone who was alive to the realities of inflation could safeguard himself against losses in paper currency by buying assets which would maintain their value: houses, real estate, manufactured goods, raw materials and so forth."[21]

Crossing the pond to England in the 1970s amid the pound's decline, David Smith wrote in *The Rise and Fall of Monetarism* that the sector "investors chose above all others was property development."[22] A *Bank of England* quarterly bulletin observed about the 1970s, "There was no other area of general area of economic activity which seemed to offer as good a prospective rate of return to an entrepreneur as property development."[23]

Writing about the 1970s economy in his classic history of the Federal Reserve, *Secrets of the Temple*, William Greider found that the economy of the Carter years "particularly benefited the broad middle class of families that owned their own homes."[24] We had a global housing boom during the Bush years precisely because the dollar was in free fall. With the greenback falling, there was similarly a run on paper currencies of all shapes and sizes around the world. Just as housing, oil, and real estate more broadly animated the 1970s economy when the dollar sank, a return to weak dollar policy during George W. Bush's presidency generated a similar result.

Remember, when the dollar is weak, there is a tendency to migrate toward the tangible, to wealth that already exists. When money is stable or strong, investors don't worry as much about having their investments eroded by inflation, so they're intrepid.

In the 1970s and 2000s, dollar policy reversed course in favor of weakness, and we suffered a cruel economic blast to the wealth of the past.

Housing benefited from the dollar's fall, while real companies in the real economy suffered in a relative sense. Contrary to the popular narrative about banks swinging for the fences, their eagerness to lend to homebuyers should be remembered as a "flight to safety" as banks searched for a safe haven. Remember, a home loan never goes to zero simply because it's backed by a house than can be repossessed. Conversely, a loan or an investment in a filmmaker, technologist, or top money manager could easily descend to zero in a short amount of time. The problem was that an economy consuming so much of its credit rather than investing it was eventually going to implode, and the decline took some banks with it. It is too bad the failed banks weren't allowed to go bankrupt.

Economists who suggest that an interest rate set by the Fed led to the housing boom are ignoring history. In the 1970s, the Fed was eagerly jacking up rates, but housing soared.

For those same economists to suggest that a low fed funds rate rendered credit "easy" is to first promote Keynesian mythology about "liquidity traps." They ask us to believe that absent the Fed, credit created in the real economy would have sat idle. The latter is not a serious presumption, nor is it serious to believe the Fed can decree credit easy. What they describe as "artificially low rates" is, at best, an admission of credit tightness, not ease. For those promoting this narrative to suggest otherwise is to believe the Fed is the only governmental body in the history of mankind that can institute artificial price controls that actually lead to abundance over scarcity.

Most important, the popular notion of "easy credit" mistakes money for the real economic resources that represent credit. The latter is the most damning indictment of all of this popular, but wrongheaded explanation of what happened in the 2000s.

Credit wasn't expanded by the Fed in the 2000s simply because the Fed, objectionable as its existence certainly is, can't do what some of its most ardent critics believe it can. Far from being an instance of "easy credit," the horrid rush into housing signaled a massive *credit contraction* as consumption prevailed over true investment. Unknown are all the economic advances that would have expanded the credit pie had the dollar been stable in the 2000s such that credit had migrated to real ideas instead of consumption.

Conclusion: Why Washington and Wall Street Are Better Off Living Apart

The investment banker is 'a producer' of money and credit,
"the capitalist par excellence."
—Joseph Schumpeter

"Your No. 1 client is the government," John J. Mack, Morgan
Stanley's chairman and chief executive from 2005 to 2009,
told current CEO James Gorman in a recent phone call.
Mr. Gorman, who was visiting Washington that day, agreed.
—*Wall Street Journal*, September 10, 2013

ALTHOUGH SILICON VALLEY can still claim top-dog status as the center of technological innovation in the United States, Austin, Texas, is increasingly part of the discussion. Advantaged by relatively low living costs, abundant outdoor activities, and the lack of a state income tax, Austin increasingly attracts the talented.

Serial entrepreneur Joel Trammel is one of the city's leading technological lights. His most recent success was NetQoS, which provides software for companies eager to track their response time to customers, their employees' performance, and other software services. Trammell founded the company in 1999 and sold it ten years later for more than $200 million to CA Technologies.

One of Trammell's subsequent projects was a book. In 2014, he published *The CEO Tightrope: How to Master the Balancing Act of a Successful*

CEO, in response to the view that there are no "courses that teach a person how to be a CEO."[1] It's an excellent book that reminds the reader why company heads are so well paid. While most of us pursue the path that most animates a specific talent, CEOs must excel at a number of things (overseeing budgeting, staffing, fostering a successful culture, etc.) all the while knowing what skills they lack. Figure no one is going to tell the company chief what he's bad at. As Trammell explains, "As CEO, your jokes will be funnier, your ideas will be better, you will be smarter—at least according to the people you work with every day."[2]

NetQoS was a private company by design (the regulatory horrors of Sarbanes-Oxley made Trammell reluctant to go public), yet Trammell is also a big believer in companies going to Wall Street in order to sell their shares to the public. Indeed, one of the shameful consequences of "SarBox" is that it has burdened smaller public companies (the large ones can more ably absorb the costs) with all manner of expensive regulations. Those costs surely played a role in the IPO plunge that revealed itself in the new millennium. Investors of all stripes have missed out on owning a portion of innovative companies. So did CEOs miss out on being public, but not for the reason some might assume.

Being a publicly traded firm is a great way for a CEO to attain valuable feedback about how he or she is doing. Trammell is a strong believer that, absent market signals, CEOs must constantly "self-diagnose our weaknesses,"[3] and one of the weaknesses he owned up to was a lack of skill when it came to raising capital (credit) for his ventures. As he put it,

> I'll be honest, my track record for providing capital is not great. *Raising money is hard.* Over my career of leading multiple companies, I have talked to more than a hundred institutional investors and have reached a deal exactly once. For this reason I advise companies to take the money when they can, because it often isn't there when you really need it.[4]

Trammell's recall of the funding difficulties that businesses face is a reminder that the Fed's conceit, whereby it decrees credit "cheap," in no way correlates with the real world of credit. The Fed was actively reducing its funds rate at the time that Trammell contemplated the death of cash-strapped NetQoS. Supposedly "easy credit" from the Fed in no way provided him with comfort. Or cash. Luckily, he had patient investors.

Looked at more broadly, Trammell's story will ideally cause readers

to rethink the popular view about "excessive pay" on Wall Street. When companies float their shares in exchange for credit, it is firms from the symbol that is "Wall Street" that are raising money from the very institutional investors Trammell deemed tough sells. The pay and bonuses on Wall Street are high precisely because those who toil in finance possess a skill at finding finance that most lack. To repeat Trammell's line, "raising money is hard." Pay on Wall Street reflects this truth.

Apple, Amazon, and Microsoft are public companies. Would readers like to contemplate a world without iPhones, without the ability to buy the world's plenty all with a click of a mouse, or without Windows to interact with increasingly inexpensive Dell computers (formerly public)?

Most of us didn't know that we needed all three of these technological giants until well after they were public. High-fliers all, unless readers can claim to have bought the shares of all three around the time Wall Street floated their shares, it would be hard to make the case that their early funding was an easy sell. Obviously, it wasn't. Investors have choices when they commit capital, and newer companies represent great risk. Companies going public are generally smaller, less established concepts in pursuit of the credit necessary to grow large. Thank goodness the investment bankers on Wall Street are skilled at finding finance for the creative concepts that aren't as easy of a sell as long-established companies, such as McDonald's, General Electric, and Disney.

Skeptics will point to the initial Internet boom, and the many companies taken public by Wall Street firms that then went bankrupt. They'll say the latter signaled a financial sector that had lost its way. Such skepticism is a misread. More realistically, the Internet boom revealed Wall Street at its best. Here was a revolutionary new industry (how many of us could live without the Internet today for even a few hours?), and Wall Street found abundant finance for all manner of experimentation. The subsequent failures signaled a healthy market economy starving the companies that didn't make sense in much the same way as nearly every car company from the early twentieth century went under. It's not capitalism if there's not a lot of failure.

Banks, too, have corporate lending arms that regularly work with small businesses, not to mention far more established companies in need of finance. For a company to expand and frequently create the jobs that come with that expansion, there must be savers first. Banks and investment banks are paid handsomely for bringing the two together.

Going back to Michael Milken, while he cleaned the clocks of investment banks that turned their noses up at "junk bonds," ultimately those same banks learned from their mistakes. Now, they all have junk-bond or "high-yield" bankers who raise money for the riskier business concepts willing to pay higher rates of interest in return for credit.

Most banks and investment banks have private equity arms now, too. In fact, it was a surprise during the 2012 presidential election that Mitt Romney didn't talk more extensively about the source of his great wealth. Bain Capital was famously invested in Staples[5] early on, but as *Bloomberg*'s Jason Kelly noted in his 2012 book about private equity, *The New Tycoons*, "private equity firms are rarely interested in companies firing on all cylinders."[6] Specifically, the high pay in private equity is most often the result of investors buying companies on the proverbial deathbed and nursing them back to health. Why Romney didn't more often express how he earned his wealth remains a mystery.

Some companies need capital in order to buy another company that fits well with their business. Wall Street financiers find the investors to make the latter happen, and just the same they're hired by the companies being purchased so that shareholders can attain the best price possible for their shares.

And while housing is not a capital good (though Airbnb is helping home and apartment owners to capitalize their houses), we can't forget something as simple as mortgage finance. Some banks undoubtedly went overboard in the 2000s (goaded on by a federal government willing to buy those mortgages, think Fannie Mae) with their lax lending standards, but it remains the case that what is an essential consumption item has become more accessible in the modern United States thanks to banks bringing together savers and borrowers. What a shame that our federal government has increasingly nosed its way into a form of credit that was getting along just fine on its own.

Perhaps most important of all, Wall Street and the banks are "price givers." To read the financial press is often to read about what stocks "Wall Street likes" or what "Wall Street thinks." This speaks to bad reporting. Wall Street's main function is to match buyers with sellers. Stock market bulls can't express their optimism unless there's a more skeptical bear willing to sell to the bull. In bringing together buyers and sellers, the finance industry provides the economy with precious signals about where credit will be utilized best, and of great importance, what to avoid.

John Paulson's name has come up throughout this book for good reason. He was able to buy insurance on mortgages that he expected to go south only insofar as mortgage bulls were willing to sell insurance to him. In that case, Goldman Sachs, Morgan Stanley, and others brought the bear in Paulson together with the bulls. The end result, while perilous at the time, was brilliant for the economy. Paulson's billions were a signal to the marketplace that further allocation of credit to the housing sector was a really bad idea.

Of course, it was troubles in the housing sector back in 2008 that brought so many financial firms to their knees. No doubt, one reason so many have a jaundiced view of Wall Street, banks, and the high pay is the bailouts of companies that market forces were trying to put out of business. Let's be clear: The bailouts were a *disaster*. They were a disaster because of the sad economic implications of saving failed businesses but also because of what they've meant for the financial sector since.

The bailouts were tragic for the economy for the simple reason that for the government to prop up what the markets don't want, it must punish the companies that markets *do want*. Failed businesses don't vanish so much as release their assets to stewards of credit with a stated objective to manage them more wisely. Successful companies in 2008 lost out because they were unable to buy depressed assets (including some of the talented individuals inside the banks) on the cheap. Also, the money the federal government used to prop up failed financial institutions had to come from somewhere. What is unknown are the good companies that lost out on credit so that the feds could save the businesses that had deployed the credit allocated to them unwisely.

The bank bailouts were the equivalent of Brady Hoke receiving a five-year extension at Michigan despite a 5-7 season while Jim Harbaugh had to wait in the wings, or of Friendster being given a government subsidy to continue consuming capital despite Facebook having rendered it irrelevant. We know that in government bad ideas live forever. That's exactly why government should never act as an investor or a savior. Business sectors and economies don't grow if the laggards are given a lifelong lifeline. Lest we forget, Silicon Valley's wealth is not a function of all of its businesses succeeding. It thrives precisely because most of its start-ups fail.

Failure is the driver of perfection. While Wall Street and the banks remain an important source of financial innovation, logic tells us that freedom to fail would make both even healthier.

As discussed in chapter 13, the argument in favor of saving failed financial institutions was most prominently made by Ben Bernanke in 2008. As this book mentioned previously, he told then House Speaker Nancy Pelosi, "I spent my career as an academic studying great depressions. I can tell you from history that if we don't act in a big way, you can expect another great depression, and this time it is going to be far worse." Well put, but also divorced from reality.

To see why, we need only consider something we all know from our history books. In the aftermath of World War II, Japan was literally destroyed. It had lost two cities to atomic bombs, and others were reduced to rubble. Most economically crippling of all, it had lost at least a generation of its best and brightest men. But within a few years of the war's end, Japan was back on its feet in rebuilding mode, all the while aggressively cutting taxes (it reduced them every post-war year right up to the 1970s) to reduce the penalty levied on work.[7] Soon enough, it was once again among the world's richest countries (so was West Germany). By the 1970s and 1980s, some Americans had started to worry (incorrectly) that Japan was set to conquer the United States economically in ways that it couldn't militarily.

Given Japan's quick revival from utter destruction, can anyone any longer take seriously Bernanke's alarm in 2008? If Japan could rebound from mass death and rubble, the notion that the U.S. economy couldn't have easily absorbed the failure of banks such as Citigroup (bailed out five times in the last twenty-five years) is not credible. As evidenced by how many times Citi has been saved, it's a credit destroyer, not a producer. The U.S. economy would have been much better off had the collections of talents that were banks and investment banks been allowed to go under. No one would have died, no buildings would have been destroyed; it would have been just the market doing the banking equivalent of firing Hoke and starving Friendster of capital.

Most important of all, recessions that bring about painful bankruptcies are the free market's way of fixing the economy. That's why when recessions are allowed to run their course free of intervention, there's a subsequent economic boom. Recessions are a beautiful sign of an economy cleansing itself by starving bad businesses of credit so that good ones can receive it in abundance. An "economy" is ultimately a collection of individuals, and as individuals we all know how valuable our mistakes are in forcing us to fix what we were doing wrong.

But while the markets were in the process of depriving the housing market of credit and shuttering the financial institutions that were too exposed to housing, thus forcing the fix of many major mistakes, the federal government intervened. It was the equivalent of Alabama's athletic director deciding to retain Mike Shula at the last minute such that Nick Saban couldn't take over the head coaching job. Had this happened in Alabama, the Crimson Tide would never have experienced its legendary string of national titles. Applied to the U.S. economy, the bailouts in 2008 helped deprive us of the proverbial coaching change that would have authored a major rebound.

So while a huge economic boom was cruelly blunted by the bailouts, Wall Street and the banking sector have ironically suffered the federal government's needless intervention the most. We know from chapter 13 that only one new banking institution has opened its doors since 2010. That fact is doubtless rooted in market forces, but with banks being told to cease "being inventive and creative,"[8] is it any wonder that those with credit are not allocating it toward banking start-ups?

Robert H. Smith has loomed prominently in this book's discussion of banking owing to his experience at the top of what was once one of the United States' largest banks. But after he retired from Security Pacific, he eventually put together a group of investors to start a community bank in Newport Beach. His experience in the aftermath of 2008 was very telling. As he described it in *The Changed Face of Banking*, one day he approached the bank's CEO about entering a new line of business. Smith asked, "Why don't we make loans to finance accounts receivable and inventory of our customers." The response he received was telling. Smith was told, "If we submitted a plan to the regulators to enter this business, it would most likely take two or three years to receive their approval for this change."[9] The American electorate correctly loathed the bank bailouts, but the irony, as Smith's stories of modern banking reveal, is that the federal government saved the banking system only to subsequently suffocate it.

While the size of banks had nothing to do with a "financial" crisis that was authored by government intervention, it's worth noting that the Washington reaction to what took place was to set about shrinking the banks deemed "too big to fail." Missed by Washington is the fact that in a capitalist system, the bigger the market-driven failure the better, simply because poorly run companies of substantial size are wasteful consum-

ers of a lot more credit than smaller ones are. Companies of all sizes, including banks, should be allowed to go under without governmental response. The economy would benefit.

Still, since Washington's alleged war on big banks began, the largest institutions have in fact grown. As of 2013, 82 percent of total U.S. banking assets were controlled by the nineteen largest banks, while 50 percent of total assets were under the control of the largest five."[10] This fact can't be minimized in light of the quote that began this chapter. As former Morgan Stanley CEO John Mack told present Morgan Stanley CEO James Gorman in 2013, "Your No. 1 client is the government."

What this tells us is that the largest banks and investment banks are increasingly not focusing their always limited resources on crafting innovative new forms of finance, or on finding credit for the companies of today and tomorrow. Instead, they are spending increasing amounts of time currying favor with the federal government. Some of the largest institutions didn't need government help in 2008, some did, but there's no distinction between them now. Thanks to the bailouts, they're all spending too much time in Washington, D.C.

What we're seeing here is that business sectors with close ties to Washington are beholden to Washington. When that's the case, and this has been particularly true for banks saved by the federal government, they're simply no longer fully engaged in the pursuit of the very commerce that would most enhance their profits. Instead, they're increasingly in the business of serving political masters who don't as much care about profits, and who view businesses as social concepts as opposed to enterprises serving the shareholders who make their work possible in the first place.

The close ties between banking and government must end. It's essential for the health of the U.S. financial sector that it seek a permanent separation from Washington. While to call for such a divorce is likely the height of idealism, it is what would be best for banks and Wall Street. They surely do essential work, as this chapter attests, but their work would be even more valuable if government weren't their most important client.

Government is the opposite of innovation, of credit creation, and of market discipline. Washington's involvement with Wall Street has changed Wall Street, and more realistically it has deformed Wall Street. The seen is a fairly prosperous financial sector, but the unseen is how much more prosperous it would be, how many more companies it would

take public, how many more companies it would be merging, and how many more financial innovations it would be achieving absent government meddling. Government's tight relationship weakens Wall Street, it realistically discredits Washington, and the combination weakens the economy by virtue of it limiting the flow of credit to the best ideas. It's well past time to end a mutually abusive relationship that is neutering—*and politicizing*—a source of credit creation.

Greater prosperity will be the reward if the banks and investment banks that have grown too close to Washington are allowed to succeed or fail on their own, and with no cushion for the failures. They'll ultimately be better off after a divorce, as will an economy reliant on the skillful allocation of credit.

PART THREE
THE FED

Baltimore and the Money Supply Myth

No individual and no nation need fear at any time
to have less money than it needs.
—Ludwig von Mises, *The Theory of Money and Credit*, 208–9

FROM 2002 TO 2008, HBO aired the television show *The Wire*. Lauded by critics as one of the best shows ever produced, *The Wire* told the story of Baltimore's tragic descent into poverty through the city's schools, drug dealers, once prosperous docks, and impossibly corrupt politicians, and through the decline of a once-great newspaper, *The Baltimore Sun*.

Amtrak passengers from Washington, D.C., to New York can view Baltimore's horrid decline up close simply by looking out the window as the train passes through the city. Whether they look left or right, passengers witness block after block of surreally run-down houses that, in better times, were occupied by the city's once-vibrant middle class.

Although *The Wire* concluded its run in 2008, conditions in Baltimore have hardly improved. In April 2015, resident Freddie Gray died after being beaten while in police custody, and his death led to days of riots that furthered the city's implosion.

Moving from Baltimore to the other side of the world, in 1988 George Gilder visited China on a trip set up by the libertarian Cato Institute. One of his fellow attendees was legendary Nobel Laureate Milton Friedman. Known for his uncompromising and articulate defense of free markets and liberty, Friedman had a different view of money. He won his Nobel

Prize based on the research he'd done on the subject. Friedman was the modern father of monetarism, a theory of money that says the central bank should closely regulate its supply.

China was a destitute country in the late 1980s. Although Friedman could match wits and knowledge with anyone when it came to elevating the genius of free markets and free people, Gilder recalled that Friedman's top advice for China's leaders was that they "get control of their money supply."[1] Gilder was skeptical but kept quiet. He admitted, "No one ever won an argument with Milton Friedman."[2]

At this point, readers perhaps share the skepticism expressed by Gilder in the quiet of his mind. Production is the source of money. Money, while not wealth, is what we work for or borrow with an eye toward accessing real economic goods. When we borrow dollars we're borrowing what dollars can be exchanged for in the marketplace. The same holds true when we produce in return for the dollars that will command goods in the marketplace. Where there's production, there's money.

That's why there's a great deal of "money supply" in Beverly Hills, California, and the Upper East Side of Manhattan, but very little in Stockton, California, and Newark, New Jersey. Friedman's view was that inflation is always and everywhere a monetary phenomenon. However, his definition of inflation was quite a bit different from the historical definition. While the traditional definition of inflation is a decline in the value of the unit of account (in our case the dollar), Friedman viewed inflation solely as a money-supply phenomenon. Inflation was a function of too much money, as opposed to a decline in the value of money. There's a difference. Figure dollars are plentiful on the Upper East Side but scarce in Newark. Despite this truth, it's not as though the Upper East Side has an inflation problem because there's so much money situated in so few blocks of a small island, nor is the dollar rising in value in Newark simply because it's so scarce there. Money migrates to where production is, simply because the productive accept it in return for their toil.

As von Mises explained, "What is usually called plentifulness of money and scarcity of money is really plentifulness of capital and scarcity of capital."[3] Money is an effect of productive economic activity. Quoting von Mises again, "Expansion and contraction of the quantity of notes in circulation are said to be never the cause, always only the effect, of fluctuations in business life."[4] Assuming no currency at all, it's not as though economic activity would cease. People are producing so that they

can consume, and money merely facilitates exchange between producers who perhaps have differing wants. If a monetary issuer, such as a central bank, were to withdraw all money from circulation, then, per von Mises, "Commerce will create for itself other media or circulation, such as bills, which will take the place of notes."[5] Money is merely an accepted measure of value, and absent a central bank, it would still come into existence because it's so useful. Remember, the vintner may not want the baker's bread, but he will sell his wine to the baker for dollars (or any other accepted measure of value) so that he can go to the butcher and buy meat.

Returning to China, its monetary authorities ultimately chose not to follow Friedman's advice. In 1994, the yuan, China's currency, was pegged to the dollar at 8.62Y/ USD. It has since moved up in value, but that's really not the point. Rather than focusing on the supply of yuan, China's monetary authorities chose essentially to import U.S. monetary policy. Particularly in the 1990s, this was a good idea. Money is a measure of value, and nothing else. As we saw in chapter 9 and our initial discussion of money, gold has historically been used to define the measure that is money because it has been so stable. And as Nathan Lewis's research has revealed about the dollar, its value from 1982 to 2000 "was crudely stable vs. gold around $350/oz."

If production rose in China, as it certainly has for decades, so logically would the supply of yuan rise with it. If it fell, so would supply in order to maintain the dollar peg. Production represents demand for money, so per Arthur Laffer, money supply is "demand determined."[6] It increases alongside economic activity that rates money in return for it. While Friedman was recommending a fixed supply of yuan without regard to production, China did the opposite and let production dictate supply. And with value of the dollar stable, so was the value of the yuan stable.

Indeed, it can't be stressed enough that money should be viewed in the way we view a ruler. We don't care about the supply of foot-rulers as long as they're twelve inches, and we similarly don't need to concern ourselves with how many or how few units of a currency there are so long as the currency unit is maintaining its value. If a currency is stable, it will be in plentiful supply in productive countries along with in productive parts of a country's economy.

To see how so-called money supply follows production, consider LeBron James. He earned $65 million in 2015 while living in Cleveland. Cleveland is somewhat of a depressed city, and any attempt by the Fed

to increase dollar supply in Cleveland wouldn't much succeed, owing to a lack of productivity around and inside the city. But tens of millions of dollars followed the very productive James as he returned to Cleveland ahead of the 2014–15 NBA. Money supply is an effect of prosperity, not a cause. Interesting about James's millions is that most are likely invested well outside of Cleveland.

Considering money supply more broadly, a visit to China quickly reveals where most of it has migrated since Gilder's visit to an impoverished country in 1988. Shanghai is a booming metropolis of frenzied production, skyscrapers, shimmering hotels, and brilliant houses. Money supply is abundant there and keeps flowing in, whereas in Kashgar, the westernmost city in China (it borders Afghanistan), there's quite a bit less in the way of money supply. What must be stressed is that Shanghai didn't win the lottery that Kashgar lost, such that monetary authorities planned abundant money in one city and very little in the other. Instead, Shanghai's production was a magnet for money, which logically migrates toward production. In Kashgar, substantially less production has resulted in substantially fewer Yuan.

At this point, readers are perhaps seeing that central bank attempts to "get control of their money supply" amount to a certain form of central planning. The supply of money can't be planned simply because central banks and governments couldn't possibly plan where production is going to take place. Money supply is an *effect* of production, not a driver of it. Ultimately, Friedman himself admitted that monetarism was unworkable, telling the *Financial Times* in 2003, "The use of quantity money as a target has not been a success. I am not sure that I would as of today push it as hard as I once did."[7]

So while Friedman ultimately admitted the obvious flaws in his monetary theory, disciples of Friedman that have emerged in modern times have not. They call themselves "market monetarists," but really they're promoting the same unworkable theory that Friedman abandoned three years before he died.

Market monetarists Ramesh Ponnuru and David Beckworth argued in the *New Republic* back in 2011, and amid weak economic growth, "What the economy needs now, contrary to the right, is a permanent monetary expansion. If the Federal Reserve delivers one, the economy, contrary to the left, won't need new federal spending—and won't suffer from spending cuts." The pundit in Ponnuru and the economist in Beckworth were

strongly suggesting that if the Fed simply increased the supply of dollars, the economy would allegedly grow because the Fed would presume to add dollars to the economy. More specifically, they called for the Fed to supposedly boost the economy with "a few years of faster-than-5-percent catch-up growth"[8] in the supply of money. Their view was that if the Fed had been engineering 5-percent money growth all along, the 2008 downturn wouldn't have happened. In a separate *National Review* column, they added that greater Fed focus on their 5-percent money growth targets would bring "nominal spending back toward its pre-crisis trend and keeps its future growth stable."[9] Writing on his own at *Bloomberg*, Ponnuru concluded:

> In targeting the level of nominal spending, the Fed would aim to ensure that total dollars spent throughout the economy grow at (say) 5 percent a year. In a year where the economy grew by 3 percent in real terms and the target was hit, inflation would run at 2 percent. The Fed would also commit to making up for undershooting that 5 percent target in one year by overshooting it the next, and vice-versa.

There is something plainly wrong about all this. For one, central planning as an economic policy died in murderous disgrace throughout much of the world in the late 1980s. Yet, the pundit and economist were explicitly calling for the Fed to plan money supply so that nominal spending could be controlled, along with GDP, inflation, and presumably unemployment? Once again, money supply is an effect, not a driver, of economic vitality. If it were the opposite, not only could the Fed engineer countrywide prosperity, but so too could sagging economies around the world. Wouldn't life be easy if growth could be planned by alleged "wise men" at the Fed, and any other central bank?

Back to reality: It's easy to see why what the "market monetarists" envision can't work, and also to see why Friedman abandoned such a plainly flawed policy. All we have to do is return to where this chapter began: Baltimore.

Let's imagine that the Fed, following the prescription of the market monetarists, were to deposit $5,000 in the bank account of every Baltimore resident. Or, even simpler, imagine a benevolent billionaire deposited $5,000 per Baltimore resident in Baltimore banks. On the surface, money supply in Baltimore would surge. But would it boost economic growth in any appreciable way? No. In fact, the money would exit Balti-

more almost as quickly as it reached bank accounts located in Baltimore. The reason for that is fairly simple. While banks have made some monumental errors in modern times, a quick drive around or train ride by Baltimore reveals that it's not a safe place to lend or invest money. An increase in Baltimore's money supply through the banking system would see it flow to better locales for investment almost immediately. Any bank that might attempt to do otherwise would quickly be asking for a bailout, as its local loans likely wouldn't be worth much.

What about Detroit? A major part of its tourist trade today isn't related to people coming to enjoy the city but to see its plethora of burned down and abandoned buildings.[10] Under the same scenario there, a money supply increase would be the definition of ephemeral.

Reducing all of this to the absurd, what if the Fed simply showered both cities with billions from helicopters? Logic dictates that most of the remaining residents would move out of Baltimore and Detroit altogether. Some would stay and shop, but even if they spent the money, the best spending options exist outside of both cities. Baltimore does have its Inner Harbor, but money spent there would be deposited at local Baltimore banks that would then make loans to individuals and businesses well outside of Baltimore. The focus on money supply presumes that its arrival is the source of production, but such a supposition is 100 percent backward. Money migrates to production; its arrival does not stimulate production. If this is doubted, readers need only consider the horrid track record of new stadiums in stimulating economic growth despite all the new "money supply" wrought by spending, or the economic aftermath of the Olympic Games in Athens.

Keynesians naively argue that government spending increases demand, but it doesn't. It merely increases government demand at the expense of reduced demand among those who produced the wealth. Monetarism is just another variant of Keynesianism that similarly, and incorrectly, assumes that demand is the source of growth.

In reality, demand *is the result* of growth; demand springs from production. Money creation for money's sake won't drive production, and hence it won't drive up demand. Money creation targeted at a lack of production is the same as shifting that same quantity of money to where there is growth. Adam Smith put it well in *The Wealth of Nations*: "The same quantity of money cannot long remain in a country in which the value of annual produce diminishes."[11] Since production is light in Detroit

and Baltimore, any attempt by the Fed or some billionaire to increase the supply of money in either city would fail rather quickly. The same rules apply to a country.

Monetarism is but the second leg of the Keynesian chair. While Austrians and supply-siders correctly reject the first two legs, modern Austrians have added a third leg to the Keynesian chair with their non-Austrian assertion that boom times are a function of government creating excess credit. Government can't create "excess credit" any more than it can spend us to prosperity. So-called excess credit from the Fed or any other government body is as much of an oxymoron as Keynesian "stimulus spending," because governments can only supply credit (access to real economic resources) that they've extracted from the real economy first. This is the opposite of stimulative, and because it signals government allocation of the economy's resources, it indicates a decline in the availability of credit necessary to fund real ideas. But even then the Fed's machinations are ephemeral—and thankfully so. Money misdirected to Baltimore wouldn't last long there.

While supply-siders are correct about reducing taxes, their celebration of the revenues that tax cuts often shower on governments amounts to tax cuts' addition as the fourth and final leg of the Keynesian chair. What supply-siders miss is that when government receives abundant revenues to spend, the massive tax that is government grows by leaps and bounds forever, thus neutering the genius of tax cuts. Some may protest that they can't control how much in the way of revenues the government receives. Yet, that's precisely why their promotion of tax cuts requires muscular discussion of how tax cuts will truly work best if they're paired with substantial shrinkage in the size of government no matter the level of revenues.

But back to the monetarist focus on money supply. Its leading lights continue to single out control of money as the source of prosperity. As part of their argument, they promote the falsehood that excessively tight money from the Fed, which, they argue, caused money supply to contract in the 1930s, led to the Great Depression. Once again, they get things backward.

For one, they forget that the Fed's sole role as of the 1930s was as lender-of-last-resort to *solvent banks* if interbank interest rates were excessively high. But as Nathan Lewis wrote in *Gold: The Monetary Polaris*, "The lending rate between banks of high credit quality was consistently low, indicating that borrowing was easy and cheap for solvent banks."[12]

In short, even if one accepts that the Fed is necessary, there was no need for the Fed to act in the 1930s unless it wanted to lend to insolvent banks; the latter most certainly was not its mission at the time. As Lewis writes, "The Federal Reserve did exactly what it was designed to do during that period."

Why the collapse in money supply? Readers probably already have a sense of why, particularly if they read *Popular Economics*. While there was nothing abnormal about the economic downturn that began in 1929, what *was abnormal* was that President Herbert Hoover, followed by President Franklin Roosevelt, mistakenly tried to intervene in what was healthy. Recessions, while painful, are a good thing. They signal an economy cleansing itself of bad businesses, malinvestment, labor mismatches, and so on. When recessions are left alone the certain result is an economic boom simply because the recession is the cure. Remember, economies are just individuals, and individuals do best when they're forced to fix their mistakes. Intervention in the process of the economy fixing itself was the first major blunder.

Worse was how these presidents intervened. The short version is that Hoover signed an increase of the top tax rate from 25 to 62 percent, and then Roosevelt eventually followed with a hike all the way to 83 percent. Both approved major increases in government spending, which are a tax like any other. Both instituted regulations that made hiring quite expensive, thus pricing eager labor out of the market. Hoover passed the Smoot-Hawley Tariff, which taxed foreign goods exported to the United States and thus subsidized the weakest U.S. economic sectors at the expense of the most productive. Roosevelt devalued the dollar from 1/20th of an ounce of gold to 1/35th, which made investment (remember, investors are buying future dollar income streams when they put credit to work) in existing and future companies quite perilous. Pouring gasoline on the fire, Roosevelt passed the undistributed profits tax of 1936, which taxed companies at rates up to 74 percent on any earnings they retained with an eye on future expansion.[13]

It can't be forgotten that economic growth is as simple as reducing the tax, regulatory, trade, and monetary barriers erected by government. But in the 1930s, every one of those barriers increased. The result was a decline in the very production that commands money in return for it. The decline in money supply in the 1930s was an effect of horrid policy, not a driver of the economic malaise. Returning to Adam Smith, "The

same quantity of money cannot long remain in a country in which the value of annual produce diminishes." Production declined in the 1930s thanks to numerous policy errors, and money supply fell in concert with the slower production. The monetarist analysis is backward.

Yet there remains another question about Baltimore. Any attempt by the Fed (or any other entity for that matter) to increase money supply there would fail, as we have made clear. Owing to a lack of production, money supplied to Baltimore would exit as quickly as it arrived. But where would it go?

It would follow production to wherever it might exist. It would migrate to Beverly Hills, the Upper East Side of Manhattan, Seattle, Greenwich, Orlando, Minneapolis, and Portland. During the weak dollar years, it would have found its way to fracking locales in Texas and North Dakota. As of this writing, with the dollar stronger alongside a slowly reviving economy, it's fair to say that much of the new money supply would find its way to Silicon Valley.

Think back to the discussion in chapter 4. Silicon Valley is in the midst of another boom. There are more than 124 unicorn companies in the Valley that can presently claim private valuations of $1 billion and above. Of course, the unicorns are mere minnows relative to the larger public companies that are worth a great deal more. American Enterprise Institute scholar Bret Swanson has noted that the "market value of seven American technology firms—Apple, Google, Facebook, Amazon, Oracle, Intel, and Microsoft—totals $2.3 trillion, more than the entire stock markets of Germany or Australia."[14] Five of those seven are based in Silicon Valley.

To be clear, Silicon Valley doesn't have a money-supply problem. So aggressively is money chasing all the innovative production in northern California that even the chefs that work at high-flying tech companies are in play.[15] Money follows production, and at least for now, Silicon Valley is one of the more popular destinations for the money that can command real economic resources. If the Fed were to drain money out of every bank in Silicon Valley, the money supply siphoned away by the Fed would return to this thriving area south of San Francisco almost as quickly as the first batch departed.

And while *Popular Economics* discusses monetary policy in greater detail, it's worth closing this chapter with some thoughts on an ideal dollar policy. What this chapter hopefully has revealed to readers is that

any attempt by a monetary authority to control the supply of money is the equivalent of that authority presuming to centrally plan production. Once again, money is an effect of production, so its supply can't be planned.

Beyond the monetarist prescription, which is wholly unworkable, there's the solution that many supply-siders frequently offer. Figure the Constitution empowers Congress "to coin money, regulate the value thereof," and "fix the standard of weights and measures.'" If so, the easy answer is for Congress to redefine the value of the dollar in terms of a commodity known for stability, like gold, and let the market price of gold regulate how many dollars the economy requires. For the sake of discussion, let's define the dollar as 1/1000th of an ounce of gold. If the price of gold rises above say $1,000/oz., then that would be a signal of too many dollars in the economy. If it were to fall below $1,000, then that would be a signal of demand for dollars outstripping supply. To operate, such a system wouldn't require the Fed, either. Nathan Lewis could design such a system between breakfast and lunch.

Perhaps an even better solution would be for Congress, once again per the Constitution, to simply define the dollar (let's again assume at 1/1000th of an ounce of gold), only to leave the creation of actual money to the private sector. That was von Mises's point when he observed that absent government-issued money supply, "commerce will create for itself other media or circulation, such as bills, which will take the place of notes." Austrian thinkers have long argued in favor of competing private currencies. Assuming a legal definition for the dollar, it's folly to assume that private issuers wouldn't create a dollar measure redeemable for 1/1000th of a gold ounce.

Today, retailers accept all kinds of credit cards, and if private money were legalized, so would they accept certain brands of a "dollar" legally defined as 1/1000th of an ounce of gold. Gradually, a few currencies would win out as money par excellence. Interesting here is that Bitcoin isn't one of those currencies. Thanks to the creators of Bitcoin's Friedmanite focus on coin supply, the value of each Bitcoin is notoriously volatile. That's a problem, because money is best when it's stable. Future private currencies will focus on stability of value over supply, and the result will be quite special.

Along the lines of the above paragraph, arguably the best answer in light of the U.S. Treasury's sad oversight of the dollar in modern times is to fully legalize private money without any Treasury or congressional

input. Perfect money is that which is unchanging in value. Market actors produce all manner of other necessary goods. Why not empower them to compete on money, too?

What we surely needn't ever worry about, however, is a lack of money supply. No productive nation will ever lack money supply, simply because production itself is a magnet for money. Just as we don't worry about where our shoes, socks, and T-shirts come from, it's fair to say we needn't worry about money either. So long as money has a legal, redeemable definition (and if it didn't, markets would come up with a definition), let the markets provide the money supply much as they do so many other goods we desire.

Quantitative Easing Didn't Stimulate the Economy, Nor Did It Create a Stock-Market Boom

You cannot step into the same river twice.

—Heraclitus

IN THE FALL OF 2014, the price of oil began to decline with great haste. While a barrel sold for more than $100 as recently as the summer of 2014, the price had fallen to $54 by December.

As the *Dallas Morning News* reported about the oil-patch carnage, "Oil prices are at their lowest level in five years. The cost to borrow money is rising rapidly."[1]

The energy sector was suffering a recession. Based on what we learned in chapter 9, we know why. Much of the abundant oil exploration activity made sense only insofar as the dollar was weak and the oil it was measured in appeared dear. But at $54, the price of oil had fallen below the break-even price of $60–$70 per barrel.

Markets are wise, and they adjust quickly. In response to a fairly rapid decline in the price of oil, credit for oil-exploration companies became more expensive. The *Dallas Morning News* report about a rapidly rising "cost to borrow" was the newspaper correctly reporting the obvious.

What is also notable about the rising cost of credit for the energy sector was how toothless the Fed's policies of low interest rates were. While it was holding its fed funds rate at "zero" in order to allegedly keep credit "easy,"

those with credit on offer had different opinions about the oil patch. With the price per barrel at \$54, credit for oil exploration companies would be expensive no matter what. The Fed was thankfully irrelevant.

Fast-forward to August 18, 2015, when the *Wall Street Journal* led with a front-page story titled "U.S. Lacks Ammo for Next Crisis." Reporters Jon Hilsenrath (the *Journal*'s lead Fed reporter) and Nick Timiraos reported:

> As the U.S. economic expansion ages and clouds gather overseas, policy makers worry about recession. Their concern isn't that a downturn is imminent but whether they will have firepower to fight back when one does arrive.
>
> Money has been Washington's primary weapon in the decades since British economist John Maynard Keynes proposed aggressive spending to battle the Great Depression. The U.S. generally injects cash into the economy through interest-rate cuts, tax cuts, or ramped up federal spending.[2]

At this point, readers are probably quite skeptical about the previous passage. Recessions are a sign of economic health; they are not situations to avoid. They signal a cleansing of all the ideas that are not economically viable. When recessions are allowed to run their course, the economy naturally benefits as bad ideas are starved of credit so that good ones can absorb underutilized economic resources. Recessions are a wondrous sign of a looming economic revival. No serious economist, politician, or civilian would ever want government to fight a recession short of aggressively reducing the huge economic burden that is government. Sadly, our federal government thinks it *should* fight recessions, and that it has the spending and interest-rate tools to do so. Such thinking is erroneous.

Federal spending isn't stimulative, simply because Congress can only spend what it's extracted from the real economy first. When Congress doesn't spend, or better yet, when it spends a lot less, the real economy can allocate what Congress doesn't consume to all manner of market-disciplined economic ideas.

Interest rates? As we see with the oil patch, it's somewhat of a toothless concept. There are no credit fairies that can produce economic resources on the cheap out of nowhere. So while the Fed presumes to make credit easy, the markets as always—and quite thankfully—march to the beat of a different drum. No matter the Fed's "easy credit" intent, oil companies were going to have to pay high rates of interest to attain credit.

At this point, it's easy to see why market discipline is so valuable. Lest we forget, when oil companies (or any other kind of company) go into the market to borrow "money," they're in fact looking to borrow real economic resources. Per von Mises, "He who tries to borrow 'money' needs it solely for procuring other economic goods."[3]

Notable here is that oil companies had, until 2014, been a "size borrower" of economic goods. From 2010 until the late 2014 oil-price decline, oil companies had borrowed almost $200 billion.[4]

What all of this should remind us is that credit is precious; it represents real resources. Of course, that's why the cost of borrowing rose so rapidly for oil companies once the price of oil started to collapse. Once oil extraction became less profitable than it had been, the cost for oil companies to access real economic resources naturally increased.

Now, consider the reverse. Imagine if the Fed had total control of credit such that it could "cushion" downturns by flooding ailing companies with the economy's limited resources. If so, readers can doubtless see that we'd suffer very weak economic growth as a rule.

Indeed, it's not as though a failure to lend to oil companies would signal a lack of overall credit in the economy. Real resources never lay idle. Someone somewhere is always borrowing or seeking investment in order to access resources with an eye on growth. While credit for oil companies is presently tight, it is quite a bit looser for technology companies in Silicon Valley, Austin, and Boston's Route 128. What oil companies don't consume will find its way somewhere else. The money, which represents access to resources, migrates to production. As of this writing, oil companies can't produce as profitably as they did a few years earlier. But as evidenced by the 100-plus unicorns in Silicon Valley, credit formerly showered on the energy industry has found new homes.

Put more simply, a Fed that could eternally prop up what the markets do not desire would prove a huge barrier to growth. Thankfully, the Fed is not the source of all credit. If so, there would be no economy in the United States. Our streets would resemble those in Haiti or India.

Hilsenrath and Timiraos wrote with some alarm that the "U.S. Lacks Ammo for Next Crisis," and for that we should be ecstatic. Government cannot invest wisely. What it can do is the equivalent of keeping Hoke on the sidelines at Michigan, Friendster flush with cash, and Beatty set to helm *Town & Country II*.

So while the Fed cannot wreck the economy in total with its cruel version of compassion, it certainly can do major damage with its extraction of a portion of the economy's credit. Although the Fed has no credit of its own, as the U.S. central bank it is empowered to redirect some credit to what it deems worthy. We've seen this in recent years with its "quantitative easing" (QE) program. Never fear. The description of QE is fairly simple.

Worried about the health of the economy in 2008, the Federal Reserve (first under Ben Bernanke, and later under his successor, Janet Yellen) over the next six years proceeded to borrow reserves from the banking system[5] so that it could buy trillions worth of U.S. Treasuries and mortgage-backed securities. It did all of this with an eye on getting a sagging U.S. economy moving again.[6] Yellen explained the program to *Time* in 2014 as a policy "aimed at holding down long-term interest rates, which supports the economy by encouraging spending."[7] It's worth spending some time to point out all that's wrong with Yellen's assertion.

For one, government need never implement policies designed to encourage spending. As individuals, we're wired to demand things, and our wants are unlimited. But since production is the source of demand (spending), we must produce first so that we can spend second.

Indeed, if all we did was spend, we'd still be living in caves. True economic advancement results from entrepreneurial ideas being matched with savings. It is thanks to savings that the economy has abundant resources, such as tractors and computers. Importantly, the savings that led to these advances have logically made us exponentially more productive such that our spending power has been greatly amplified. Assuming QE boosted spending more than otherwise, far from stimulating the economy, it in fact slowed it down by reducing the stock of savings available to fund economic advances that would make us even more productive, and thus able to spend more.

As for QE allegedly "holding down long-term interest rates," remember, the Fed has credit to allocate only insofar as it extracts it from the real economy. Just as governments can't spend without taking resources from the private economy first (thus reducing consumption in the private economy, by definition), the Fed can't borrow trillions from banks without removing trillions worth of credit from the private economy. Had it not borrowed those trillions from the banks, it's not as though the

trillions would have sat idle in bank vaults. Banks cannot pay for deposits without lending them out. They would be bankrupt if they did.

Not only could the Fed not make credit more available by extracting it from the private economy, but its efforts to keep interest rates down also didn't much change the on-the-ground reality in the real economy. Think back to the oil industry example that began this chapter. No matter how the Fed influences the rate at which banks lend to one another, or even the interest rates on longer-term U.S. Treasuries, it can't change the fact that noneconomic ideas are going to experience rapidly rising borrowing costs.

Some may argue that the Fed's efforts to hold down rates made credit access slightly easier owing to its Treasury-buying pushing down interest rates on Treasuries (the more valuable a bond is, the lower its interest rate). But what can't be forgotten are the trillions worth of credit that the Fed extracted from the private economy in order to push those rates down. What the Fed giveth, it first taketh from the private markets. Simple logic says that QE didn't make borrowing easier.

All of which brings us to what the Fed spent the trillions it borrowed from banks on: U.S. Treasuries and mortgage-backed securities. To believe the popular notion that QE stimulated the economy one would have first to believe that the Fed's subsidization of federal spending and borrowing somehow gave the economy a boost. If so, one would have to conclude that Paul Ryan and Nancy Pelosi are more skillful at allocating the economy's resources than are Warren Buffett, Jeff Bezos, Peter Thiel, and other captains of industry.

Furthermore, a believer in the allegedly stimulative nature of QE would have to think that the economy is enhanced when the federal government creates programs that last forever and continuously cost the taxpayer more money no matter their efficacy or economic benefit. In short, you'd have to believe that increased funding on an annual basis for Friendster-equivalent government programs is better for the economy than leaving the credit in the private economy so that investors can put it to work. Sorry, but such a presumption is not a serious one.

Mortgage-backed securities? As we already know, the purchase of a house is consumption, not investment. That purchase doesn't create factories, software, and transportation advances. What the Fed perhaps forgot in attempting to prop up the housing market was that market indices had, in 2008, resoundingly rejected further allocation of limited resources to the housing sector, which was depriving the productive

parts of the economy of credit. Moreover, the banking sector was so over-exposed to the housing market back in 2008 that many of the biggest names in finance were brought to their knees by their error.

Yet the Fed, in its infinite un-wisdom, chose to double down with credit extracted from the private economy on something that markets had loudly rejected. To write about the thinking that underlay QE is to marvel at the stunning lack of common sense that drove the Fed's actions. Markets had made plain that housing no longer required investment, yet the Fed directed trillions of our wealth toward housing anyway. For one to believe that any of this was stimulative amounts to willful blindness of gargantuan magnitude. But the sad story of QE gets even dumber. Please read on.

Despite the shockingly obtuse actions of our central bank, a resilient economy managed to slowly recover despite the Fed's extraction of trillions worth of credit from it. Amid the rebound, the stock market began to rally. Amazingly, the consensus was that QE was the driver of it. Morgan Stanley senior managing director Ruchir Sharma was hardly alone when he wrote in a *Wall Street Journal* op-ed, "Talk to anyone on Wall Street. If they're being frank, they'll admit that the Fed's loose monetary policy has been one of the biggest contributors to their returns over the past five years."[8]

Sharma and many others embraced the idea that the Fed's QE policies created lots of dollars in search of return, and then the central bank's pursuit of a zero interest rate caused yield-hungry investors to park their easy money in the stock market over lower-yielding bonds. Apparently, government manipulation of markets works after all. Or maybe not.

Indeed, the accepted wisdom about the bull market raised many simple objections. First, the Fed's imposition of artificially low interest rates on the way to supposedly easy credit would have to have been one of the few instances in global economic history of price controls actually leading to abundance over scarcity.

Second, if the pursuit of yield was what was actually luring investors into rapidly rising shares, logic dictates that Treasuries and corporate bonds would have been declining in value, a reflection of investor flight away from that which was prosaic and yielding little. The problem there was that yields on Treasuries and corporate bonds remained low throughout the program.

Third, and assuming the supposed flight of easy money into equities, one investor's purchase of shares is another investor's sale. An investor

rush into equities with allegedly easy Fed money by definition signals a perhaps wiser investor exit from those same equities. There are no buyers without sellers, except in the unreal world inhabited by members of the Fed. Supposedly, these charitably average individuals, who have "a 100 percent error rate in predicting and reacting to important economic turns," according to John Allison, and who act as though there are buyers without sellers, let alone that there are borrowers without savers (what else could explain their decision to lower the Fed's rate to zero?), can engineer rallies. Basic common sense says that they could not have done what the consensus said they did, because in the real world, there are buyers *and* sellers.

Let's bring von Mises back into the discussion of how markets work:

> Even prices that are established under the influence of speculation result from the cooperation of two parties, the bulls and the bears. Each of the two parties is always equal to the other in strength and in the extent of its commitments. *Each has an equal responsibility for the determination of prices.*[9]

Fourth, markets never price in the present; they price in the future. With the quantitative easing side of the Fed's intervention over by October 2014, and its end well telegraphed before then, wouldn't investors have long before rushed out of the very markets that this easing allegedly caused them to rush into? Yet, the stock-market rally continued well into 2015.

The common answer to the above is that markets were so overly manipulated that equity prices reflected their being the only game in town for investors who wanted some semblance of return. But to believe this, one would have to believe that central bankers suddenly figured out how to engineer bull markets.

The problem with such an assertion, particularly one that says low rates push investors into stocks, is that the latter has been policy from the Bank of Japan since the 1990s. Low interest rates across the yield curve have long been the norm for Japan's central bank, as has quantitative easing (Japan's economy has suffered 10 doses of QE from the Bank of Japan[10]). Yet, the Nikkei 225 is still half of what it was in the late 1980s.

Moving to China, its stock markets started to buckle in August 2015. Worried about stocks falling further, the Chinese government spent tens of billions of yuan trying to prop the market up.[11] It failed. Logically.

Importantly, a major market decline, like what occurred in Japan, and

a collapse, like in China, is what one would generally expect from central bank manipulation of rates and credit, and in China, stock market indices. As we learned in often-bloody fashion in the twentieth century, governmental attempts to plan markets always end in failure. Because they do, and because markets discount the future, one would have to believe that economists at the Fed were intensely market savvy such that their interventions were actually doing some good; that, or they know how to trick investors about the good of intervention in ways that central banks up to now haven't known. The second scenario seems unlikely for equity markets as deep and informed as those based in the United States. As for the first, the idea that extracting trillions from the economy to buy Treasuries and mortgage securities could stimulate the economy and markets is not fit for serious discussion.

Beyond all that, readers need only think back to the necessity of recessions. They're essential because they're an economy's way of cleansing all the bad stuff from it. The nonallowance of recessions means, to varying degrees, that the credit-destroyers get to continue destroying credit at the expense of new and better ideas that fuel booms. Stock markets are no different. Left alone, corrections are healthy for forcing the same purge that recessions do. An unwillingness to allow a cleansing means that too many lousy businesses are hogging always limited credit. By definition, this will prop up numerous laggards and render any subsequent rallies less vibrant. As Los Angeles fund manager Mark Johnson (founder of Growth Strategies) likes to explain it, "We have the fall and winter to clear out the excess built up in the spring and summer."

Some readers may question the view that the Fed's wildly obtuse imposition of QE was not the source of the (2009–present?) stock-market rally. If so, your author is relieved to respond. Indeed, the dismissal of the previous argument, which was meant to expose all the flaws in the theory that the Fed authored a stock-market rally, if nothing else proves that the central bank is way too powerful, and to the detriment of the economy and the stock market.

Indeed, if readers believe that the Fed can artificially engineer good times that block out the bad, what they're really saying, perhaps unwittingly, is that the Fed is powerfully robbing us of exponentially greater prosperity by virtue of allegedly giving us mildly good times. That's the case because just as nature is nature, and economies are individuals, so are stock markets simply collections of companies. If the Fed is truly

propping up weak companies in the stock market, just think how much healthier the stock market would be if the truly weak were allowed to implode so that the strong could access the resources utilized in subpar fashion by the weak, all the while luring the investors in the weak to their shares? In short, if people can disprove this chapter's argument that QE did not create an economic or stock market boom, that in fact it "achieved" both, then they've made my argument for me about the importance of abolishing the Fed.

Until then, the seen is what the stock markets did despite the horrid implementation of QE. The unseen is how much higher U.S. markets would have risen in the aftermath of 2008's correction, absent the Fed's meddling. Stated simply, just as a recession left alone is the surest signal of a coming economic boom, so is a bear market left untouched a sign of a roaring bull in the offing.

As for the rally that did take place, as opposed to the Fed being the source of exuberance, it seems more realistic to point to the gridlock that has prevailed in Washington since early 2012. The latter would seemingly have been a more likely driver of optimism for it having somewhat removed government as a risk to future returns. And while the same would be said if it were a Republican in the White House, it's worth pointing out that President Obama's presidency for the most part happily ended in a legislative sense at the end of 2012.

We also can't forget how a strong dollar in the 1980s and 1990s coincided with booming equities. Remember, when investors invest, they are buying future dollar income streams. The value of the dollar has soared against gold since August 2011. Let's also include Ben Bernanke's merciful departure from the Fed—Bernanke was the original author of the offense to common sense that was QE—thanks to Obama's wise decision to not reappoint him. Although Yellen continued the QE program for a time, she shut it down in 2014. Regardless of her, or Bernanke's, scarily obtuse views about how an economy grows, Yellen's Fed is less activist than was Bernanke's.

It's highly unlikely that the cause of the bull market was the Federal Reserve's extraction and reallocation of resources toward government spending and housing consumption. Those who believe otherwise must conclude, by their own illogic, that the end of the twentieth century, when decentralized markets ably exposed central planning as fatally flawed, was all a mirage.

The Fed Has a Theory, and
It Is 100 Percent Bogus

It is simply absurd to argue that increasing unemployment
will stop inflation.
—Robert Mundell

IN 1970, Dallas-based technology company Texas Instruments brought to market the first pocket electronic calculator. While it's hard to imagine today, the adding and subtracting machine retailed for $400.[1]

At present, Amazon retails all manner of pocket calculators, generally in the $3 to $5 price range per instrument. A packet of six on the site goes for $23.99. Calculators come as part of the package with Microsoft Windows and other software programs.

Here lies the beauty of economic progress, specifically economic growth. Individuals grow rich in a capitalist society by virtue of turning obscure and expensive luxuries solely enjoyed by the rich—from the car to the computer to the cell phone—into inexpensive goods for all income classes to enjoy.

It bears repeating that the best way to speculate on how the poor and middle class will live in the future is by observing how the rich live today. Odds are good that within the next two decades, private air travel, which the rich enjoy to the exclusion of the rest of us, will morph into an everyday service that all American income classes will utilize.

The only barrier to advances that transform the luxuries of the rich into common goods is government. It alone has the ability to erect the

tax, regulatory, trade, and monetary barriers to production that will slow beautiful economic evolution. On the other hand, if the electorate votes in politicians who are eager to roll back the size and scope of government, readers can rest assured that the future will be abundant, and all about lower prices for once exceedingly expensive goods. Such is the ease and genius of economic growth.

What is interesting about what is also so basic is that the Fed disagrees. In light of the vandalism to basic economics that was quantitative easing, maybe we shouldn't be surprised.

To understand the source of the Fed's disagreement, it's useful to cite a column that the *Wall Street Journal*'s Ben Leubsdorf penned in August 2015. He wrote, "Federal Reserve officials might raise interest rates soon because they have a theory: Falling unemployment pushes up prices and wages, requiring tighter credit to keep inflation in check."[2]

The Fed's theory about economic growth being the source of inflation came from the late economist A. W. Phillips. He purported to prove that if the very investment that leads to job creation becomes too abundant, the economy somehow suffers inflation related to too many people working. Apparently, prosperity's downside is that too many people have jobs, demand for workers outstrips supply, and the result is higher inflation.

The Fed very much stands by this theory. As David Altig, research director at the Atlanta Fed, told Leubsdorf, "We haven't lost faith in the [Phillips curve] framework."[3] As Donald Kohn, former Fed vice chairman, stated in 2008, "A model in the Phillips curve tradition remains at the core of how most academic researchers and policymakers—including this one—think about fluctuations in inflation."[4] Fed Chairman Yellen certainly believes in the Phillips curve. Talking in February 2015 about what the Fed deems inflation, Yellen offered: "Provided that labor market conditions continue to improve," the Fed will hike the fed funds rate when it's "reasonably confident that inflation will move back over the medium term toward our 2% objective."[5]

There's clearly reason for skepticism about what the Fed deems the cause of inflation. Figure economic growth is a sign of advancing economic conditions that lower prices, not increase them. All that, plus it's hardly true that the labor market is static when we consider the arrival of new workers to the same market on an annual basis. But for now, it's worth considering the Fed's conceit about managing economic growth,

along with its version of inflation by fiddling with the rate at which banks borrow from one another.

That is the case because banks are but one source of lending in the economy. And as the chapters on banking reveal, banks are a shrinking source, representing around 15 percent of the total lending. Intuitively, we know this to be true. No matter the interest rate set by the Fed, the cost of credit varies across the economy: it's tight for moviemakers; it's paid for by technologists with equity stakes to venture capitalists; less proven companies pay "junk" rates of interest for access to economic resources; oil companies, at the moment, pay more for credit in light of how perilous it is to drill for oil with the price well down from highs set earlier in the 2000s.

Of greatest importance, the banks that the Fed interacts with in supplying them with dollar credit have it only insofar as the Fed extracts it from somewhere else in the economy. The Fed doesn't have tractors, computers, and desks in warehouses that it can lend out. When it "eases" or "tightens" credit, it at best, distorts where economic resources migrate. Thankfully, it doesn't distort the flow of resources too much. We know this is true because if the Fed were the source of resource access, then the U.S. economy would resemble Haiti's. Assuming the Fed simply creates money out of thin air, as some pundits like to say, doing so doesn't increase the amount of credit available. At best, it disrupts the natural market-driven process whereby resources are allocated.

But the good news, once again, is that the market for credit dances to the tune of a song that isn't playing at the Federal Reserve. Even if the Fed "tightens," the supply of dollar credit is global. Here's how the great Arthur Laffer explained it to the late Robert L. Bartley (legendary editor of the *Wall Street Journal's* editorial page) in the 1970s. As Bartley recalled in his wonderful book *The Seven Fat Years* (1992),

> Laffer would draw a tiny black box in the corner of a sheet of paper. "This is M-1," currency and checking deposits. A bigger box was M-2, including savings deposits. Still bigger boxes included money-market funds, then various credit lines. Finally, the whole page was filled with a box called "unutilized trade credit"—that is, whatever you can charge on the credit cards in your pocket. Do you really think, he asked, this little black box controls all of the others. The money supply, he insisted, was "demand determined."[6]

Taking this further, Bartley recalled the wisdom of 1999 Nobel Laureate Robert Mundell, who also regularly attended the gatherings with Bartley, Laffer, and other supply-side thinkers. Mundell pointed out what remains true today: Most "dollars" (two-thirds to be exact[7]) are outside the United States in banks, money-market accounts, and other savings vehicles far from the Fed's meddling. Mundell told Bartley that "if the Fed tried to squeeze" the supply of dollar credit, dollar supply held in institutions well outside the U.S. banking system "would grow faster to meet demand and make up the difference."[8]

The Fed is often seen as the sole bank teller, but the happier reality is that the sources of dollar credit, which represent access to real economic resources, are both domestic and global in nature. They're also increasingly controlled by entities that don't interact at all with the Fed. It's popular to suggest that the Fed "controls the money supply," but going back to chapter 16, any attempt by the Fed to flood Baltimore with dollar credit would fail almost immediately. With economic activity increasingly scarce in Baltimore, any attempts to supply local banks with credit would quickly result in those same banks lending the dollars to individuals and businesses well outside of Baltimore. At the same time, if the Fed were to drain of dollars all banks in and around Silicon Valley, supply of the same from financial institutions and companies around the world would quickly grow faster to meet the intense dollar demand that results from all the productivity in Silicon Valley.

In the United States, efforts by the Fed to drain banks of dollar credit would simply cause other sources of dollar credit from around the world to make up for the Fed's decision. Credit is everywhere simply because, at its core, it's real economic resources. That's why even if the dollar were abolished in total as a medium of exchange; private actors would quickly create a dollar equivalent necessary to facilitate the exchange of, and investment in, production.

To all this, some might ask why the Fed can so easily spook stock markets with talk about raising interest rates. In modern times, there's been commentary about investor "tantrums" when Fed officials have merely talked about raising the funds rate. This commentary is misplaced. Remember, an investor can throw a "tantrum" and sell only insofar as a smiling investor is willing to buy what the apparently Fed-fearing investor wants to sell. Bulls and bears set the prices of shares together, while

the notion of an investor tantrum incorrectly presumes that markets have sellers only sometimes.

Still, it's a fair question about central bank rates, but one belied by Japan most notably. If low rates from central banks were the source of market rallies, then Japan's stock market would have soared over the last twenty-five years. Yet, the Nikkei is still trading at levels half of what they were in the late 1980s. Questioners would also have to explain the 1980s and 1990s, when U.S. markets rallied despite a much higher fed funds rate from our central bank.

The better response is to point out what's undeniably true: the Fed's attempts to influence the cost of real economic resources amounts to *market intervention*. History is clear that such meddling by governmental entities is a barrier to productivity, not a driver of it.

The Fed can't create the credit that is economic resources. However, it can influence the direction of some of the resources (think QE, among other examples) created in the private economy. What that indicates is that absent the Fed's obnoxious conceit, whereby it seeks to influence who gets what, we'd have market-disciplined forces allocating credit much more effectively, and at all manner of interest rates. Banks would still exist, too, but they wouldn't have their credit decisions influenced by the Fed; thus, they would be even more useful to real economic activity. And with the Fed having no influence on where economic resources flow (think QE again), the total credit available in the economy would be much greater. Stock markets, as logic would dictate, would surely be higher under a scenario of non-Fed intervention in the market. (Once again, see the failed central-planning experiments of the twentieth century.)

Yet, the popular view inside the Fed, namely, that economic growth is the cause of inflation, still requires a response. Hard as it may be for most readers to believe, the broad view inside the Fed is that too many people working and prospering will cause the economy to "overheat." Outwardly fearful of too much prosperity, the central bank explains that it must centrally plan economic growth that's weaker than would otherwise be the case in a free market. More explicitly, the Fed's policy—assuming a booming economy—is to *put people out of work*.

If all of this is doubted, consider a passage from Richard Nelson, former manager of banking research at the New York Fed, in a July 2015 *Wall Street Journal* op-ed. Nelson called for the Fed to raise interest rates:

"If the Fed waits until the natural rate of unemployment is reached, there will be many months when interest rates are too low. These low rates can cause the economy to overheat, putting pressure on prices."[9] What this passage immediately tells us is the Fed cannot control inflation, because what the Fed presumes to be inflation quite simply is not. Economic growth, no matter how robust, is never the source of broad pricing pressure. In truth, economic growth, almost by definition, is evidence of falling prices.

But first, it makes sense to address Fed presumptions that the United States is an island with no access to non-U.S. labor and production capacity. That's why the Fed thinks growth causes pricing pressure; basically, we'll run out of labor and production capacity. Yet as the sentient undoubtedly realize, U.S. companies regularly access labor and manufacturing capacity well outside of the United States. Lou Dobbs calls it "outsourcing."

Also, U.S. companies are constantly figuring out ways to attain more output with less in the way of labor inputs. This is called *productivity*. We live it all the time. Most of us no longer deal with a live human when we're at the bank, grocery store, and gas station, not to mention when we buy movie, airplane, or train tickets. Markets constantly innovate around the limits to labor imagined inside a Federal Reserve that is plainly untouched by the real world.

Indeed, if the Federal Reserve were more aware of what's happening out here, it would know that economic growth is evidence of price-shrinking advances in productivity. As we already well know, during the early part of the twentieth century, as the global economy soared, the price of a car plummeted. In the 1980s and 1990s, as the economy similarly soared, the price of increasingly advanced computers fell. With the proliferation of the Internet, the prices of most everything fell. My *Forbes* colleague Rich Karlgaard long ago tagged all this frenzied economic growth gifting us with falling prices as the "Cheap Revolution."

When you think about it, economic growth is always a Cheap Revolution. Spurts of growth turned former luxury items, such as the car, mobile phone, computer, and Internet, into common goods enjoyed by all. More to the point, when we consider what Fed economists deem "inflation," the car, cell phone, computer, and Internet are among the biggest *job destroyers* in world history. To put it plainly, the very prosperity that the Fed seeks to blunt is what erases the very labor "shortages"

the Fed naively deems inflationary in the first place. While the Fed is wholly confused about the nature of inflation, Fed officials also miss that the abundant growth they incorrectly fear as the source of inflation is in fact its cure.

Ultimately, the only true inflation is a decline in the value of the currency, in our case a decline in the value of the dollar. Importantly, the latter is the U.S. Treasury's responsibility.

The Fed has a theory about inflation that is 100 percent incorrect, because it presumes that prosperity is the cause of pricing pressure. Economic growth not only renders high prices low but also, by virtue of the productivity enhancements that growth signals, relieves the labor-supply pressures that a confused Fed deems one of prosperity's negative tradeoffs.

That the Fed can influence the direction of credit even a little bit is a major problem, simply because economic resources are precious. They are what entrepreneurs and businesses access on the way to creating the advances that author booming economic growth. What this tells us is that the Fed's meddling in the allocation of credit robs the economy of the advances that would lower the prices of luxuries that are currently enjoyed by the rich. In short, the Fed itself constitutes a barrier to the lower prices that we the people would all treasure.

For those who still believe we need the Fed to keep a lid on the "money supply," what can't be stressed enough is that our central bank cannot control that supply. Money migrates to production. So unless Fed apologists intend to empower the Fed to plan production, it will never be able to control the money supply.

The simple truth is that even if the Fed could drain the world economy of every dollar ever printed, money would still be abundant in the United States, simply because money is what the productive demand when they produce. It's what the productive utilize in order to exchange their production with others, and it's what the allocators of credit use to measure the value of their investments in existing and future business concepts.

Von Mises was right: No nation need ever worry about the proper supply of money. If the dollar disappears tomorrow, dollar substitutes will quickly fill the breach. They will, because money, while not wealth or credit, is an essential lubricant that the productive utilize to exchange wealth and credit.

Do We Really Need the Fed?

*Capital is always available; it's just a matter of what
the price, terms, and conditions are.*
—Robert H. Smith, former CEO of Security Pacific Bank

ACCORDING TO *FORBES*, Taylor Swift earned $80 million in 2015 alone. Having successfully crossed over from country singer to pop-music star-let, Swift is the picture of success: Her album *1989* has sold 3.6 million copies (and counting); she performs before packed *stadiums* as opposed to arena audiences; she possesses a songwriting gift and passion for music. The sky is seemingly the limit for the twenty-five-year-old performer.[1]

Yet imagine if one day Swift gave away all of her worldly possessions: the publishing and royalty rights to all of her songs, all the money in her bank and brokerage accounts, the houses and apartments across the country, and so on. What if she gave away everything except the clothes on her back?

While she would be poor in terms of net worth, she could walk into any bank, investment bank, hedge fund, and venture capital firm any-where in the world and quickly walk out with access to millions. This would be true even if the Fed hiked its funds rate to 10, 20, or 50 percent. The number does not matter.

Swift could access abundant economic resources just by showing up. Even if she gave everything away, she would still have her Promethean work ethic, her much-admired talent as a songwriter, and her ability to

entertain filled-to-capacity stadiums with her performing ability. Swift is the personification of "easy credit" any time, any day, and anywhere.

Reversing scenarios, imagine, if by some quirk in the federal sentencing system, that disgraced financier Bernard Madoff was released from prison. If so, no matter the Fed's loose stance, no matter the fed funds rate, and no matter the central bank's naive attempts to create credit with quantitative easing, Madoff would be shown the door by any respectable (or not-so-respectable) lender, no matter his willingness to pay usurious rates of interest for credit. At this point, it's worth quoting Hazlitt in longer form. As he said in *Economics in One Lesson*:

> There is a strange idea abroad, held by all monetary cranks, that credit is something a banker gives to a man. Credit, on the contrary, is something a man already has. He has it perhaps, because he already has marketable assets of a greater cash value than the loan for which he is asking. Or he has it because his character and past record have earned it. He brings it into the bank with him. That is why the banker makes him the loan.[2]

In a chapter about whether or not we need the Fed, the Swift and Madoff examples are a reminder of how unequal—and unnecessary—the Fed is to its task. As often is the case with government creations, the Fed presumes a one-size-fits-all solution for a vast collection of unique individuals. The Fed can decree credit easy, but in the real world people and businesses will be judged on their individual reality. Swift is an easy loan under almost any circumstance, while Madoff is a bad credit risk no matter the circumstance. Apple can borrow at some of the lowest interest rates in the world,[3] thanks to its vast array of amazing products desired by the citizens of the world. The U.S. Treasury can borrow (sadly) at the world's lowest rates simply because its debts are backed by the most economically productive people on earth.

Therein lies the Fed's power. It has no credit of its own, but since it is a creation of the federal government, which has credit in spades, courtesy of its overtaxed subjects, the Fed is able to influence (thankfully not too much) where some credit migrates. What a shame this is. Governments can spend only what they've taken from people first, and the Fed can't allocate credit that represents access to real economic resources without extracting those resources from the U.S. economy first. Why keep around that which intervenes in the natural workings of the markets? Didn't we

learn in the twentieth century (often through mass murder and starvation) just how dangerous it is to empower central planners?

One reply in the Fed's defense is that we need it to keep the U.S. banking system in sound shape. But the obvious problem with that claim is that the Fed has been a rather lousy regulator of the banks it's been told to oversee. As we learned in chapters 6 and 13, Ben Bernanke and Alan Greenspan were clueless about the problems bubbling up in banks related to subprime loans, and that eventually reduced many banks to bailed-out wards of the state.

Another reply is that banks need some backstop in case of near-term cash shortages. We know from chapter 13 that the Fed initially existed solely as a lender of last resort to *solvent banks* (my, how that had changed by 2008) in the 1930s. Still, if that was and remains the sole purpose of the Fed, then let's shut it down. As the quote from Robert Smith that opens this chapter reminds us, no well-run business or bank ever dies owing to a lack of money. Absent the Fed, all manner of cash-rich companies and individuals would eagerly lend to solvent banks, simply because they could get a good return for doing so.

So we don't need the Fed for the solvent banks, and if it's going to be allowed to operate in order to save the banks that can't get credit, that's another reason to shut it down. Those who think the banking system is important should wholeheartedly agree with this.

If we love the banks, if we think them essential for our economic health, then we shouldn't want the Fed to be lending to members of the banking system that are insolvent or unable to raise private credit. The existence of such "zombie banks" weakens the banking system overall. Failure is a source of strength, and to suggest that banks are different in this regard, that they can't be allowed to fail or are too big to fail, amounts to willful blindness. No economic sector and no economy can truly thrive if some participants—particularly the biggest ones—are a protected class.

This notion of the Fed as the lender of last resort is no longer relevant. Indeed, it's almost unthinkable. As Robert Smith put it in *Dead Bank Walking*, going to the Fed for a loan is "nearly unheard of."[4]

Indeed, a request for a loan from the Fed's "Discount Window" is an *admission of failure*. It is an admission that private market sources are so unimpressed with the requesting bank's assets that none would provide reasonably inexpensive credit to the bank. When Security Pacific ran into

trouble in the early 1990s and worried about insolvency, Smith warned one of his executives that seeking a loan from the Fed would "permanently destroy Security Pacific's reputation": "Even if we borrowed for only a few days, it would be a public relations catastrophe. We'd be a Wall Street laughingstock."[5] Security Pacific ultimately secured a loan from First Boston worth $1 billion in order to continue operating without Fed support. What Smith's story illustrates is that the Fed is now a lender of last resort only for banks that cannot secure private funding. Therefore, this function of the Fed must be shut down with the banking system and overall economy in mind.

Through a congressional mandate (aka the Humphrey-Hawkins Full Employment Act), the Fed is required to balance unemployment with inflation. But as the previous chapter made plain, the two have nothing to do with one another. It's also hard to control what one doesn't understand. To the Fed, inflation is caused by prosperity, at which point it strives to fiddle with interest rates and money supply in order to limit the economy's ability to grow. Yet prosperity is the enemy of rising prices, while money supply is a function of production. As for employment rates, unless people feel the Fed can fine-tune the infinite decisions that cause investors to invest, and business owners to hire, the notion of the central bank tinkering with job creation ought to horrify them.

All of which brings us to interest rates. As we learned in the introduction and chapter 1, an interest rate is a price like any other. As a price, the interest rate is meant to float to whatever rate maximizes the possibility that those who have access to credit (savers) will transact with those who need access to economic resources (borrowers). It's time to be serious here and to say what's true: Neither the Fed nor any governmental body could ever have a clue about what the proper price of credit is.

We don't let a central authority plan the cost of McDonald's value meals; central planners could never know what the best price point is for luring customers into McDonald's restaurants. In this case, we are talking about the cost of value meals, but with credit we're talking about the cost of accessing *all* the economy's resources. Allowing our central bank to meddle in that is not the stuff of a serious nation.

Worse, the Fed constantly exposes itself as comically unserious when it comes to planning credit. Whereas Uber raises the cost of accessing its drivers when demand for them is highest, as a way to make sure drivers are plentiful when and where they're needed most, the Fed, in its infinite

ineptitude, lowers the cost of accessing credit at the time when the desire for it is highest. Uber balances the needs of passengers *and* drivers, while the Fed acts as though the savers who make credit possible don't exist.

The logical and correct answer to all of this is that the Fed's zero-interest-rate regime of modern times is an admission from the central bank that it has failed miserably. Worse, those who presume to set the price of credit are not expressing much in the way of common sense. No serious economist would ever attempt to set the price of a market good at zero.

And so the real markets for credit happily move on without the Fed, pricing resource access at different rates to reflect the truth that all individuals and businesses are different. Meanwhile, the Fed resides in its unreal world, realistically one of children who believe something can be had for nothing.

End the Fed? *With great haste.* It's an offense to common sense. On its best days, the economists in the Fed's employ embarrass the profession by presuming to set the price of access to the economy's resources as though the tragedy that was the twentieth century's flirtation with central planning never happened. Happily, for all of us, the real market for credit exists well outside of the Fed's confused walls.

Still, we must end the Fed because on its worst days it does major damage. Leaving aside the bank bailouts that have weakened the banking system, the biggest danger with the Fed is that it has any role in the allocation of credit at all. The Fed wasn't "printing money" to conduct its horrid quantitative easing scheme; rather, it was doing something much worse. In borrowing trillions from America's banks while backed with America's credit, the Fed helped deprive the U.S. economy of a massive rebound that would have taken place absent the central bank and federal government presuming to allocate so many trillions of the economy's precious resources.

Once again, end the Fed. Its functions in no way add to economic growth; market interventions never do. Moreover, the very occurrence of said interventions holds back growth in substantial ways. For doing so, the Fed's machinations greatly reduce the amount of credit in the economy.

With all that said, readers beware. Ending the Fed does not get us out of the woods. The next chapter will show why.

End the Fed? For Sure,
But Don't Expect Nirvana

.

The credit of the English Government is so good that
he could borrow better than anyone else in the world.
—Walter Bagehot, *Lombard Street*, 105

IN HER EXCELLENT 2007 book, *The Forgotten Man*, historian Amity Shlaes describes early morning meetings at the Roosevelt White House. Shlaes excels at giving the reader a sense of being there, and here's how she set a typical morning scene in 1933 as Franklin D. Roosevelt still lay in his pajamas:

> They met in his bedroom at breakfast. Roosevelt sat up in his mahogany bed. He was usually finishing his soft-boiled egg. There was a plate of fruit at the bedside. There were cigarettes. Henry Morgenthau from the Farm Board entered the room. Professor George Warren of Cornell came; he had lately been advising Roosevelt. So did Jesse Jones of the Reconstruction Finance Corporation. Together the men would talk about wheat prices, about what was going on in London, about, perhaps, what the farmers were doing.
>
> Then, still from his bed, FDR would set the target price for gold for the United States—or even for the world. It didn't matter what Montagu Norman at the Bank of England might say. FDR and Morgenthau had nicknamed him "Old Pink Whiskers." *It did not matter what the Federal Reserve said.*[1]

In 1933, FDR made the decision to devalue the dollar from 1/20th of an ounce of gold to 1/35th of an ounce.[2] Forgetting the lesson of the early 1920s, when the integrity of the dollar was maintained, Roosevelt devalued the dollar and thereby marked the first time the United States defaulted on its debt.

As Carmen Reinhart and Kenneth Rogoff describe in *This Time Is Different* (2009), "The abrogation of the gold clause in the United States in 1933, which meant that public debts would be repaid in fiat currency rather than gold, constitutes a restricting of nearly all the government's domestic debt."[3] With the United States heavily in debt thanks to spending that was logically failing to stimulate the economy, FDR reduced the value of the dollars being returned to holders of U.S. debt.

Importantly, what Roosevelt did was much bigger than a default. I have already said it a number of times, but when investors invest, they are buying future dollar income streams. The dollar is the measure used in all such commercial contracts, yet by the proverbial stroke of a pen, those contracts and investments meant something quite a bit different.

Bringing Peter Thiel back into the discussion, "The value of a business today is the sum of all the money it will make in the future."[4] There are no companies and no jobs without investment first, yet FDR devalued the capital commitments made by the investors that are so crucial to economic progress. Perhaps even worse was the on-the-fly way in which FDR played around with the most important price (the dollar) in the world. Shlaes describes one morning meeting with FDR and his brain trust this way:

> One morning, FDR told his group he was thinking of raising the gold price by twenty-one cents. Why that figure? his entourage asked. "It's a lucky number," Roosevelt said, "because it's three times seven." As Morgenthau later wrote, "If anybody knew how we really set the gold price through a combination of lucky numbers, etc.; I think they would be really frightened."[5]

All of this is worth bringing up for the purpose of revealing, if nothing else, the terrible policymaking that needlessly elongated a downturn that, if left alone by Herbert Hoover and Roosevelt, would have been the source of a healthy economic rebound. Recessions, like market corrections, are an economy's way of clearing out all the debris on the way to boom times. The Great Depression did not have to be.

But for the purposes of this chapter, FDR's dollar meddling requires

discussion, because one of the most common objections to the Federal Reserve is that since its creation in 1913, the dollar has lost more than 90 percent of its value. It's a horrid number, and the unseen is the massive economic advances that would have made the abundant present seem impoverished by comparison but that did not come into being. However, this objection to the Fed is one of those instances where correlation is not causation.

Lest we forget, FDR decided to devalue the dollar, and per Shlaes, "It did not matter what the Federal Reserve said." Stated simply, the first major decline in the value of the dollar had nothing to do with the Fed. So incensed was Fed Chairman Eugene Meyer by FDR's decision that he actually resigned.[6]

Let's shift to 1944 and the Bretton Woods monetary conference at the Mount Washington Hotel. The U.S. delegation was led by members of the U.S. Treasury; assistant secretary Harry Dexter White was the lead U.S. delegate. With the dollar pegged to gold at 1/35th of an ounce, the currencies of the free world would peg theirs to a dollar that had a stable definition. At least from the standpoint of the United States, the global currency agreement, per Benn Steil's *The Battle of Bretton Woods* (2013), was largely a creation of the Treasury and the Roosevelt White House.[7]

And while there were sometimes large wiggles in the dollar price of gold in the aftermath of 1944, the dollar was defined as 1/35th of an ounce right up until 1971. President John F. Kennedy was needled about letting the dollar's price lapse, but his response in the early 1960s was revealing: "This nation will maintain the dollar as good as gold at $35 an ounce, the foundation stone of the free world's trade and payments system."[8]

As readers know, the next major devaluation of the dollar took place in August 1971, when President Richard Nixon decided to sever the dollar's peg to the yellow metal. Yet, once again, this was not a decision made inside the Federal Reserve. In fact, Fed Chairman Arthur Burns was passionately opposed to Nixon's decision. Voluminous history reveals this in certain terms.

In *The Age of Reagan: The Fall of the Old Liberal Order, 1964–1980*, historian Steven F. Hayward wrote the following about Nixon's gold decision: "Fed Chairman Arthur Burns opposed the move, predicting that the stock market would crash and that *Pravda* would have a field day by saying the abandonment of the gold standard was a sure sign of the collapse of capitalism."[9]

According to Allen J. Matusow's 1998 book, *Nixon's Economy*, after the meeting in which Nixon and his advisers decided to sever the dollar's gold link, "Burns stayed behind to make a last plea for gold," but also (perhaps fearful about his job) "to tell the president he would back him whatever he decided."[10] Fed "independence" has always been a myth.

In *Inside the Nixon Administration: The Secret Diaries of Arthur Burns, 1969–1974* (2010), Burns privately wrote about Nixon and his economic advisers' pursuit of an unhinged dollar: "Meetings during the past several months have finally convinced me that the ignoramuses around the White House, led by the fanatical [George] Shultz, have just about convinced the President that monetary policy is not what it should be. I'll do what I can to set him straight, because I hate to see him worry so unnecessarily about matters that he neither understands nor can do anything about."[11]

And when Nixon finally acted on the poor monetary policy advice that he was being fed, Burns confided to his diaries:

> My efforts to prevent the closing of the gold window—working through Connally, Volcker, and Shultz—do not seem to have succeeded. The gold window may have to be closed tomorrow because we now have a government that seems incapable, not only of constructive leadership, but of any action at all. What a tragedy for mankind![12]

Once the dollar was floating absent its golden anchor, it was Burns who campaigned to "restore as much of the old order as possible."[13] He was unsuccessful, and the dollar still floats without definition nearly forty-five years later. None of this is to defend the Fed, but the modern narrative tying it to the dollar's destruction is vastly overdone.

Moving to Jimmy Carter's presidency, the thirty-ninth president inherited a debased dollar thanks to Nixon's error. Here we learn, yet again, that presidents get the dollar they want, and without regard to the Fed. In a June 1977 speech, Treasury Secretary Michael Blumenthal intimated that even though the Japanese yen had crushed the dollar up to 1977, the dollar was still too strong.[14] The speech was a strong signal about Carter's dollar stance, and the dollar's value declined even more; from $140/ounce when Carter entered office to $220/ounce by 1979.[15]

Interesting about 1979, for those who feel it is the Fed's machinations that have debauched the dollar, is that Carter appointed Paul Volcker, an allegedly "tight money" supporter, as Fed Chairman in August of that

year. Yet, as another example of how the Fed isn't terribly relevant when it comes to the dollar's exchange rate (Fed officials generally don't talk about the dollar's value, leaving that to Treasury), the price of gold had soared to $875 by January 1980 amid the dollar's continued descent. Happily, for at least the next two decades, the dollar rebounded. Its rebound helped an economy reliant on investment begin to right itself.

What, or who, was the driver of the dollar's revival? The answer lies in the simple truth that markets never price in the present. They always reflect the future. In this case, Ronald Reagan's primary wins for the Republican presidential nomination started piling up in the early part of 1980. Even better, Reagan affirmed on the campaign trail, "No nation in history has ever survived fiat money, money that did not have a precious metal backing."[16]

Markets seemingly priced Reagan's victory before polling data and the pundits did, and as presidents get the dollar they want, investors weren't going to wait for Reagan's inauguration to begin correcting the dollar's value upward. In the booming 1980s, the dollar price of gold declined by 52 percent.[17] What is interesting about the 1980s versus the 1970s, for those who believe that the dollar's value is all about the Fed's "money supply" tinkering, is that, per Nathan Lewis's *Gold: The Once and Future Money* (2006), "base money" (the amount of currency held by the public along with reserves held by financial institutions with the Fed) grew 8.13 percent per year in the 1970s versus an average annual growth of 7.52 percent in the 1980s,[18] but with completely different results in terms of dollar vitality. This is a reminder that the president and the U.S. Treasury secretary trump the Fed in the crucial area of the dollar's value.

Readers already know from chapter 13 that the dollar continued to rise in relation to gold in the 1990s. President Bill Clinton's dollar policy was arguably even better than Reagan's, because his Treasury ceased any and all Japan bashing. This too signaled an administration that preferred a stronger dollar, and markets abided.

In the 2000s, the dollar sank again (see chapter 9 for the results). Money is just a measure, and it's not as though the dollar fell on its own with the arrival of George W. Bush to 1600 Pennsylvania Avenue. Instead, his Treasury's constant questioning of the importance of a strong dollar signaled a change in policy that was reflected in the greenback's decline. President Obama continued it with Tim Geithner at Treasury's helm during his first term (in this case bashing China's exports to the

United States). But since 2011, the Obama administration and Treasury have been rather quiet about China, and the dollar has somewhat revived.

If you doubt all of this, consider one of the bigger drivers of modern Fed hatred: quantitative easing. This hideous program lasted from 2008 to 2014. The Fed's wrongheaded borrowing of trillions from banks was written about all too often (falsely; the Fed did much worse than print money, as chapter 17 hopefully revealed) as "money printing." But as mentioned, the dollar has soared in value since 2011, as the gold price makes plain.

What needs to be stressed here, as *Popular Economics* does at length, is that the dollar should be neither strong nor weak. A truly strong dollar would be one that is unchanging in terms of value. A floating dollar robs money of its sole purpose as a measure meant to facilitate trade and investment. All that said, amid what the Fed's critics termed rampant "money printing," the value of the dollar increased for the last three years of it.

In brief, the dollar's value is a political concept, as opposed to a Fed concept. Reagan was realistically the last president to talk about the dollar, and that's unfortunate. To the extent that modern candidates talk about monetary policy, they talk about the Fed. And while the Fed deserves consignment to the dustbin of history, what bothers the Fed's critics the most is something the Fed has little control over. The weak dollar that has reared its ugly head on occasion over the last one hundred years has been a function of lousy presidents, not the Fed. This fact hopefully will remind readers that ending the Fed, while essential, will not fix all that ails us.

Another major source of modern Fed criticism is rooted in the Fed's close relationship with the banks it regulates, along with the bailouts of some of those financial institutions. That the Fed has "saved" banks like Citi so many times over the years has proven bad for the banking system, and bad for the economy since some institutions now owe their existence to government.

Still, it was Congress that passed the funding for the ill-conceived Troubled Asset Relief Program (TARP) meant to prop up banks that should have been allowed to go under. It was also rather threatening words from Treasury Secretary Henry Paulson that caused some banks that didn't even need the money to take it. John Allison was CEO of BB&T Bank at the time, and while his institution didn't need any relief, regula-

tors implicitly threatened his bank with a shutdown if it didn't accept the money that it didn't want, or need.[19]

Assuming the Fed closed its doors tomorrow, banks would still have strong political connections in Washington. Ending the Fed would in no way signal an end to the bailouts of banks and financial institutions. The economy will still suffer the ongoing policies that have made certain financial institutions a protected class. As Allison explained it, "It is very likely that without TARP, we would have had a deeper economic correction. However, it is also very probable that the correction would have been shorter and the long-term economic growth trend more healthy."[20]

But let's not forget what this book is about: credit. Credit, as readers well know by now, isn't money. If it were, we'd all have credit in abundance. When we seek "money credit" we're solely in pursuit of the real economic resources—tractors, computers, desks, chairs, labor, and so on—that money can procure. Credit is what we produce in the real economy. Assuming the Fed is properly relieved of its ability to misallocate a portion of the economy's credit (this form of relief quickly expanding the economy's supply of credit), we still have the federal government to contend with.

And lest we forget, our federal government has no resources. Its ability to redistribute credit is solely a function of what it takes from us first.

There are so many examples of this, but consider Fannie Mae and Freddie Mac. As of the fall of 2008, ahead of Treasury taking them into conservatorship, these two federally sponsored mortgage entities, according to Robert H. Smith, "carried on their balance sheets or had insured 57 percent of the $12 trillion of mortgage loans outstanding."[21] While housing is an essential market good, it still represents credit consumption. Housing doesn't make us more productive or lead to software innovations. When readers think about how much of their wealth has been consumed by housing, they must consider all the economic advances that never took place thanks to the politically correct obsession the political class has with housing people on the dime of others. Such waste hurts rich and poor alike.

Since the 2008–2009 recession, graduate school student debt has doubled to $1.19 trillion. And as the *Wall Street Journal* acknowledges, "Propelling the surge in grad-school debt is a welter of federal programs that make it easier for students to borrow large amounts, then have substantial chunks of those debts eventually forgiven."[22] Taxpayers once

again foot this bill with substantially slower growth, as innovative ideas in search of credit go wanting so that already flush institutions of higher learning can continue to raise tuition, well aware that a federal government will foot the bill using the money of others.

As we learned in chapter 7, Medicare, a program that was instituted at the cost of $3 billion in 1965, is projected to cost taxpayers more than $1 trillion within the next several years. All this spending, and the elderly still can't easily find medical care under the program.

Those are just three of countless examples. The point here is that the federal government is the biggest credit destroyer of all. It's not just the initial spending on wasteful programs that is so economy crushing; it's the fact that government programs almost never die, no matter their worth. Spending always and everywhere attracts special interest groups, so a dollar spent on a program in year one eventually turns into many dollars being spent on the same program years down the line.

Deficit hawks waste a lot of time worrying about the deficits that result from such spending. The better answer, once again, is that *all* government spending is deficit spending. Government has no resources other than what it extracts from us. The deficits aren't the horror show we'll leave future generations; the horror show is *now*, and we're its victims, through substantially less advancement and economic growth. The sad burden we'll leave future generations is a society much less evolved, and much less free, than it otherwise would be.

Importantly, ending the Fed won't alter the doings of the federal government, easily the biggest credit destroyer of all. Some will point to the Fed's subsidization of government spending through QE, and while unfortunate and economy sapping, let's not forget that long before QE was implemented, and long after it ends, the federal government could and can borrow more easily than any other entity on earth.

It can borrow with ease not because those running it have a clue but because the taxpayers shower it with trillions in revenues every year. The federal government's immense ability to redistribute trillions worth of economic resources annually is solely a function of those trillions, along with its ability to fleece you, me, Jeff Bezos, and everyone else. The federal government throws its weight around, but it's not its own. That weight was taken from us, and all the dollars spent should horrify us for their representation of all the innovations that never saw the light of day thanks to the economy-crushing burden that is our federal government.

In 2015, Wendy Guillies, president of the entrepreneur-focused Kauff-man Foundation, reported that more than half of young companies that sought credit had been turned down.[23] We already know that most economic participants thankfully ignore the Fed as they set the proper price of credit, and that most bank lending takes place away from the banks the Fed interacts with. Yet many young businesses can't access credit. No doubt some can't access it to the economy's betterment, but when we're looking to point fingers for a tight credit environment, our federal government requires prominent mention. The federal government consumes more than \$3.5 trillion in precious resources per year, so it's worth considering what businesses never get funding so that government waste can continue. Credit would be needlessly tighter even if the Fed didn't exist.

I do not write all this to alarm readers. I simply want to point that, assuming an end to the Fed, there's much more work to be done. After that, we must always be cheerful. Think of what we've accomplished *despite* this massive government burden that has consumed so much of what we've produced. Imagine then what we could achieve if it were smaller.

There's so much to be optimistic about precisely because the answers to our prosperity are easy. Reduce the weight on freedom and credit creation that is government, and the quick result of doing so will be immense prosperity. As the concluding chapter will discuss, there's an advance coming that has the potential to thoroughly change our economic lives for the better.

Conclusion: The Robot Will Be the Biggest Job Creator in World History

We come now to the last fallacy about saving with which I intend to deal. This is the frequent assumption that there is a fixed limit to the amount of new capital that can be absorbed, or even that the limit of capital expansion has already been reached. It is incredible that such a view could prevail even among the ignorant.
—Henry Hazlitt, *Economics in One Lesson*, 187–88

WE DON'T THINK very much about common goods such as the washing machine, car, computer, ATM, and Internet today. We don't need to. They're everywhere.

What's perhaps been forgotten is that all five are robots. They are robots because they are labor-saving devices. Before they existed, all kinds of human labor were required to fulfill the basic (washing machine) to advanced (Internet) functions that these, perhaps primitive, robots now handle for us. As a writer, I am horrified by the thought of writing a book without the Internet. Oh, my, the days and weeks it would take to search libraries and microfiche for the most basic of information sans the Internet!

Of course, that's why increasingly sophisticated robotic technology bodes so well for future economic growth. If we can mechanize certain forms of work on the way to even more abundant economic resources, then the credit necessary for amazing entrepreneurial advances will

grow by leaps and bounds. The washing machine is surely a basic kind of robot relieving us of work, but imagine more advanced robots, and the kind of toil *they* could save us from having to do. We'll be even more specialized in our chosen professions thanks to these advances, and let's face it, when we're doing what we love we're much more productive. Still, there are critics.

As robots increasingly adopt human qualities, economists are starting to worry. As the *Wall Street Journal* reported in February 2015, some "wonder if automation technology is near a tipping point, when machines finally master traits that have kept human workers irreplaceable."[1] Oh well, they've happily been doing this for quite some time as the opening of this chapter has hopefully revealed.

The fears of economists, politicians, and workers themselves are way overdone. They should embrace the rise of robots *precisely because* they love job creation. *Robots are credit creation personified.* When entrepreneurs borrow dollars with an eye on starting companies, they are borrowing real economic resources. Robots, by their very name, promise cheap resources necessary for entrepreneurialism in abundance.

After that, robots will ultimately be the biggest job creators, because aggressive automation will free up humans to do new work by virtue of robots erasing toil that was once essential. Lest we forget, there was a time in American history when just about everyone worked, whether they wanted to or not, *on farms,* just to survive. Thank goodness technology destroyed lots of agricultural work and freed up Americans to pursue a wide range of vocations off the farm.

With their evolution as labor inputs, robots bring the promise of new forms of work that will have us marveling at labor we wasted in the past, and that will make past so-called *job destroyers,* like wind power, water power, the cotton gin, the car, and the computer, seem small by comparison. All the previously mentioned advances made lots of work redundant, but far from forcing us into breadlines, the destruction of certain forms of work occurred alongside the creation of totally new ways to earn a living. Robots promise a beautiful multiple of the same.

To understand why, we need to keep reminding ourselves that what is saved on labor redounds to increased credit availability for new ideas. Jobs aren't finite; rather they're the result of investment. For every Google, Amazon, and Apple, there are tens of thousands of failed entrepre-

neurial attempts to be like one of the aforementioned giants (all three are major employers). But for entrepreneurs to make big experimental leaps, they must first have the credit to do so. The profit-enhancing efficiencies that robots personify (even to their most ardent critics) foretell a massive surge of investment that will gift us with all sorts of new companies and technological advances that promise the invention of new kinds of work previously unimagined.

There are no companies and no jobs without investment first, and the investors whose capital creates companies and jobs are attracted to profits. If they live up to their labor-saving billing, robots will generate massive profits that will lure even more investment into the companies and ideas of the future.

The above is what economists, politicians, and pundits too often miss. Far too many view economic growth through the prism of jobs created. This gets it 100 percent backward. If growth and prosperity were about job creation, then the solution would be simple: abolish tractors, cars, ATMs, light bulbs, and the Internet. Everyone would be working, but life would be marked by unrelenting drudgery.

In truth, economic growth is about *production*. It is about producing more with less. Thank goodness for that. In the world's poorest and most backward countries, seemingly everyone works all day and every day. But in the United States and other economically advanced countries that have embraced the robot-equivalents of the past, kids are free to enjoy childhood, the elderly are able to enjoy retirement, and mothers and fathers get to devote more of their time to watching their kids grow up. All of this is due to labor-saving advances throughout history that have showered us with staggering abundance for less and less in the way of labor inputs. Robots, once again, signal more of this wondrous same.

Fear of a less labor-intensive future scares people for two ill-conceived reasons. First, they presume that money is the same as credit. But if it were, then El Salvadorians could access as much credit as Americans do.

But as readers know well at this point, credit is access to real economic resources. In that case, when production soars thanks to labor-saving advances, so does the amount of credit available to entrepreneurs who are eager to innovate. And as history shows, innovation itself is the inventor of new forms of work. If this is doubted, consider the Internet. Twenty years ago most were largely unaware of it, but in 2015 millions of Americans have a job that is directly related to that which was irrelevant

in 1995. Millions more can claim work *related to the rise of the Internet* as a visit to Seattle and Silicon Valley quickly reveals.

The creation of working robots will itself lead to all manner of direct and indirect work opportunities, and then the production abundance that mechanized labor will bring once again promises an amazing surge of credit availability. The latter will fund plenteous investment in healthcare advances, transportation innovations, and new business concepts that will render the jaw-dropping technology of today rather quaint by comparison.

The second mistake that technology and robot skeptics make, and this is arguably the bigger one, is that they presume the nature of work is static. They believe there will be no replacement for work made redundant by progress. Undoubtedly, there were carriage drivers in the nineteenth century who sought abolishment of the car in order to remain employed in the twentieth century. Future writers will draw a similar analogy with the robot.

So while the car erased all sorts of job functions, the prosperity that followed its mass production clearly shows that much better jobs replaced the destroyed ones. Constant change is the stuff of a dynamic, advanced economy. It is in poor countries that the nature of work is static. In rich ones, we constantly innovate away the toil of the past in favor of more prosperous work forms that are less back breaking, consume less of our time, and best of all, maximize the possibility that we will be doing the work that most animates our individual talents.

People's wants are forever unlimited, and until capitalism fulfills every want, cures every disease, and feeds every human being on earth, *meaning never*, there will always be investment capital chasing advances and solutions. The definition of "work" is historical, and with the erasure of previous work forms by robots, humanity's genius will be freed to focus on infinite unmet needs in the marketplace that were previously ignored. Among many other maladies, the scourge that is cancer will be attacked by exponentially more investment, as well as by the minds that investment seeks out.

What of the Fed in all of this? Even the most congenital statists who naively believe the Fed creates credit will be wowed by what's ahead. The Fed, by definition, can't create credit, but more exciting is the fact that the credit surge the robot promises will render the Fed even more irrelevant in the economic scheme of things. If Congress doesn't end the Fed, the robot will.

This book has aimed to correct the silly views that credit is money and that absent the Fed we would have no money and no credit; the rise of the robot signals an abundant future of both. Production is the source of credit, and it is also a magnet for the money that represents access to real economic goods.

The talk right now is that a robotic future is nearing. If so, readers should rejoice. The labor saved by such a technological advance will gift us with an investment boom that will truly transform our lives and work for the better. The future can't come soon enough. Robots will be the biggest job creators in world history.

NOTES

INTRODUCTION

1. Alan S. Blinder, "Overselling the Importance of When the Interest-Rate Rise Begins," *Wall Street Journal*, August 13, 2015.

CHAPTER ONE

1. "Taylor Swift's Bite of the Apple," editorial, *Wall Street Journal*, June 22, 2015.
2. "Uber Valued at More Than $50 Billion," Douglas MacMillan & Telis Demos, *Wall Street Journal*, July 31, 2015.

CHAPTER TWO

1. Rob Cassidy, "Trojans Take the Crown," Rivals.com, February 4, 2015.
2. Joanne C. Gerstner, "Michigan Makes It Official: Jim Harbaugh Is the Football Coach," *New York Times*, December 30, 2014.
3. SR/College Football, http://www.sports-reference.com/cfb/schools/stanford/.
4. See Rivals.com.
5. SR/College Football, http://www.sports-reference.com/cfb/coaches/urban-meyer-1.html.
6. "Buckeyes' momentum boosts recruiting," *USA Today*, January 14, 2015.
7. Lindsay Schnell, "Unreal," *Sports Illustrated*, August 10, 2015.
8. USCFootball.com, http://www.usctrojans.com/sports/m-footbl/trojans-in-the-nfl.html.
9. Richard Boadu, "32 Minutes and 42 Seconds With Barry Switzer," *Grantland*, February 25, 2014.
10. Greg Bishop, "Who's Moved On? THIS GUY," *Sports Illustrated*, August 3, 2015.

11. Rivals.com Team Rank, https://sports.yahoo.com/texastech/football/recruiting/teamrank/.

12. Ibid.

13. Ludwig von Mises, *Human Action* (Atlanta: Foundation for Economic Education, 1998), 649.

CHAPTER THREE

1. Brian Grazer and Charles Fishman, *A Curious Mind* (New York: Simon & Schuster, 2015), 107.

2. Ibid., 36.

3. See AFI: http://www.afi.com/100years/movies10.aspx.

4. Peter Biskind, "Madness in Morocco: The Road to *Ishtar,*" *Vanity Fair,* February 2010.

5. Peter Biskind, *Star: How Warren Beatty Seduced America* (New York: Simon & Schuster, 2010), 488.

6. Ibid., 538.

7. Ibid., 527.

8. Ibid., 541.

9. Ibid., 542.

10. Ibid., 545.

11. Grazer and Fishman, *A Curious Mind,* 139.

12. Ibid., 101.

13. *Forbes,* http://www.forbes.com/pictures/mfl45ekhem/robert-downey-jr-20/.

14. Paul Scott, "From Washed-Up Drug Addict to $100M Man," *Daily Mail Online,* May 23, 2013.

15. Ibid.

CHAPTER FOUR

1. Claire Cain, "Wearing Your Failures on Your Sleeve," *New York Times,* November 8, 2014.

2. Mike Isaac, "Upstarts Raiding Giants for Staff in Silicon Valley," *New York Times,* August 19, 2015.

3. Thomas K. McCraw, *Prophet of Innovation: Joseph Schumpeter and Creative Destruction* (Cambridge, Mass.: Belknap Press, 2007), 70.

4. Ibid., 73.

5. Julianne Pepitone & Stacy Cawley, "Facebook's first big investor, Peter Thiel, cashes out," *CNNMoney,* August 20, 2012.

6. Peter Thiel, with Blake Masters, *Zero to One* (New York: Crown Business, 2014), 84.

7. Tim Harford, *Adapt: Why Success Always Starts with Failure* (New York: Farrar Strauss and Giroux, 2011), 236.

8. George Gilder, *Knowledge and Power* (Washington, D.C.: Regnery, 2013), 5.
9. Thomas Kessner, *Capital City: New York City and the Men behind America's Rise to Economic Dominance, 1860–1900* (New York: Simon & Schuster, 2004), 216.
10. Nick Schulz, "Steve Jobs: America's Greatest Failure," *National Review* online, August 25, 2011.
11. Dawn Kawamoto, Ben Heskett, and Mike Ricciuti, "Microsoft to invest $150 million in Apple," *CNET*, August 6, 1997.
12. Walter Isaacson, *The Innovators* (New York: Simon & Schuster, 2014), 184.
13. Robert L. Bartley, *The Seven Fat Years* (New York: Free Press, 1992), 142.
14. Isaacson, *The Innovators*, 185.
15. Ibid., 187.
16. Harford, *Adapt*, 12.

CHAPTER FIVE

1. Daniel Fischel, *Payback: The Conspiracy to Destroy Michael Milken and His Financial Revolution* (New York: Harper Collins, 1995), 3.
2. Robert H. Smith, *Dead Bank Walking* (Bath, U.K.: Oakhill Press, 1995), 62.
3. Ibid., 64.
4. Ibid., 65.
5. Ibid., 62.
6. Ibid., 68.
7. Ibid., 55.
8. Ibid., 58. Emphasis mine.
9. Ibid., 58–59.
10. M. J. Lee, "Donald Trump: I'm Worth $10 Billion," *CNN Politics*, July 15, 2015.
11. Natalie Robehmed, "Why Jennifer Lawrence Is The World's Highest-Paid Actress," Forbes.com, August 20, 2015.
12. Fischel, *Payback*, 42.
13. Ibid., 158.
14. Ibid., 25.
15. Andrew Ross Sorkin, "Junk Bonds, Mortgages and Milken," *New York Times*, April 29, 2008.
16. Fischel, *Payback*, 198.
17. Glenn Yago, "Junk", Library of Economics and Liberty, http://www.econlib.org/library/Enc/JunkBonds.html.
18. Fischel, *Payback*, 17.

CHAPTER SIX

1. Emily Smith, "Hedge Mogul's Sky-High Buy," *New York Post*, August 20, 2015.
2. Kevin Dugan, "Jumping the Gun," *New York Post*, August 20, 2015.
3. Gregory Zuckerman, *The Greatest Trade Ever: The Behind-the-Scenes Story of How John Paulson Defied Wall Street and Made Financial History* (New York: Broadway Books, 2009), 233.
4. Alexandra Stevenson, "After Fed, Bernanke Offers His Wisdom, for a Big Fee," *New York Times*, May 20, 2014.
5. CNBC, "Bernanke: My Inflation Record at the Fed Is One of the Best," February 26, 2013.
6. Kitco.com.
7. *Forbes*, http://www.forbes.com/profile/john-paulson/.
8. Zuckerman, *Greatest Trade Ever*, 32.
9. Ibid., 35.
10. Michael Lewis, *The Big Short: Inside the Doomsday Machine* (New York: W. W. Norton, 2010).
11. Zuckerman, *Greatest Trade Ever*, 153.
12. Ibid., 145.
13. Ibid., 15.
14. Fortune editors, "Star Dims for Goldman's Youngest Partner," Fortune .com, January 17, 2012.
15. Walter Bagehot, *Lombard Street: A Description of the Money Market* (New York: Peter L. Bernstein, 1999), 225.

CHAPTER SEVEN

Epigraph: Mark Leibovich, *This Town: Two Parties and a Funeral—Plus, Plenty of Valet Parking!—in America's Gilded Capital* (New York: Penguin Group, 2013), 171.

1. Warren Brookes, *The Economy in Mind* (New York: Universe Books, 1982), 55.
2. Steven F. Hayward, *The Age of Reagan: The Conservative Counterrevolution, 1980–1989* (New York: Crown Forum, 2009), 77.
3. Stephen Moore, "Reaganomics Won the Day," *National Review* online, June 7, 2004.
4. Frank Newport, "Congress' Job Approval at New Low of 10%," Gallup Poll, February 8, 2012.
5. Mollie Reilly, "The Clintons Have Earned about $30 Million from Speeches, Book Sales Since 2014," *Huffington Post*, May 15, 2015.
6. FoxNews.com, "Obama to Business Owners: 'You Didn't Build That,'" July 16, 2012.
7. Sally C. Pipes, "Medicare at 50: Hello, Mid-Life Crisis," *Wall Street Journal*, July 30, 2015.

8. Steven F. Hayward, *The Age of Reagan: The Fall of the Old Liberal Order, 1964–1980* (Roseville, Calif.: Prima Publishing, 2001), 7.
9. Hayward, *Age of Reagan: The Conservative Counterrevolution*, 31.
10. James Ward, "The Enduring Genius of the Ballpoint Pen," *Wall Street Journal*, June 6–7, 2015.
11. Pipes, "Medicare At 50."
12. Hayward, *Age of Reagan: The Fall of the Old Liberal Order*, 19.
13. Hayward, *Age of Reagan: The Conservative Counterrevolution*, 62.

CHAPTER EIGHT

1. Harford, *Adapt*, 10.
2. Klint Finley, "Sprint Has Officially Saved RadioShack from Extinction," Wired.com, March 31, 2015.
3. Michael D. Tanner, "War on Poverty at 50: Despite Trillions Spent, Poverty Won," Cato Institute, January 8, 2014.
4. Ibid.
5. For more on TVA, see http://www.tva.com/abouttva/index.htm.
6. Zachary A. Goldfarb, "Candidate Obama, Echoing Tea Party, Called Ex-Im Bank 'Little More than a Fund for Corporate Welfare,'" *Washington Post*, June 26, 2014.
7. Anupreeta Das, "The Wannabe Buffetts: Smorgasbord of Followers Claim Billionaire's Name," *Wall Street Journal*, February 27, 2015.
8. Warren Buffett, "Better than Raising the Minimum Wage," *Wall Street Journal*, May 22, 2015.
9. Morgan Quinn, "7 Investing Mistakes Warren Buffett Regrets," GOBankingRates, April 23, 2015.

CHAPTER NINE

1. Harford, *Adapt*, 1–2.
2. Adam Smith, *The Wealth of Nations* (New York: Modern Library, 1994, 1776), 3.
3. Ibid., 5.
4. Douglas Irwin, *Free Trade under Fire* (Princeton, N.J.: Princeton University Press, 2002), 18.
5. Gregory Zuckerman, *The Frackers: The Outrageous Inside Story of the New Billionaire Wildcatters* (New York: Portfolio Penguin, 2013), 5.
6. Jerry Taylor and Peter Van Doren, "The Green Energy Economy Reconsidered," *Forbes*, April 25, 2011.
7. Smith, *Wealth of Nations*, 370.
8. George Gilder, *The 21st Century Case for Gold: A New Information Theory of Money* (Washington, D.C.: American Principles Project, 2015), 64.
9. Ibid., 69.
10. Hayward, *Age of Reagan: The Conservative Counterrevolution*, 68–69.

11. Steve Forbes, "Powerful Antiterror Weapon," *Forbes*, October 6, 2006.

12. Kitco.com.

13. Bartley, *Seven Fat Years*, 32.

14. Ibid., 33.

15. Bloomberg.com.

16. Zuckerman, *The Frackers*, 3.

17. Nathan Lewis, "The Correlation between the Gold Standard and Stupendous Growth Is Very Clear," Forbes.com, April 11, 2013.

18. Zuckerman, *The Frackers*, 126.

19. Euan Mearns, "The Oil Price: How Low Is Low?" OilPrice.com, August 11, 2015.

20. Zuckerman, *The Frackers*, 310.

21. Rick Jervis, "Slumping Oil Prices Not Slowing Texas Boom," *USA Today*, October 27, 2014.

22. John Tamny, "Let's Be Serious, Falling Oil Prices Are Not Causing the Busts in Texas and North Dakota," Forbes.com, February 2, 2015.

23. Erin Allworth, Russell Gold, and Timothy Puko, "Deep Debt Keeps U.S. Oil Firms Pumping," *Wall Street Journal*, January 7, 2015.

24. Ibid.

CHAPTER TEN

1. Robert Conquest, *Reflections on a Ravaged Century* (New York: W. W. Norton, 2000), 103.

2. Hedrick Smith, *The Russians* (New York: Quadrangle/New York Times Book Co., 1984), 696.

3. Smith, *Wealth of Nations*, 367.

4. Smith, *The Russians*, 696.

5. Windsor Mann, "Rubio: Our National Security Depends on Sugar Subsidies," *National Review* online, August 31, 2015.

6. Mark Hendrickson, "Where the Supply-Siders Totally Blew It," RealClearMarkets.com, May 7, 2015.

7. Donald Luskin, "Smells Like Victory," *National Review* online, July 12, 2005.

8. Bart Jansen, "Grrridlock: You Aren't Alone," *USA Today*, August 26, 2015.

CHAPTER ELEVEN

1. Ludwig von Mises, *The Theory of Money and Credit* (Indianapolis, Ind.: Liberty Fund, 1912), 341.

2. Rothbard quoted in Ron Paul, "Fractional Reserve Banking, Government, and Moral Hazard," *Financial Sense*, July 9, 2012.

3. von Mises, *Theory of Money and Credit*, 341.

4. Adam Fergusson, *When Money Dies: The Nightmare of Deficit Spending, Devaluation, and Hyperinflation in Weimar Germany* (New York: Public Affairs, 2010), 113. My emphasis.

5. Ibid., 87.

6. Ibid., 140. My emphasis.

7. von Mises, *Theory of Money and Credit*, 379.

8. Lawrence W. Reed, *Excuse Me, Professor: Challenging the Myths of Progressivism* (Washington, D.C.: Regnery, 2015), 154.

9. Ron Paul, "Fractional Reserve Banking, Government, and Moral Hazard," *Financial Sense*, July 9, 2012.

10. Eric Margolis, "The Terror of Chinese Paper," LewRockwell.com, August 29, 2015.

11. Benn Steil, *The Battle of Bretton Woods: John Maynard Keynes, Harry Dexter White, and the Making of a New World Order* (Princeton, N.J.: Princeton University Press, 2013), 139.

12. Robyn Meredith, *The Elephant and the Dragon: The Rise of India and China and What It Means for All of Us* (New York: W. W. Norton, 2007), 34.

CHAPTER TWELVE

1. Greg Bensinger, "Amazon Posts Surprising Profit," *Wall Street Journal*, July 23, 2015.

2. Yahoo Finance, http://finance.yahoo.com/q?s=AMZN.

3. Greg Bensinger, "Amazon Curtails R&D on Consumer Devices," *Wall Street Journal*, August 27, 2015.

4. Thiel, *Zero to One*, 44.

5. Craig Karmin, *Biography of the Dollar: How the Mighty Buck Conquered the World and Why It's under Siege* (New York: Crown Business, 2008), 4.

6. Flamson quoted in Smith, *Dead Bank Walking*, 93.

CHAPTER THIRTEEN

Epigraph: Robert H. Smith, *The Changed Face of Banking: Who Will Be the Last Bank Standing?* (Portland, Ore.: CreateSpace Independent Publishing Platform, 2014), 3.

1. Karen Talley, "Sam's Club to Offer Loans Up to $25,000," *Wall Street Journal*, July 6, 2010.

2. G. Edward Griffin, "The Creature from Jekyll Island," American Media, July 2009 print, 12–13.

3. Andrew Ross Sorkin, *Too Big to Fail: The Inside Story of How Wall Street and Washington Fought to Save the Financial System—and Themselves* (New York: Viking, 2009), 443.

4. Thomas E. Woods Jr., *Meltdown: A Free-Market Look at Why the Stock Market Collapsed, the Economy Tanked, and Government Bailouts Will Make Things Worse* (Washington, D.C.: Regnery, 2009), 49.

5. Patricia Cohen, "Zero to 789, in 26 Months," *New York Times*, October 11, 2014.

6. www.lendingclub.com.

7. Smith, *Changed Face of Banking*, 84.

8. Ibid., 84.

9. Susan Johnston, "Will Wal-Mart's New Checking Accounts Change the Game?" *U.S. News & World Report*, October 21, 2014.

10. Walter B. Wriston, *The Twilight of Sovereignty: How the Information Revolution Is Transforming Our World* (New York: First Replica Books Edition, 1997), 126.

11. Michael Freeman, *ESPN: The Uncensored History* (Lanham, Md.: Taylor Trade Publishing, 2000), 59.

12. Michael Germanovsky, "Credit Card Movies: How to Fund Cinematic Dreams," *Fox Business*, November 2, 2012.

13. Reuven Brenner, "Stock Market Booms, Busts, and Free Flow of Information," *Asia Times*, July 21, 2015.

14. "Well Funded," *The Economist*, August 6, 2014.

15. Smith, *Changed Face of Banking*, 4.

16. Ryan Tracy, "A New Bank Sprouts, At Last, in Amish Land," *Wall Street Journal*, March 30, 2015.

17. Smith, *Changed Face of Banking*, 80.

CHAPTER FOURTEEN

1. Henry Hazlitt, *Economics in One Lesson* (New York: Three Rivers Press, 1979), 181.

2. Woods, *Meltdown*, 26.

3. Ibid.

4. MoneyCafe.com, http://www.moneycafe.com/personal-finance/fed-funds-rate-history/.

5. Allen J. Matusow, *Nixon's Economy: Booms, Busts, Dollars, and Votes* (Lawrence: University Press of Kansas, 1998), 184.

6. Ronald I. McKinnon and Kenichi Ohno, *Dollar and Yen: Resolving Economic Conflict between the United States and Japan* (Cambridge, Mass.: MIT Press, 1997), 15.

7. Kitco.com.

8. David Frum, *How We Got Here: The 70's—The Decade that Brought You Modern Life—For Better or Worse* (New York: Basic Books, 2000).

9. George Gilder, *Wealth and Poverty* (New York: Basic Books, 1981), 176–77.

10. Quin Hillyer, "Catch a Falling Dollar!" *American Spectator*, November 27, 2007.
11. Gustav Cassel, *Money and Foreign Exchange after 1914* (London: MacMillan, 1922), 21.
12. Kitco.com.
13. Smith, *Wealth of Nations*, 305.
14. John Allison, *The Financial Crisis and the Free Market Cure: Why Pure Capitalism Is the World Economy's Only Hope* (New York: McGraw-Hill, 2013), 5.
15. Peter J. Wallison, *Bad History, Worse Policy: How a False Narrative about the Financial Crisis Led to the Dodd-Frank Act* (Washington, D.C.: AEI Press, 2013), 260.
16. Zuckerman, *Greatest Trade Ever*, 45.
17. Nigel Lawson, *The View From No. 11: Memoirs of a Tory Radical* (New York: Doubleday, 1993).
18. Alexandra Wolfe, "Alan Greenspan: What Went Wrong," *Wall Street Journal*, October 18, 2013.
19. Zuckerman, *Greatest Trade Ever*, 107.
20. Gilder, *Wealth and Poverty*, 176–77.
21. Fergusson, *When Money Dies*, 109.
22. David Smith, *The Rise and Fall of Monetarism* (London: Penguin, 1987).
23. Ibid.
24. William Greider, *The Secrets of the Temple: How the Federal Reserve Runs the Country* (New York: Simon & Schuster, 1989), 41.

CHAPTER FIFTEEN

Epigraph: McCraw, *Prophet of Innovation*, 74.
1. Joel Trammell, *The CEO Tightrope: How to Master the Balancing Act of a Successful CEO* (Austin, Tex.: Greenleaf Book Group Press, 2014), 6.
2. Ibid., 12.
3. Ibid., 4.
4. Ibid., 79. My emphasis.
5. Matt Taibbi, "Greed and Debt: The True Story of Mitt Romney and Bain Capital," *Rolling Stone*, August 29, 2012.
6. Jason Kelly, *The New Tycoons: Inside the Trillion Dollar Private Equity Industry that Owns Everything* (Indianapolis, Ind.: Bloomberg Press, 2012).
7. Nathan Lewis, *Gold: The Once and Future Money* (Hoboken, N.J.: John Wiley and Sons, 2007), 110.
8. Smith, *Changed Face of Banking*, 80.
9. Ibid., 104.
10. Ibid., 96.

CHAPTER SIXTEEN

1. Gilder, *The 21st Century Case for Gold*, 14.
2. Ibid.
3. von Mises, *Theory of Money and Credit*, 378–79.
4. Ibid., 340.
5. Ibid.
6. Bartley, *Seven Fat Years*, 51.
7. Gilder, *The 21st Century Case for Gold*, 23.
8. David Beckworth and Ramesh Ponnuru, "Tight Budgets, Loose Money," *New Republic*, November 3, 2011.
9. David Beckworth and Ramesh Ponnuru, "Monetary Regime Change," *National Review*, June 12, 2012.
10. Alana Semuels, "Detroit's Abandoned Buildings Draw Tourists instead of Developers," *Los Angeles Times*, December 25, 2013.
11. Smith, *Wealth of Nations*, 370.
12. Nathan K. Lewis, *Gold: The Monetary Polaris* (Portland, Ore.: Create Space Independent Publishing Platform, 2013), 208.
13. John Tamny, *Popular Economics: What the Rolling Stones, Downton Abbey, and LeBron James Can Teach You about Economics* (Washington, D.C.: Regnery, 2015), 232–33.
14. Bret Swanson, "Permission Slips for Internet Innovation," *Wall Street Journal*, August 15, 2015.
15. Isaac, "Upstarts Raiding Giants for Staff in Silicon Valley."

CHAPTER SEVENTEEN

1. James Osborne, "Price Slide Hurts Energy Deals" *Dallas Morning News*, December 27, 2014.
2. Jon Hilsenrath and Nick Timiraos, "U.S. Lacks Ammo for Next Crisis," *Wall Street Journal*, August 18, 2015.
3. von Mises, *Theory of Money and Credit*, 341.
4. Ailworth, Gold, and Puko, "Deep Debt Keeps U.S. Oil Firms Pumping."
5. Louis Woodhill, "Why the Fed's QEIII Will Not Work," RealClear Markets.com, November 11, 2010.
6. Romain Hatchuel, "The Fed Rate Hike May Be a Mirage," *Wall Street Journal*, October 26, 2014.
7. Rana Foroohar, "Janet Yellen: The 16 Trillion Dollar Woman," *Time Magazine*, January 20, 2014.
8. Quoted in John Tamny, "The Comical Myth about Low Rates Boosting the 1 Percent," RealClearMarkets.com, August 5, 2014.
9. von Mises, *Theory of Money and Credit*, 287. Emphasis mine.
10. Jeffrey Snider, "Janet Yellen Uses Fed Failures to Expand the Fed's Mandate," RealClearMarkets.com, July 28, 2014.
11. "The Usual Chinese Suspects," editorial, *Wall Street Journal*, September 1, 2015.

CHAPTER EIGHTEEN

Epigraph: Quoted in Bartley, *Seven Fat Years*, 62.

1. Hayward, *Age of Reagan: The Fall of the Old Liberal Order*, 290.
2. Ben Leubsdorf, "The Fed Has a Theory, But the Proof Is Patchy," *Wall Street Journal*, August 24, 2015.
3. Ibid.
4. Kohn quoted in John Tamny, "The Phillips Curve Is Dead, Except at the Fed," RealClearMarkets.com, September 16, 2008.
5. Paul Davidson, "Yellen Plots Rate-Hike Road Map," *USA Today*, February 25, 2015.
6. Bartley, *Seven Fat Years*, 51.
7. Karmin, *Biography of the Dollar*, 4.
8. Bartley, *Seven Fat Years*, 52.
9. Richard W. Nelson, "Why the Fed Needs to Get Off of the Dime," *Wall Street Journal*, July 24, 2015.

CHAPTER NINETEEN

Epigraph: Smith, *Dead Bank Walking*, 47.

1. *Forbes*, http://www.forbes.com/profile/taylor-swift/.
2. Hazlitt, *Economics in One Lesson*, 43.
3. John Balassi and Josie Cox, "Apple Wows Market with Record $17 Billion Bond Deal," *Reuters*, April 30, 2013.
4. Smith, *Dead Bank Walking*, 163.
5. Ibid.

CHAPTER TWENTY

1. Amity Shlaes, *The Forgotten Man: A New History of the Great Depression* (New York: HarperCollins, 2007), 147. My emphasis.
2. Lewis, *Gold: The Once and Future Money*.
3. Carmen M. Reinhart and Kenneth S. Rogoff, *This Time Is Different: Eight Centuries of Financial Folly* (Princeton, N.J.: Princeton University Press, 2009).
4. Thiel, *Zero to One*, 44.
5. Shlaes, *Forgotten Man*, 148.
6. Eric Rauchway, *The Money Makers: How Roosevelt and Keynes Ended the Depression, Defeated Facism, and Secured a Prosperous Peace* (New York: Basic Books, 2015).
7. Steil, *Battle of Bretton Woods*, 177.
8. Stephen Moore and John Tamny, "Weak Dollars, Weak Presidents," *American Spectator*, December 2008–January 2009.
9. Hayward, *Age of Reagan: The Fall of the Old Liberal Order*, 262–63.
10. Matusow, *Nixon's Economy*, 153–54.
11. Robert H. Ferrell, *Inside the Nixon Administration: The Secret Diary*

of Arthur Burns, 1969–1974 (Lawrence: University Press of Kansas, 2010), 39.

12. Ferrell, *Inside the Nixon Administration*, 49.
13. Matusow, *Nixon's Economy*, 170.
14. McKinnon and Ohno, *Dollar and Yen*, 15.
15. Kitco.com.
16. Bartley, *Seven Fat Years*, 109.
17. John Tamny, "Gold's Plunge Is Cause for Optimism," *Wall Street Journal*, April 18, 2013.
18. Lewis, *Gold: The Once and Future Money*, 228.
19. Allison, *Financial Crisis and the Free Market Cure*, 170.
20. Ibid.
21. Smith, *Changed Face of Banking*, 72.
22. Josh Mitchell, "Grad-School Loan Binge Fans Debt Worries," *Wall Street Journal*, August 19, 2015.
23. Thomas F. 'Mack' McClarty, "Small Business and the Secret of Big Growth," *Wall Street Journal*, September 3, 2015.

CHAPTER TWENTY-ONE

1. Timothy Aeppel, "Jobs and the Clever Robot," *Wall Street Journal*, February 24, 2015.

INDEX